C000078377

THE OTHER
HUNDRED

THE OTHER HUNDRED

100

FACES
PLACES
STORIES

ENTREPRENEURS

CONTENTS

The Other Hundred Entrepreneurs

THE SPIRIT OF CREATION

DIGITALLY RELEASED

WORDS OF MY OWN

AFTERWORD

FOREWORD

Chandran Nair

FOREWORD

Chandran Nair

Welcome to the second edition of The Other Hundred, this time on the theme of entrepreneurs. Through its hundred stories, it offers an alternative to the view that most successful entrepreneurs were trained at elite business schools or run Nasdaq-listed high-tech firms. Here, instead, are people who have never written a formal business plan, hired an investment bank, planned an exit strategy or even dreamt of a stock market flotation. Some work for themselves, others employ a few people, still others a few hundred. These are the people behind the statistic that small and medium-sized businesses contribute half of all jobs in Africa and two-thirds in Asia.

The moment I realised the need for this book was at a global workshop on entrepreneurship organised by one of the world's major economic forums. Within minutes of it starting, I found myself utterly bemused at how quickly its participants – a mixture of investors, consultants and business leaders – had turned to discussing funding and finance, debt/equity ratios, the role of private equity and return on capital. Did none of them realise that for 99 out of every 100 entrepreneurs, money is nothing more than the cash in the till at the end of the day?

That meeting left me acutely aware of how in the rarefied world of global business the notion of what is an entrepreneur has lost almost all its links with the ways in which a person sets about trying to improve their material well-being by starting a business. In this book, I want to return the word "entrepreneur" to its roots by capturing a tiny part of the enormous variety of ways in which entrepreneurship manifests itself around the world. Through its pictures and stories, I hope we succeed in showing that entrepreneurship is thriving across cultures, classes and genders, in everyday life and in the unlikeliest of places.

A secondary motive for choosing entrepreneurs as the theme for this book was the reception received by its first edition, *The Other Hundred*. Before that book's launch, I had feared that its argument against the celebration of excess epitomised by the Forbes' billionaires list and its many imitators would too easily be interpreted as just another of the many anti-rich/pro-poor books found on the shelves of many bookshops.

Instead, I was surprised how readily the book touched people from a wide range of backgrounds and resulted in wide-ranging discussions. This was encouraging for me and my hopes that more and more people are recognising the inherent contradictions of a single-minded pursuit of material progress. Also heart-warming was feedback I received about how the book had lifted a veil on people, places and cultures that many rarely think about. Two friends told me how their elderly parents had spent days reading and rereading the book. Another, a father with two young boys, told me how with the aid of an atlas, reading a page each night, the three of them had discovered and explored one new country after another. I hope this second book will also help people to find ways of engaging with the world in a similar way.

Even before launching the first volume of The Other Hundred, I had hopes of making these books a series, and indeed part of a larger project. Although the form of

Here are people who have never written a business plan,
hired an investment bank, planned an exit strategy
or dreamt of a stock market flotation

that project remains incomplete, what has become clear in my mind is that it must have two core elements. First, an attempt to depict our complex world using words, pictures and graphics in ways that open up access to the broadest of audiences – one far beyond that reached by even the most popular of our current crop of economic and social commentators. And second, a dismantling of such over-simplified notions of there being "the best", "the most successful", "the richest" or even "the most beautiful", and their replacement with ideas that reflect difference, variation, service, care and thoughtfulness.

I hope that through the pages of this book you can get a glimpse of an alternative vision of entrepreneurship – one that centres on the efforts of people, either individually or in groups, who for reasons of necessity, belief, ambition or a desire to serve others, take a risk and go out on their own, sometimes against the mainstream, to make things a little better.

These are people such as farmer Gholam Hossein, who with his sons has made a pulley system to help nomads carry their livestock across a river in north-west Iran. His story shows us how necessity and entrepreneurship can always take us by surprise. Then there is Maggy Lawson's fabrics company in Togo, successful enough to have brought her a Mercedes Benz and a string of homes across Europe. A personal favourite are the Montreal shopkeepers and their very different form of entrepreneurial obsession – one in which money appears to play an almost vanishingly minimalist role. And then there is 66-year-old Ma Xiancheng, a repairer of shoes for monks at a monastery in west China who shows us that entrepreneurship can be a link to the past as much as a means to the future.

I hope the experiences of these and the other people depicted in this book suggest that there are multiple ways of thinking about success, beyond that popular benchmark of an initial public offering which so enamours the world's business and financial media. Being an important part of a community, perhaps? Or establishing an institution that could last for generations? Or even – as the barbers of Schorem in Rotterdam have done – creating the environment in which you want to spend your working day?

This book would not have been possible without the contributions of hundreds of people from around the world. By far the most important of those are the photographers and journalists from nearly 150 countries who responded to our open call and sent in an extraordinary range and variety of submissions. They are in turn indebted to the people who allowed their stories to be pictured and recorded. Selecting the hundred submissions that fill the pages of this book was a hugely painful task – mainly because of the amount of excellent work which we most reluctantly had to exclude.

Nearer home, a large team of people each played their own role in making this book a reality. Stefen Chow, The Other Hundred's photography director, defined and drove the project's open call with relentless enthusiasm. Again, he was the key figure leading to our three judges, Ruth Eichorn, Lisa Botos and Yumi Goto, whose reputations lent enormous credibility to the project, helping to draw photographers of the highest calibre from around the world.

The book's editor, Simon Cartledge, played a key role in shaping and refining the ideas underpinning this year's Other Hundred. He was helped enormously in the process of producing the book by the talents and eye of designer Vickie Chan, while Claudia Fischer-Appelt again helped design the cover.

I owe a special thank you to the core Other Hundred team at the Global Institute for Tomorrow – Adeline Heng, our project manager, Surya Balakrishnan, our assistant editor, and their assistants, Rachita Mehrotra, Samara Melwani and Yuxin Hou, the latter two who led the charge on the global open call.

As with our first edition, accompanying the photographs of this book are a series of brief texts by writers from around the world: journalists Eliane Brum from Brazil and Yasmine El Rashidi from Egypt, Nigerian writer Tolu Ogunlesi, football historian David Goldblatt, former publisher Robyn Bargh from New Zealand and Chinese film-maker Huang Wenhai, each of whom interpreted the idea of the "other" entrepreneur in their own distinctive way.

Novelist Tash Aw's Introduction sets the tone for the book with his suggestion for removing money – at least in abundance – from our equation of what is needed for success. And Ian Johnson, in his Afterword, proposes that if humans are to make it through the coming century, then likely it will be because of the achievements of more ordinary people – such as those of this book.

As with many ambitious projects, we also needed support from sponsors. I am hugely grateful to the generous assistance of ORIX Corporation, East West Group, TC Capital, BASF, Solving Efeso, Quam Financial Services Group, RS Group, *The International New York Times*, IDSMED and APG, all businesses which I have long had the honour of working and being associated with.

This project would have been impossible without the help and support of all my colleagues at the Global Institute for Tomorrow, Eric Stryson, Karim Rushdy, Mei Cheung, Feini Tuang, Helena Lim, and Caroline Ngai, and the assistance they received from our excellent interns, Austin Liu, Chi Yeung Yau, Jinney Chong, Maya Petersohn, Ruby Lai and Tricia Harjani.

Finally, I would like to thank Novin Doostdar and all the other staff at Oneworld Publications for their continuing support for The Other Hundred. Once again, I hope we have lived up to their remarkable trust that we would deliver a worthwhile addition to their catalogue.

Hong Kong
October 2014

INTRODUCTION

Tash Aw

INTRODUCTION

Tash Aw

Not long ago I was on a bus in Singapore, heading out of the city centre to the sprawling suburbs in the west of the island. Avenue upon avenue of nondescript government-built apartment blocks stretched for miles, each identikit building distinguished only by a small numbered sign on its side that announced its address. The bus stopped; the man sitting next to me – in his late sixties or early seventies – left in a hurry. It was only after the bus had pulled away that I noticed he had left behind the magazine he had been reading earlier – the monthly magazine of a private bank, read and re-read until its glossy pages were frayed at its edges.

I flicked through it and saw the Chinese title of its main article, an interview with a self-made property tycoon: "It Didn't Feel Good to be Poor". Further on, there were adverts for luxury apartments overlooking Central Park in New York and an article on the convenience of travelling in private jets.

I looked out of the window at the featureless ranks of government-built housing, where the majority of Singaporeans live, a place where the island nation's proud statistic of having more millionaires per capita than any other country in the world means nothing at all. And yet, even here, there was a very fixed notion of what it means to be successful.

In a world of rapidly evolving technology with an appetite for seemingly limitless globalisation, some ideas seem to be growing more focused, increasingly tethered to narrow strictures. Ambition and success have, it would appear, become synonymous with

money: cold, hard cash, and lots of it. But as these dreams become more predictable and stripped down to a harsh bottom line, it also becomes more obvious than ever that the vast riches that many dream of will forever remain the stuff of fantasy. The more simple and convenient we render the attainment of wealth, the more distant that prospect becomes. The most surreal and depressing thing I ever saw was a formula, scribbled on a piece of paper on a desk at a university in Singapore that read:

HARD WORK > SUCCESS > WEALTH > HAPPINESS FOREVER

So what happens when money, or at least an abundance of it, is taken out of the equation? If you are the last of a dying breed of artisan photographers capturing the old-fashioned beauty of weddings and baptisms in Quito, Ecuador, or you manage a collective of women who run a thriving bakery in Malawi, or make stringed musical instruments in Portugal, you know, really, that the Upper East Side penthouse and the private jet will forever be out of bounds. Aspiration becomes a more nuanced, complex idea.

It is this complexity of ambition – of desire, hope and fear – that The Other Hundred celebrates: the reality of daily life across the globe in all its grimy richness. In this collection of portraits, the real stories of what we strive for unfold in a tableau, as if in a classical Chinese scroll or a Brueghel painting, intricate in its tales of individual endeavour. There is not one message, but many.

What happens when money is taken out of the equation?

Some people are clearly on the up, like South African fashion designers Lethabo Tsatsinyane and Teekay Makwale with their Soweto-based Smarteez brand; or Ghanaian Ibrahim Djan Nyampong, whose ingenious bamboo bicycles are carving out a niche market in Europe and the United States. Others, like Fahmi Fersi, who imports Chinese ink cartridges for redistribution in Tunisia, are still struggling, hit by the global financial crisis and political events beyond their control.

Some are not in it for profits at all: the commercial efforts at Chile's Calabacillo Marine Forest Nature Sanctuary are dedicated entirely to the protection of its rich seaweed. A highly skilled art restorer in Italy, a linguist-turned-matchmaker in Belarus, an organisation in Uganda that makes apps for classrooms, hipster-artisans in Brooklyn, an "aquaponic" pioneer in Singapore – all these people share an ingenuity and a determination to establish themselves and their work in the absence of an obvious fat cheque at the end of the month. Their dreams might well involve the promise of financial reward, but what seems to matter more is the process of what they do, the here and now, rather than the pay-off.

It is the highly charged present or the humdrum daily routine that involves us in the fabric of these people's lives. What The Other Hundred achieves is to suspend time – no, even better, to keep it ticking over – so that we become enmeshed in the ongoing endeavour of its subjects across the globe. We follow them as they progress: theirs is not a story told, but one that continues, and within it, we are able to locate our own narrative.

For me, as a novelist, perhaps the most engaging tale of resourcefulness and resilience is that of Philani, a 24-year-old recovering drug addict in Johannesburg, who reviews second-hand books on the streets, relating his opinions to passers-by. If they like what they hear, they can buy the books from him. I have no doubt that for him, like everyone else, It Doesn't Feel Good to be Poor. Yet for him, like everyone else, the path to success and happiness will never have the beautiful linearity that we have come to expect.

THE 100 PLACES

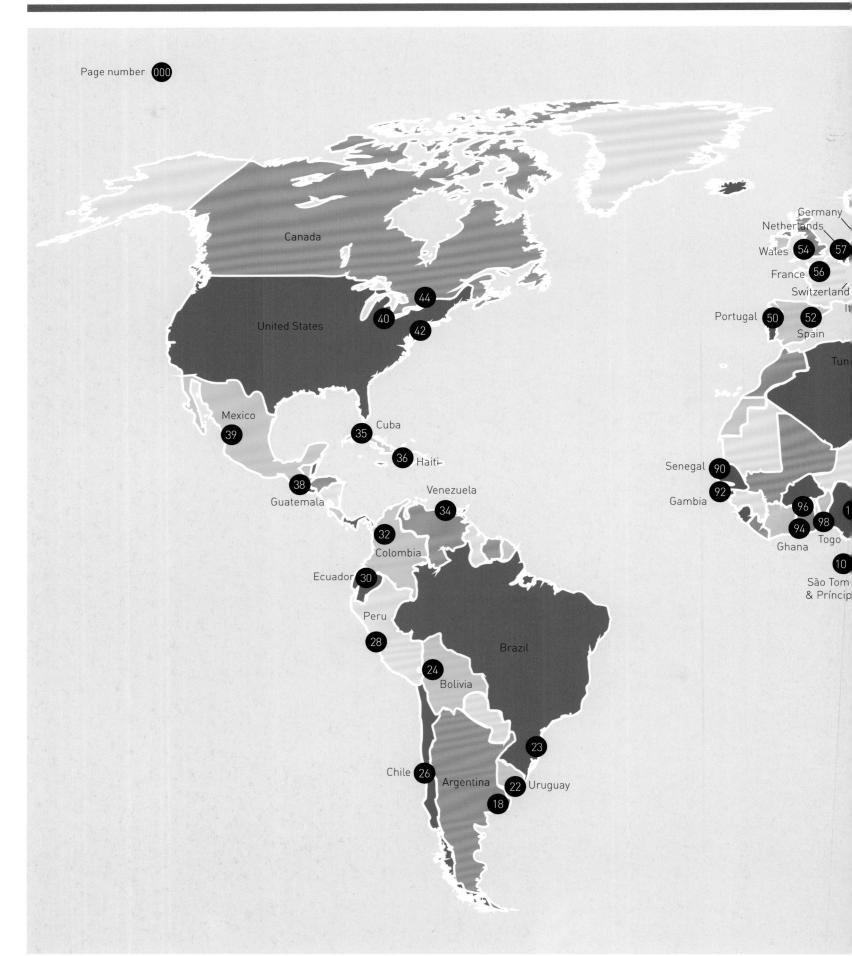

Page number 000

Canada

United States

44

40

42

Mexico

39

Cuba

35

36 Haiti

38

Guatemala

Venezuela

34

32

Colombia

Ecuador 30

Peru

28

24

Bolivia

Brazil

Chile 26

Argentina

22 Uruguay

18

Germany

Netherlands

Wales 54

57

France 56

Switzerland

It

Portugal 50

52

Spain

Tun

Senegal 90

Gambia

92

96

94

98

Ghana

Togo

10

São Tom

& Príncip

1

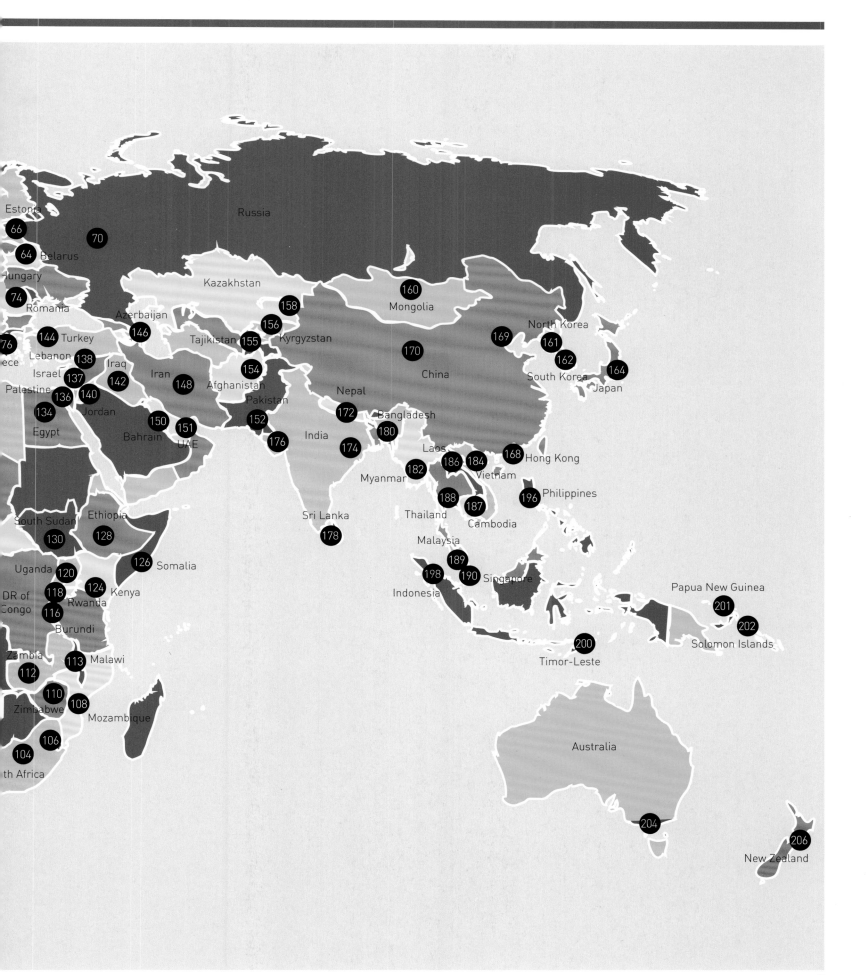

Estonia
66
64 Belarus
Hungary
74
Romania
76
ece
Lebanon 138
Israel 137
Palestine
136
134
Egypt

70

Russia

Kazakhstan

158
156
Azerbaijan
146
Turkey 144
Tajikistan 155 Kyrgyzstan
Iraq
142 Iran 148 Afghanistan
140
Jordan 150
Bahrain 151
UAE

154
152
176
India
174

Mongolia
160

170

North Korea
169
161
162
South Korea
164
Japan

China

Nepal
172 Bangladesh
180

Laos
182 186 184 168 Hong Kong
Vietnam
Myanmar 188 196 Philippines
187
Thailand Cambodia

Sri Lanka
178

South Sudan Ethiopia
130 128
Somalia
126
Uganda 120
DR of 118 124 Kenya
Congo 116 Rwanda
Burundi
Zambia 113 Malawi
112
110 108
Zimbabwe
Mozambique
106
104
th Africa

Malaysia
189
198 190 Singapore
Indonesia

200
Timor-Leste

Papua New Guinea
201
202
Solomon Islands

Australia

204

206
New Zealand

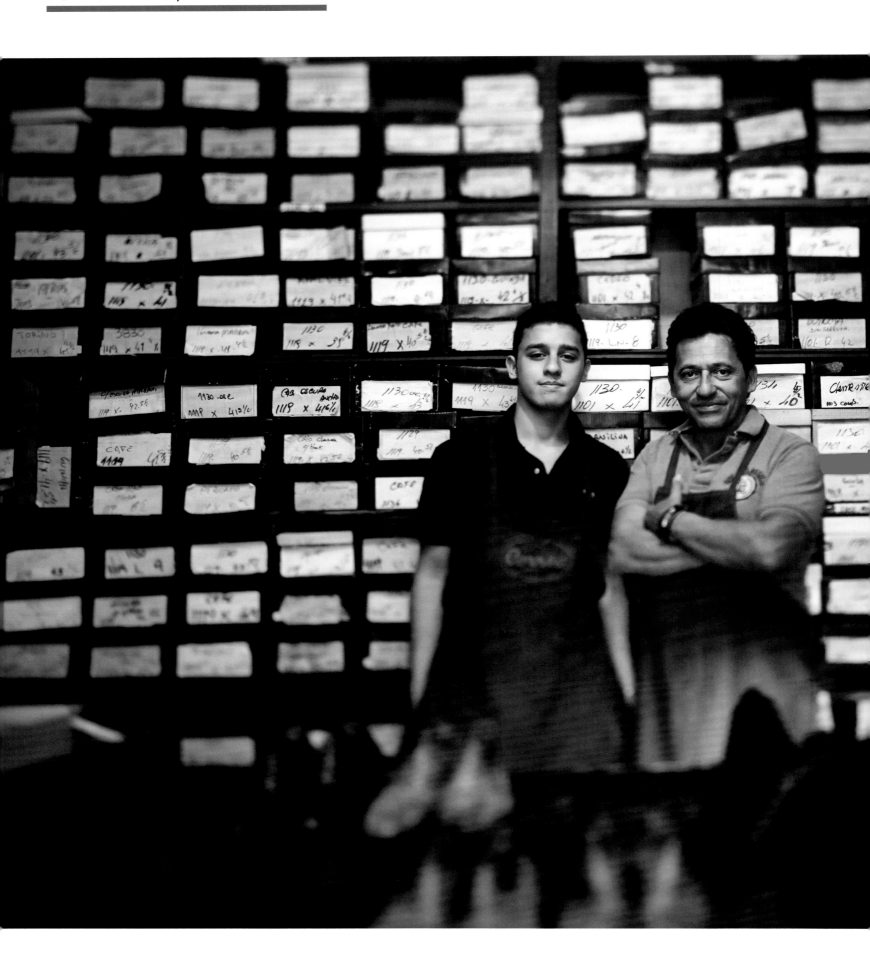

Nearly six decades ago, in 1955, on a small street in Buenos Aires' Palermo district, Felix Correa founded Calzados Correa, a maker of men's shoes. He opened a workshop, hired the best Argentine, Spanish and Italian craftsmen he could find, then started selling the shoes they made by walking up and down the streets of his neighbourhood, knocking on doors in search of customers.

Slowly, his reputation grew. "You are going to be the best craftsman ever," his customers told him. "We will still wear your shoes when you are gone."

Felix spent much of his free time outdoors, with football a particular passion. In 1992, in the middle of a game, he had a heart attack and died. His son, Dani, then 32, inherited the business. As a boy, Dani had spent all his hours after school sitting alongside his father, watching and learning. He promised to run Correa with the same passion and spirit as his father.

Today, Correa employs a dozen staff. A pair of its off-the-shelf shoes takes around two weeks to make and sells for around US$350. Although Dani continues only to make men's shoes, his younger brother has opened Correa Ladies across the road from Correa, a separate business specialising in women's footwear.

Dani, now in his mid-fifties, sometimes wonders about Correa's future. "What will happen when I'm gone?" he asks. The answer, he knows, lies with his older son, Juan, now in his early 20s. He understands the spirit of the company, says Dani. "Be creative. Follow your instincts. Be genuine," he advises his son.

Photographer
ANATOL KOTTE

Dani Correa and his oldest son, Juan. Every Friday Dani closes his shop to organise a barbeque for his staff and friends.

Overleaf: Dani with one of a half-made pair of shoes. Correa's customers include Argentine television stars and celebrities.

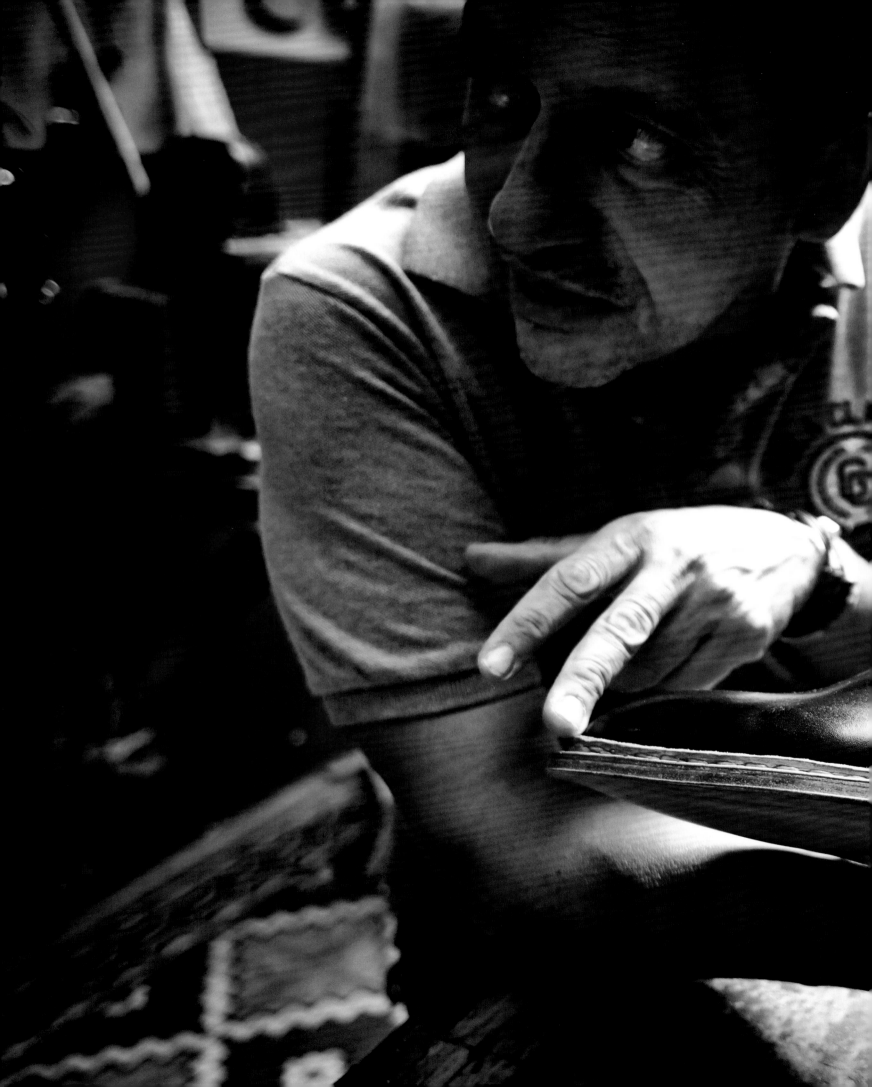

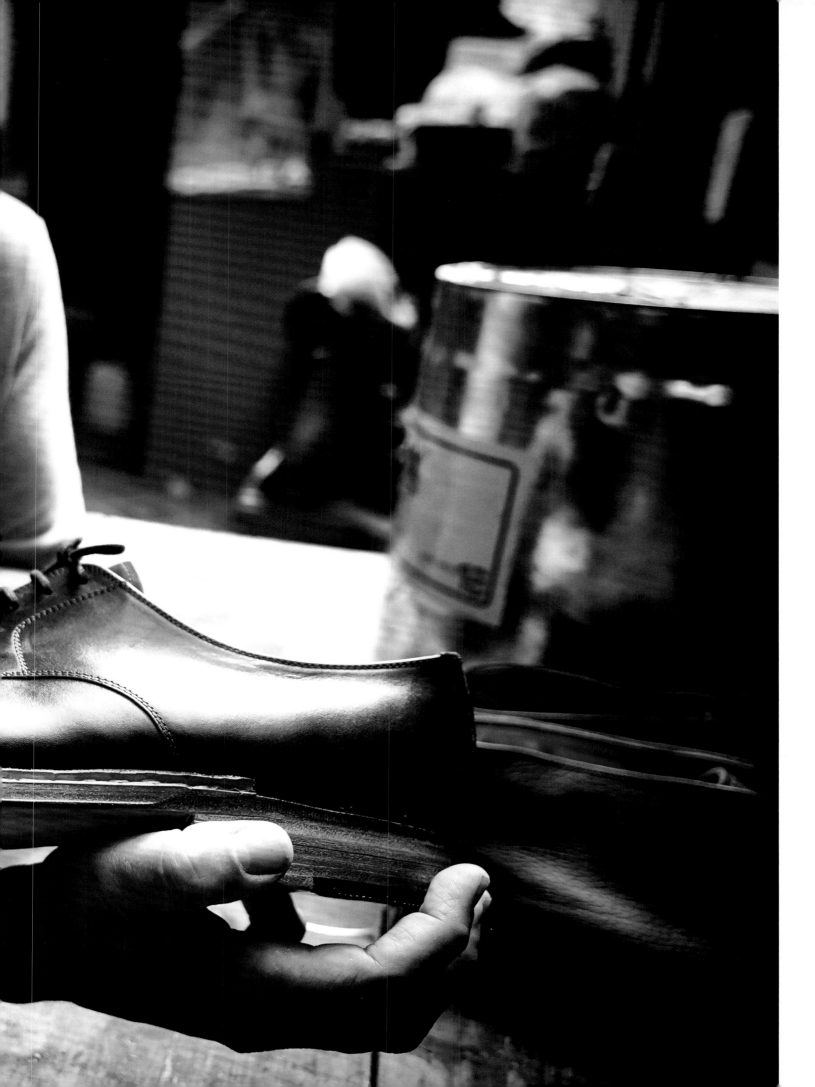

MONTEVIDEO, URUGUAY

Laura Carrasco, 27, works part-time as an illustrator, drawing posters for events, bands, dancers, and artists, to help pay her way through university in Montevideo, the capital of Uruguay.

A student of the visual arts at the Universidad de la Republica, Uruguay's only public university, and the country's oldest and largest tertiary institution, she cannot recall a time when she wasn't drawing.

Much of her love of drawing comes from the simple pleasure of putting pencil to paper. She sees the act of creating her detailed drawings as a natural tranquilliser – one that anyone can use. "Everybody can draw," she says.

Photographer
CELESTE ROJAS MUGICA

Laura in the balcony room of the house in Montevideo's Ciudad Vieja (Old City) district that she shares with four of her friends.

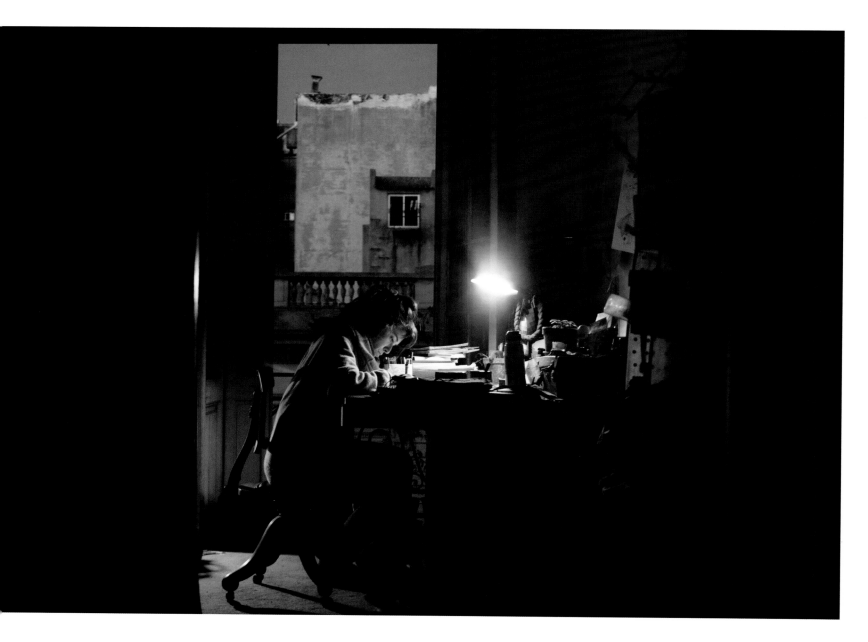

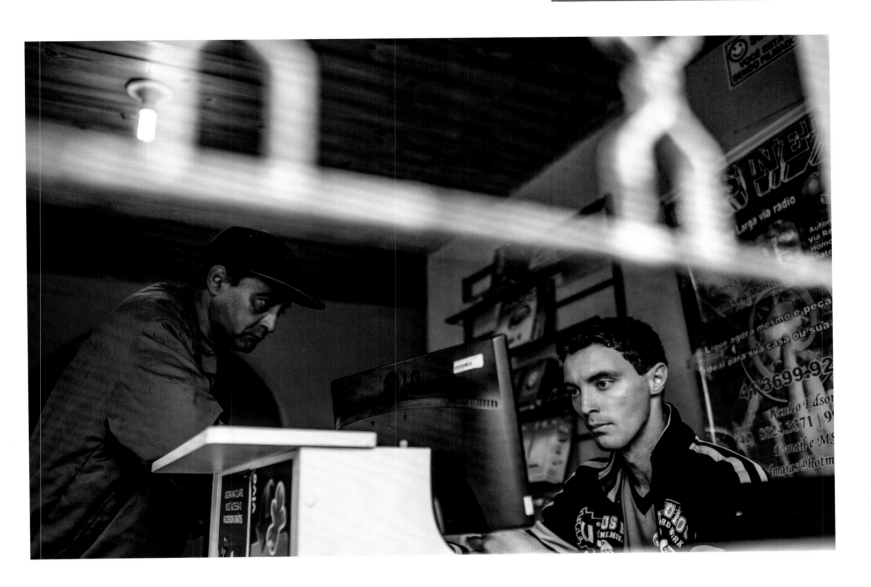

Edson da Maia Stenheuser, 24, usually known as Ed, runs a stationery store-cum-internet bar in São João Batista, a rural district with a population of some 7,000 people in the metropolitan area of Curitiba, the capital of southern Brazil's Paraná state.

Before Ed opened his business six years ago, whenever anyone wanted to pay a utility bill, add value to their mobile phones or access the internet, they had to travel 7 kilometres to the nearest urban centre. Today, his store provides all these services.

Ed set up his business with the help of a US$600 micro-loan from Aliança Empreendedora, a non-governmental organisation that supports micro-entrepreneurs by providing information and funding. He says about 300 people access the internet through his computers on a regular basis. And thanks to an antenna he has built on the top of his store, local households can also listen to radio broadcasts.

BRAZIL'S INTERNET

While nearly half of urban households across Brazil have internet connections, penetration in rural areas is far lower at just one in ten homes – explaining why around half of Brazilians access the web from one or another of the country's 100,000-plus internet bars such as Ed's.

Source: forbes.com, itdec.com

Photographer
BRUNNO COVELLO

23

COTAPATA VALLEY, BOLIVIA

In January 2011, the Cotapata Mining Co-operative, a small mine in the heart of Bolivia's Cotapata National Park, became the world's first producers of Fair Trade gold.

The cooperative, set up in 1991, now has 25 full members supported by 40 other workers. Its members say their mine offers some of the best working conditions of any mine in Bolivia. Monthly salaries for workers of US$300-600 are far above Bolivia's national minimum wage of US$80.

The mine received its Fair Trade certification after meeting conditions set by the Alliance for Responsible Mining, a Colombia-based non-governmental organisation, and Germany-based Fairtrade International, a body that brings together fair trade producer networks and certification organisations from around the world.

To receive the certification, the cooperative had to meet a range of working practice, safety and environmental standards, among them increasing the number of women workers, providing insurance to all members and recycling mercury used in the mine's production process.

As well as leading to an improvement in the mine's working conditions, Fair Trade certification also earns the cooperative an additional 10 percent on all the gold they sell. The cooperative initially used the extra money it received to build a health centre and improve its local school. Now, working in partnership with a local university, the money is being spent on projects aimed at minimising the mine's environmental impact.

Photographer
VALERIAN MAZATAUD

Workers at the Cotapata Mining Co-operative live in a permanent camp beside the mine.

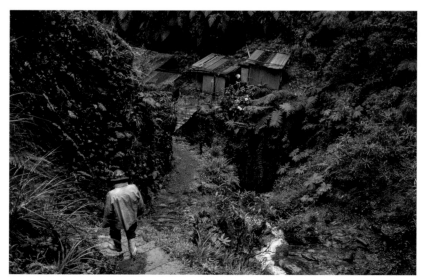

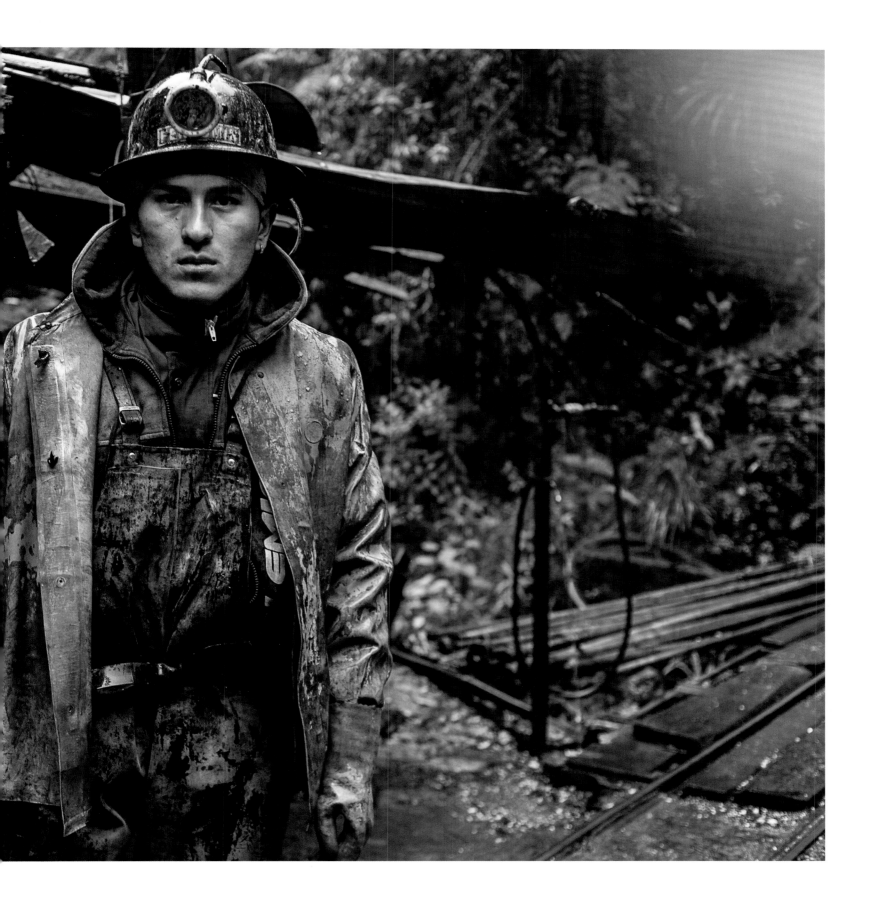

NAVIDAD, CHILE

In April 2013, Chile opened its first nature reserve dedicated to preserving a forest of seaweed, the Calabacillo Marine Forest Nature Sanctuary at Navidad in the country's central VI Liberator General Bernardo O'Higgins Region.

Four years earlier the 15-hectare area had been designated a protection zone after fishermen and seaweed collectors from six local communities came together and agreed to harvest its resources in a sustainable way.

After being collected on the beach – a task principally performed by groups of women – the seaweed is washed with sea water and left to dry in the sun for one day. After being stored for a further day in local homes or warehouses, it is then transported by truck to a processing plant on the summit of a nearby hill where the air, thanks to its elevation, is far drier than at sea level.

Once processed, the seaweed is incorporated into various products, including a range of jams made with local fruit that has recently become popular in Santiago, Chile's capital, and other regions of the country.

Photographer
FERNANDO RODRIGUEZ

OCEAN HARVESTERS

World seaweed production, share of total, percent	
China	61
Rest of Asia	30
Europe	4
South America	2
North America	2
Africa	1

Source: World Fish Center

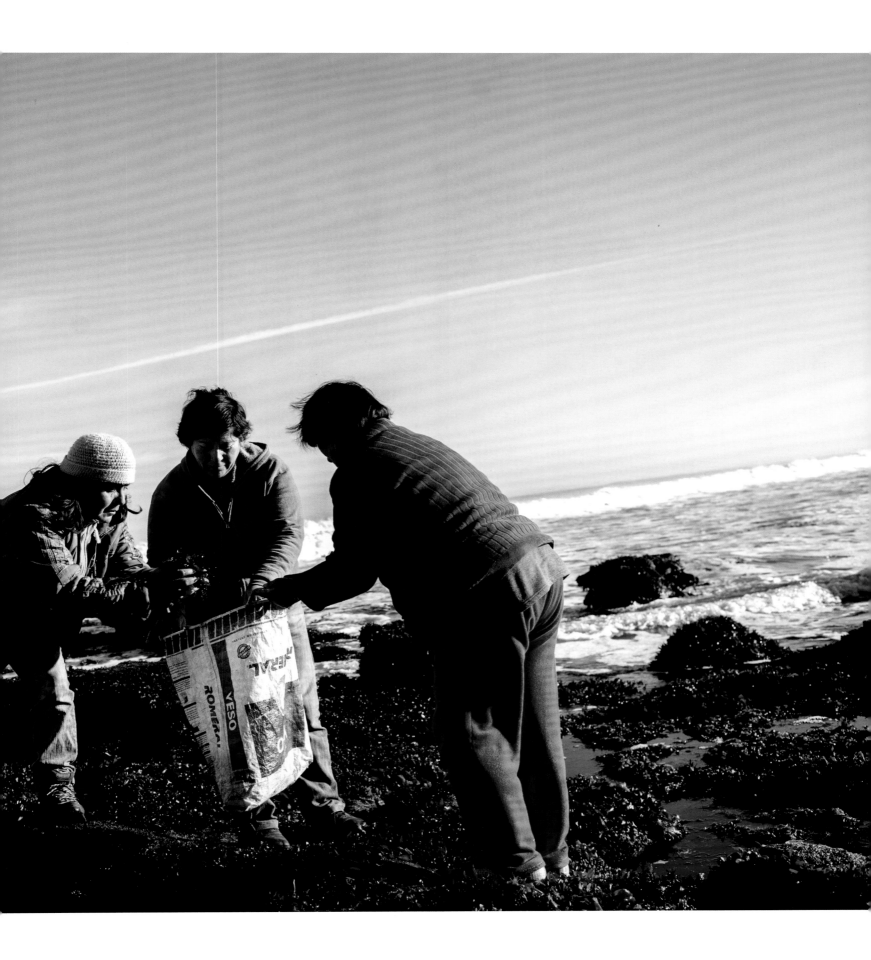

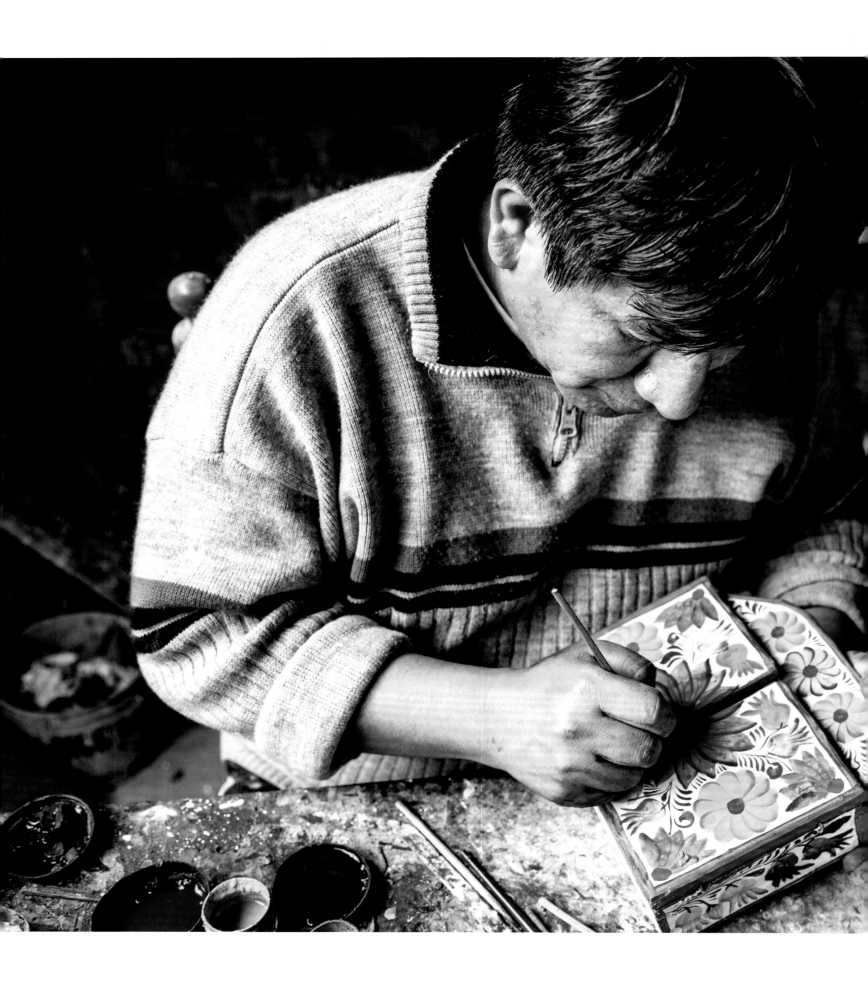

Mabilón Jiménez Quispe survives in one of Lima's poorest areas thanks to his handicraft, making *retablos*, a folk art derived from traditional Catholic church art.

The floor of his workshop, on the roof of his family's house in the Juan de Lurigancho neighbourhood of the Peruvian capital, is cluttered with small wooden *retablo* boxes, some unpainted, others decorated with colourful flowers. The interiors of most of the boxes are filled with Biblical scenes in which Jesus, Mary and Joseph are portrayed as indigenous people, and lamas replace camels.

Mabilón was born in Ayacucho, an Andean city known for its handicrafts, into a family with a long tradition of making *retablos*. He fled to Lima after a Maoist guerrilla group, Sendero Luminoso (Shining Path), launched a brutal insurgency leading to tens of thousands of deaths in the highland region around the city at the start of the 1980s.

Mabilón sells his work in Peru and overseas. But the earnings from this time-consuming craft are meagre, and many other *retablo* makers have abandoned the craft to take up other work. Today, only around 50 families in Lima make *retablos*, just half of them working by hand as Mabilón does.

Photographer
JESPER KLEMEDSSON

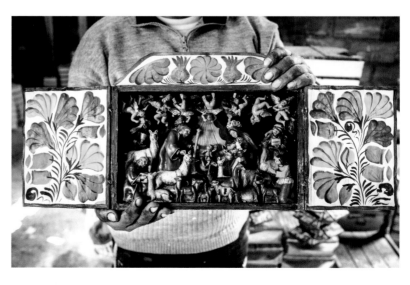

QUITO, ECUADOR

Jose Luis Paredes, 53, is one of the few artisan photographers still working in Quito, the capital of Ecuador.

He began working as a photographer's assistant around the age of 15, later starting his own business. For many years, he photographed the weddings, first communions, graduation ceremonies and parties of middle and upper class families in Quito and its surrounding districts. He took studio portraits and supplied the photographs people needed for passports and other official documents.

But since digital cameras and mobile phones with cameras arrived in Ecuador, his income has fallen by nearly two-thirds. "Nowadays, everybody can buy a cell phone with a camera in it, or a 'digital matchbox' with better features and more megapixels than my camera," says Jose.

DIGITAL SWITCH
Photographs taken annually, billion

■ Analogue ■ Digital

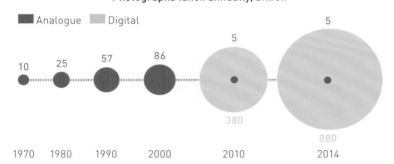

10	25	57	86	5	5
				380	880
1970	1980	1990	2000	2010	2014

Source: 1000memories.com

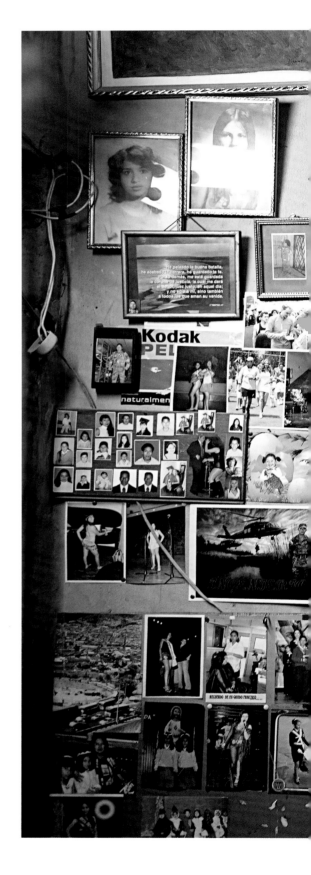

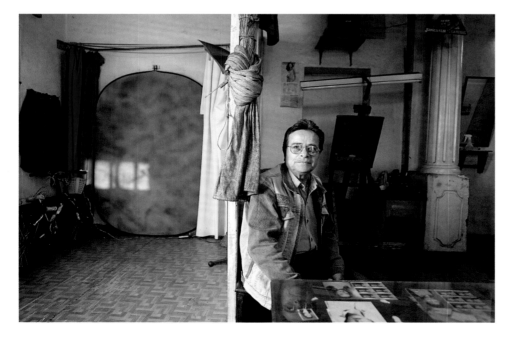

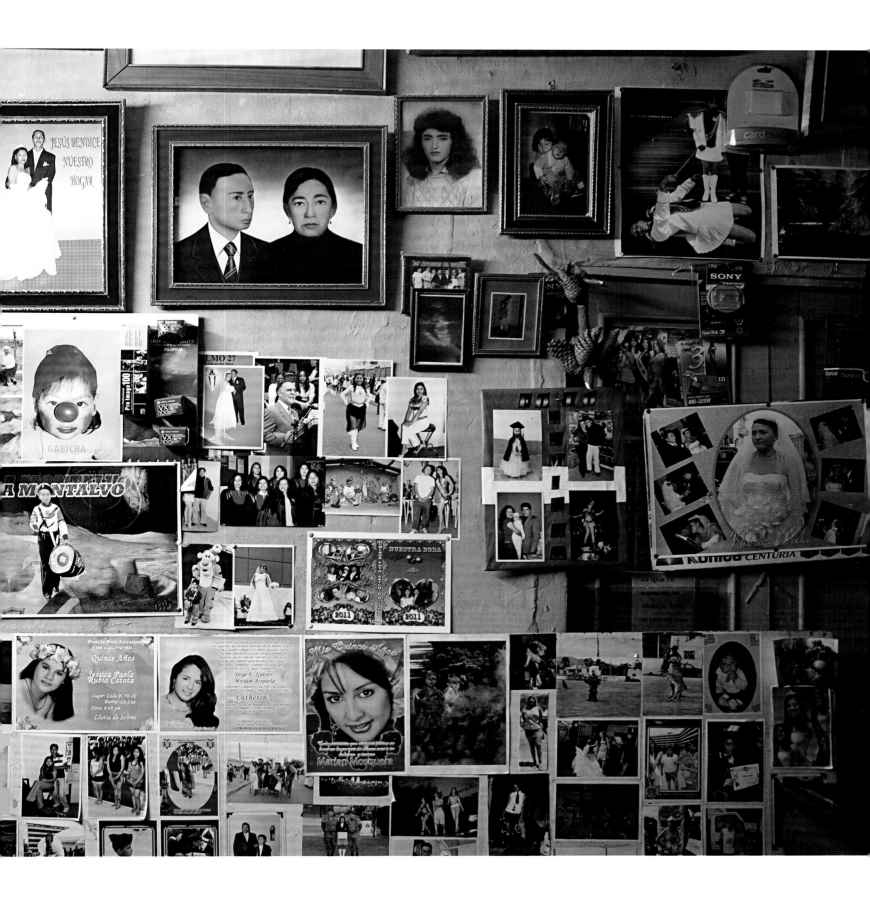

MEDELLIN, COLOMBIA

Nevardo De Jesus, 44, and Vilma Gloria, 43, along with their eleven sons and daughters, run a small garment-making business inside their home in Aranjuez, a district of Medellín, Colombia's second largest city.

Originally from a rural area near Dabeiba, a city in the state of Antioquia, the family's move to Medellín began in 2004 when guerrillas from one of Colombia's many armed groups threatened them with death if they failed to leave their home within a few hours.

Nevardo, along with the family's six oldest children, moved to Medellín in search of work. But as even their combined income was not enough to rent a home big enough to house the whole family, Vilma was forced to remain in the countryside with their other children, moving from one temporary home to another.

After buying some sewing machines, Nevardo started his garment-making business in 2009, gradually increasing its output – mostly of children's clothing – to the point where he was able to reunite his entire family under the same roof in early 2014.

Photographer
FRANCESCA LEONARDI

COUNTRIES WITH THE LARGEST INTERNALLY DISPLACED POPULATIONS

Colombia	3.9–5.3 million
Iraq	2.3–2.6 million
Sudan	2.2 million
DR Congo	1.7 million
Somalia	1.5 million

Source: UNHCR

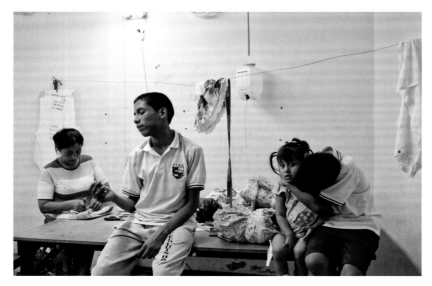

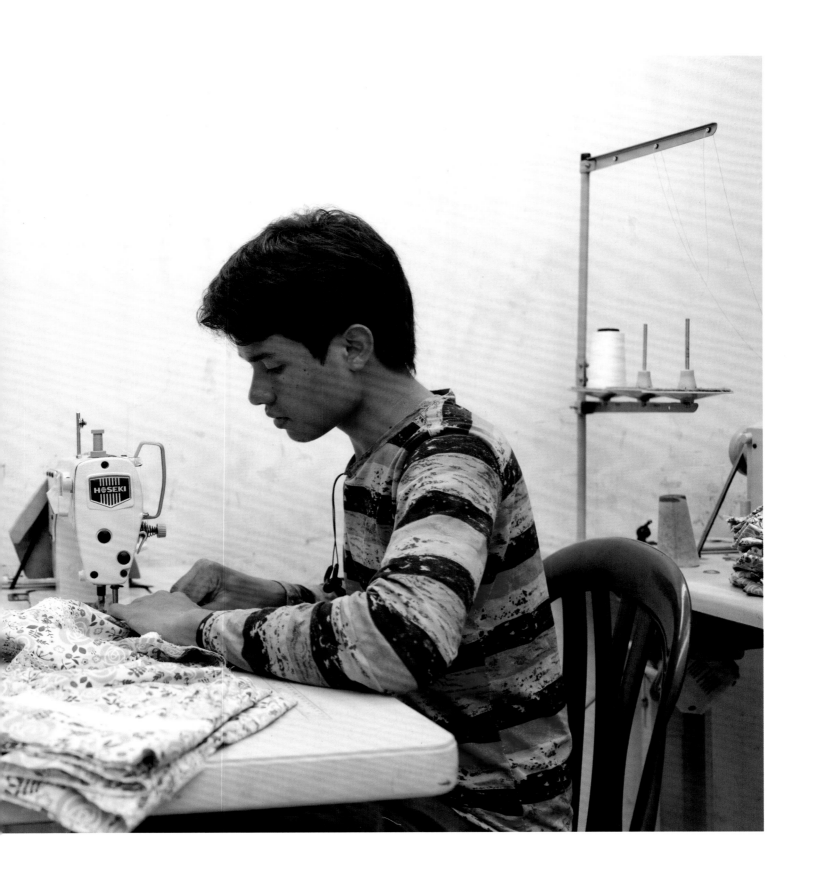

Octavio, 21, one of Nevardo and Vilma's eleven children, at work in their family garment-making business.

MARGARITA ISLAND, VENEZUELA

Omaira Navaez, 42, runs a business renting chairs and tables for events near her home in Margarita Island, an island in the Caribbean Sea just off the coast of north-eastern Venezuela.

Married to a fisherman and with six children – two sons and four daughters – she began her business in 2000 with one of the first loans made by Bankommunal, a micro-financing body that at the time was establishing its first branches in rural communities across Venezuela.

Omaira used the money to buy eight chairs and two tables that she then hired out for use at funerals, parties and other events. Slowly she grew her business, first buying more furniture, then adding a bicycle and cart to help with delivery and pickup.

Today, she has more than 100 sets of chairs and tables and uses a truck to transport them to her customers. Some weekends, her furniture is used at several parties or events simultaneously. She is also one of the leaders of her local Bankommunal branch, encouraging and supporting others who want to follow in her footsteps.

Photographer
RAMON LEPAGE

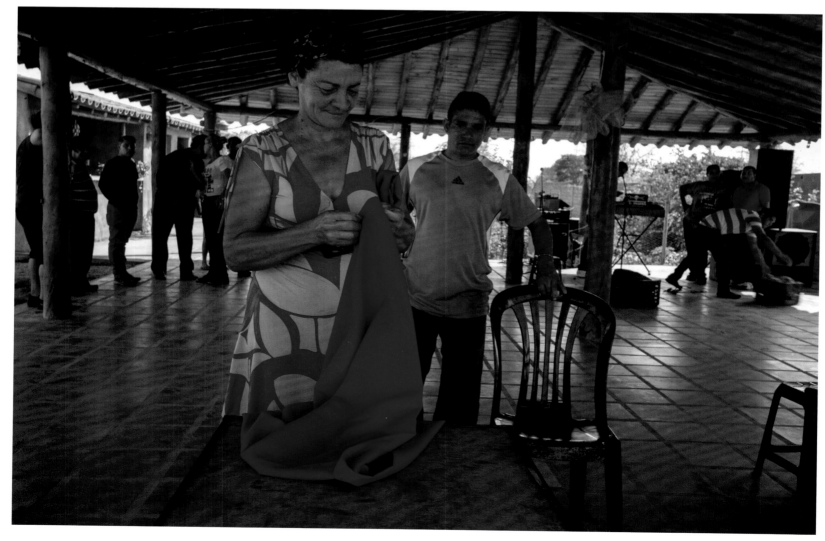

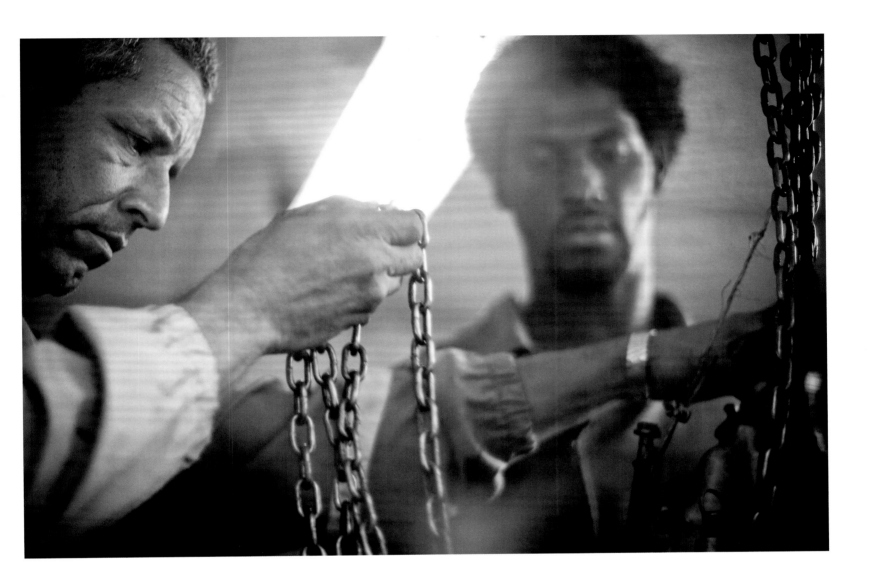

Jorge runs a workshop repairing cars, engines and other machinery in a quiet residential neighbourhood on the outskirts of Havana, the Cuban capital.

Until the 1990s, he worked at a state-owned garage. Following the collapse of the Soviet Union and the ending of its economic subsidies to Cuba, the government reluctantly legalised self-employment. Jorge left his job to set up his own business.

In a country where supplies of mechanical goods and spare parts are in acute short supply, he and his workers have acquired a reputation for resourcefulness and ingenuity in fixing and adapting equipment.

Running a private business makes Jorge better off than most of his neighbours, nearly nine out of ten of whom are employed by the state on low wages. He spends much of his extra money on helping his son, a talented dancer, travel overseas with his ballet academy.

Photographer
REBECCA RADMORE

35

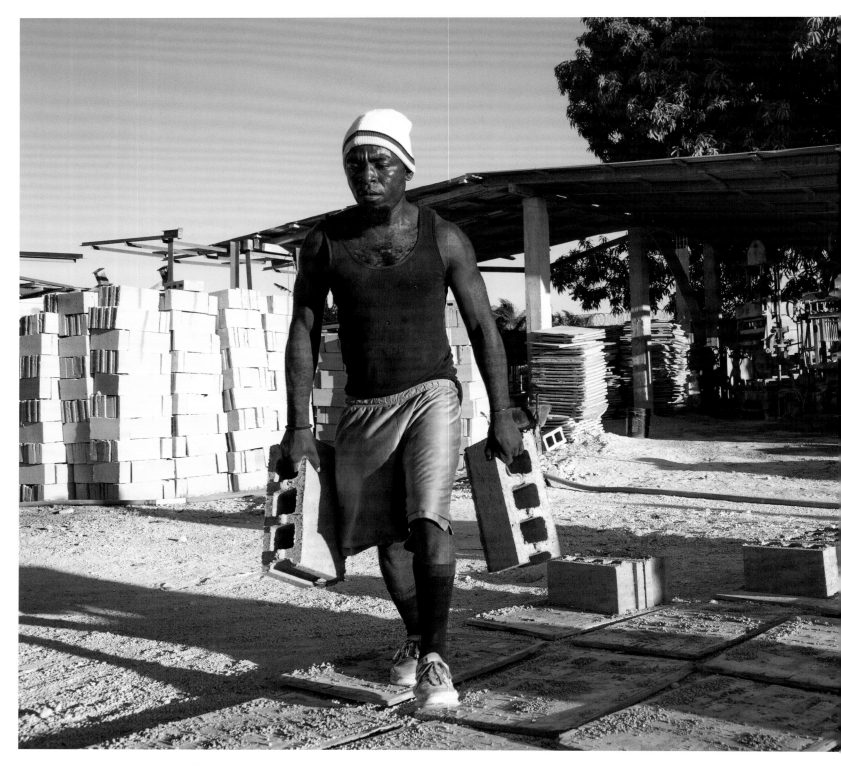

A worker at Myrtha's company.

Photographer
FELIPE JACOME

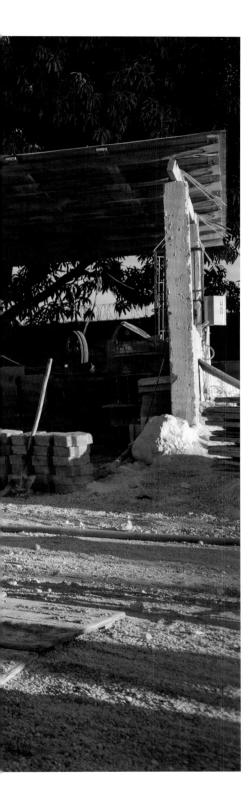

Myrtha Joseph Baptiste launched her concrete block-making company, Bel Kay, in 2011, the year after the Haitian capital Port-au-Prince was devastated by an earthquake that left more than 100,000 people dead.

Like many other people in the city, she was horrified that one of the main reasons why 250,000 buildings had collapsed was the poor quality of construction materials. A civil engineer in her late 40s, her firm – whose name means "nice house" in Haitian Creole – now employs a dozen workers making high-quality blocks.

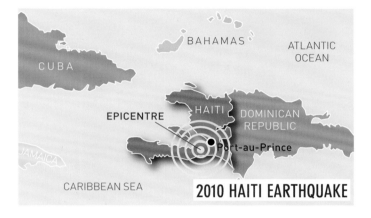

A mural on the outside of a building materials business shows the right mix of cement, sand, and water needed to make strong concrete blocks.

GUATEMALA CITY, GUATEMALA

"We all have to make a living," says Victor Mendez, typing away at his desk at the corner of 18th Street and 7th Avenue in Guatemala City's Civic Center district.

With an official illiteracy rate of 16 percent and an indigenous population of more than 50 percent who do not speak Spanish as a first language, many Guatemalans need assistance filling out official documents. Victor, who previously worked as an accountant until he was laid off, is one of many who have started up sidewalk businesses typing up forms and legal documents to help meet their needs.

Working in a district filled with courts, city offices and other government institutions, he charges around US$1.25 to fill out an official document, a little more for affidavits or other documents that need to be written from scratch. "Business is good. I can't complain – I am always busy," he says.

Photographer
JAMES RODRIGUEZ

GUATEMALAN LITERACY

Young people	94 percent
Adults	78 percent
Elderly people	42 percent

Source: Unesco

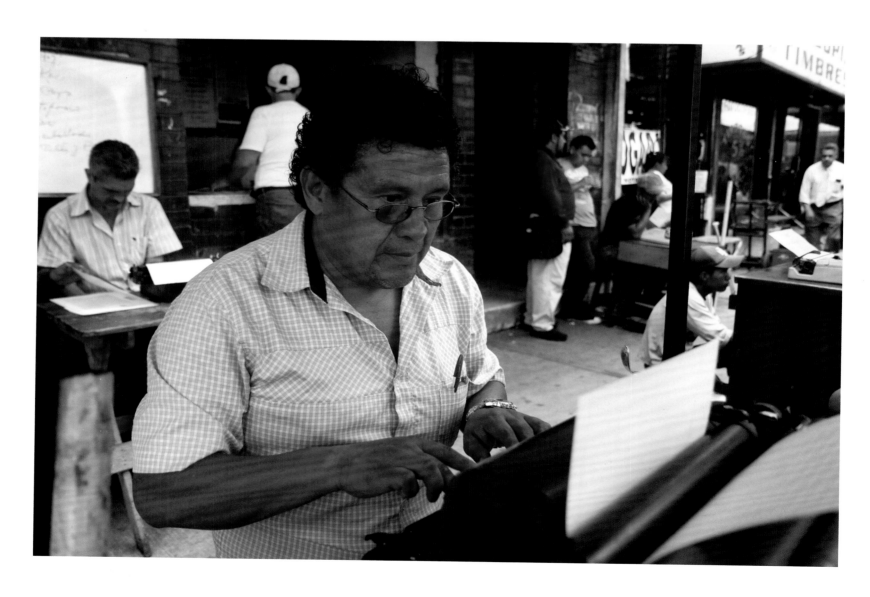

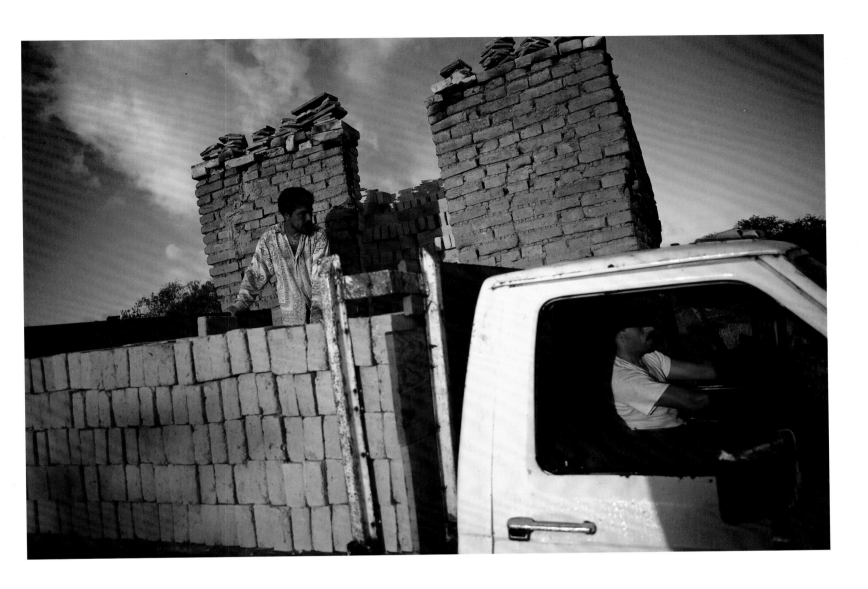

The Chavez family have made bricks by hand for more than four generations, working outside the city of Tepic on Mexico's eastern coast.

When the weather is fine, the family's father and grandfather start work at five o'clock each morning. After coming home from school, their sons join them in the afternoon. The family then continues working until darkness falls, usually stopping between six and seven o'clock in the evening.

Because rain makes it impossible for their bricks to dry out properly, when the weather is bad, the family goes off to look for labouring work elsewhere.

With most construction companies now buying machine-made bricks from large firms, their business is slowly dying.

Photographer
CESAR RODRIGUEZ BECERRA

DETROIT, USA

Motown has become Growtown? While there are no exact figures, officials in Detroit estimate that their city – the one that like no other city in the United States stands for industrialisation – has more than 900 urban lots used to grow produce.

The Detroit of today is a faded image of the city whose assembly lines sent Model T Fords and Mustangs to the world. It has a 30 percent unemployment rate and more than 33,000 vacant, crumbling houses. While 1.8 million people lived in Detroit half a century ago, only 700,000 do so today.

This is not about big-city folks growing tomatoes on the balcony. It is subsistence agriculture born out of adversity. A lot of people from downtown cannot afford to drive to the suburbs and buy expensive fruit and vegetables. Instead, they need to eat and make some money on the side, selling most of what they grow at local markets.

Formal recognition of their status came in April 2013 when the Detroit City Council passed the city's first agricultural zoning ordinance. Today, raising vegetables and other crops is a legal use of land.

Photographer
FLORIAN BUETTNER

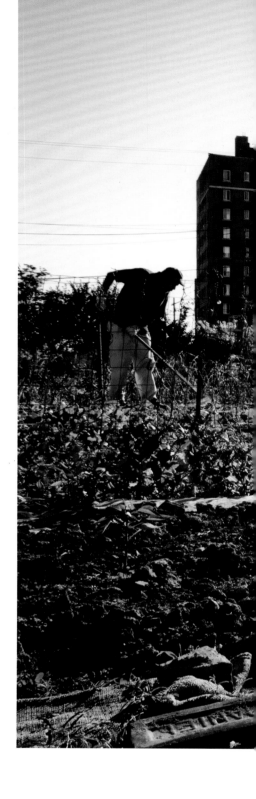

DISAPPEARING DETROIT

Population, million people

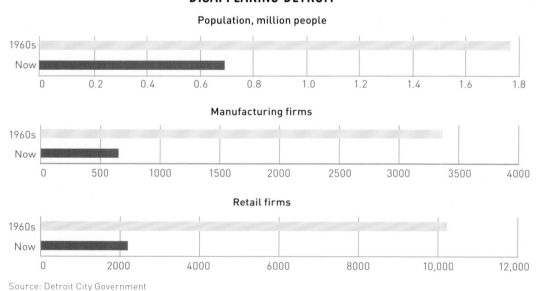

Manufacturing firms

Retail firms

Source: Detroit City Government

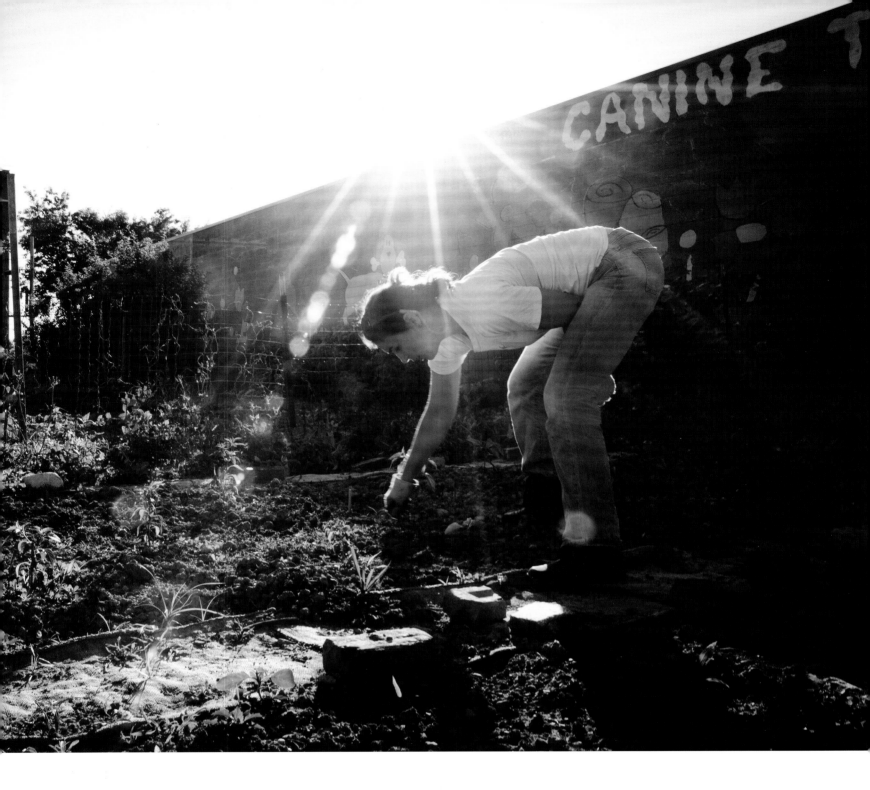

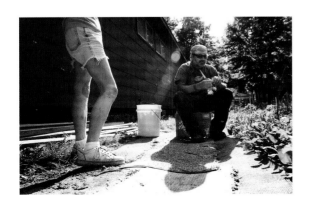

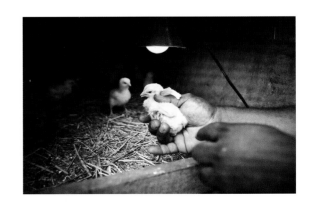

NEW YORK, USA

They grew up in the age of Amazon, with computers and iPods manufactured worlds away. But for these New Yorkers, handicraft is far from a thing of the past. In workshops sprinkled across Brooklyn, small groups of artisans are using their hands to bring manufacturing back to a city and a country where most consumer goods are imported.

Whether they are developing high tech and meticulously crafted instruments, or creating successful jewelry lines with recycled materials, the goal of these "indie capitalists" is to make high-quality, small-run "authentic" goods.

Photographer
BENJAMIN PETIT

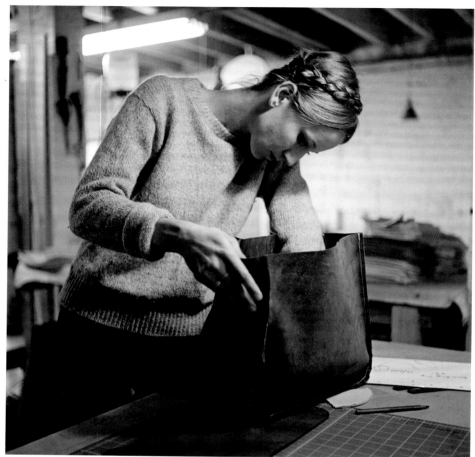

01

01 Lindsay Carver started working at Stanley & Sons, a producer of bags and aprons based in a basement in Williamsburg, a district of Brooklyn popular with indie rock musicians and artists, three years ago.

02 Colin Spoelman founded Kings County Distillery in 2010 in a room in Williamsburg, relocating it to the Brooklyn Navy Yard in 2012.

02

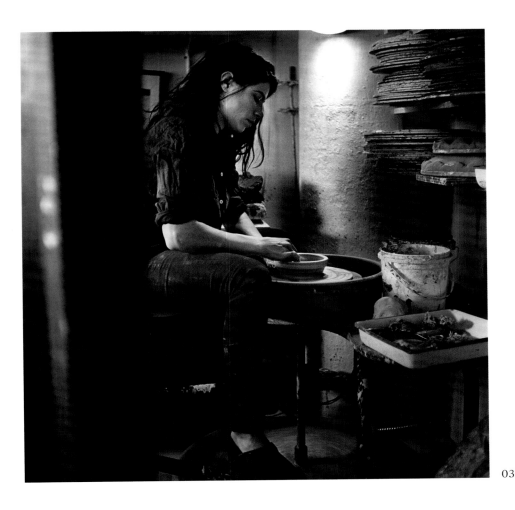

03

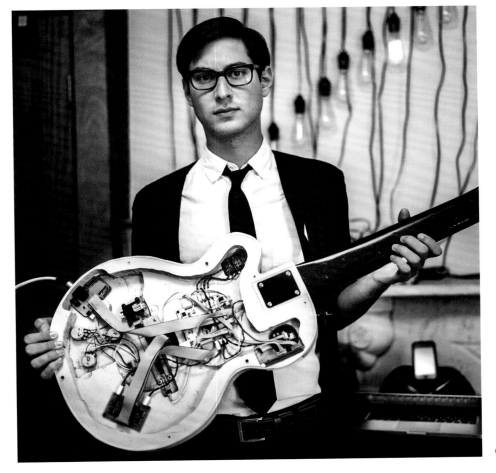

04

03 Clair Catillaz makes a bowl from clay in her ceramic studio, ClamLab, at her home in Bushwick, one of Brooklyn's working class neighbourhoods.

04 Paul Rothman's Fridgebuzzz Electronics, based in Greenpoint, Brooklyn's most northerly district, makes guitars, synthesisers and other electronic music instruments.

MONTREAL, CANADA

Vladimir Antaki's "The Guardians" project was born from a desire to document and pay tribute to shopkeepers he calls the "guardians of urban temples" – owners of shops that are sometimes magical, overloaded with elements, colours and stories, guarded by figures who are sometimes touching and funny.

Interviewed by Slate magazine, he said: "These places are the remaining sanctuaries that contain our souvenirs and traditions. We find a nostalgic and humane quality that can be difficult to find in other commercial environments. We share stories and thoughts. As I mentioned before, I try, through my composition, to portray my 'Guardians' and their spaces in the most majestic and iconic way possible."

Since taking up photography in 2003, he has collected portraits of more than 200 "guardians" from nine cities. The five selected here are all from his current hometown, Montreal, in eastern Canada.

Photographer
VLADIMIR ANTAKI

01 Denis, with the help of his wife, Francine, ran a series of antique shops in Montreal between 1990 and 2013. After Denis died in October 2013, Francine decided to close the last of these shops and move to Eastern Townships, a region of south-eastern Quebec.

02 Esther, now in her mid-eighties, took over H. Fisher & Fils, a shop specialising in tailoring and sewing supplies, around two decades ago after the death of her husband, the son of its original owner. "I get up in the morning and I come here. I have something to do," she says. "I meet people, I talk to people, I take orders and I enjoy it very, very much."

03 Having seen her partner successfully run an antique store and art gallery for 16 years, Guylaine decided she too should set up a retail business. She rapidly discovered, however, that operating even a small business was trickier than she had anticipated. Shortly afterwards, she left her original large premises to move into a more modest shop.

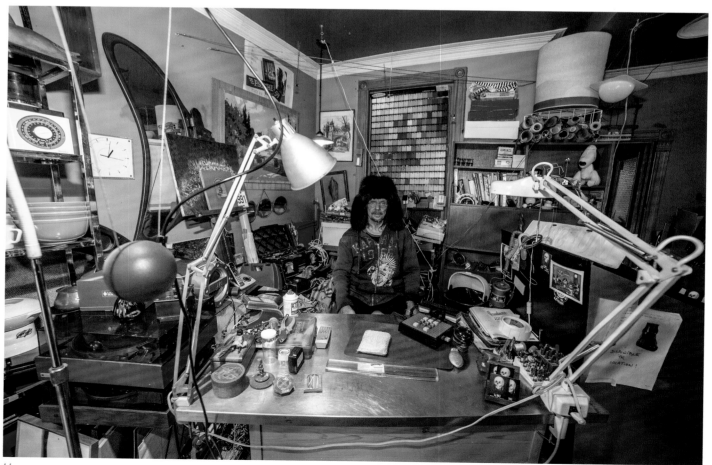

01

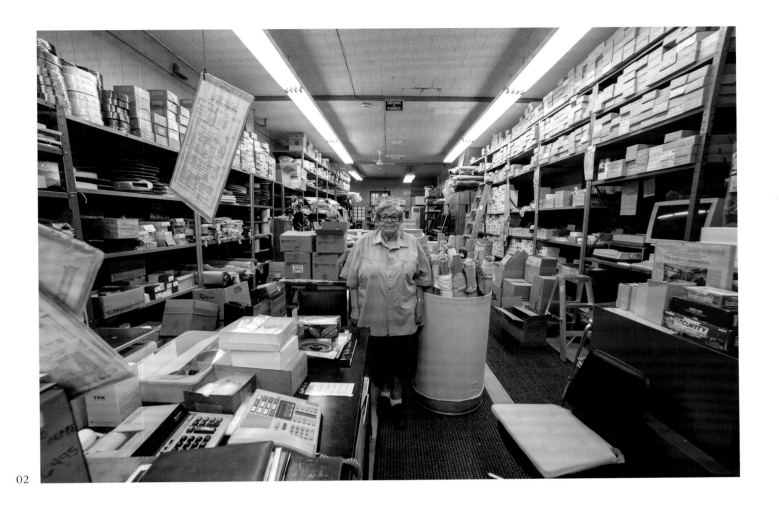

02

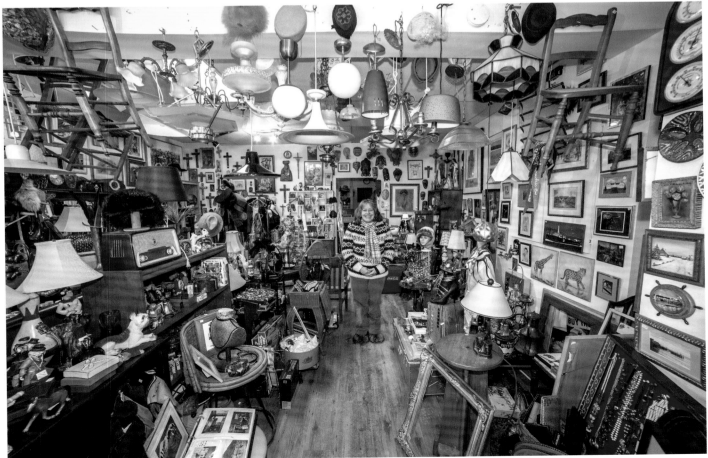

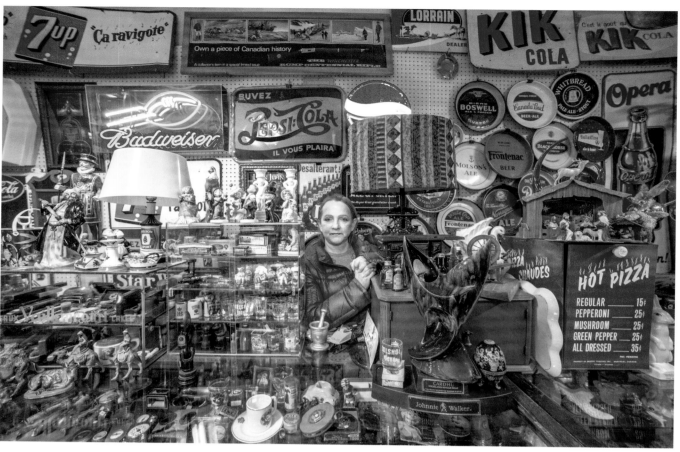

Marie's store, Retro Ville, is filled with objects, most of them from the 1950s, that belonged to her late husband, who ran the shop from when he opened it in 1978 until his death a few years ago. Six months after taking this photograph, Marie sold all her stock and closed the shop.

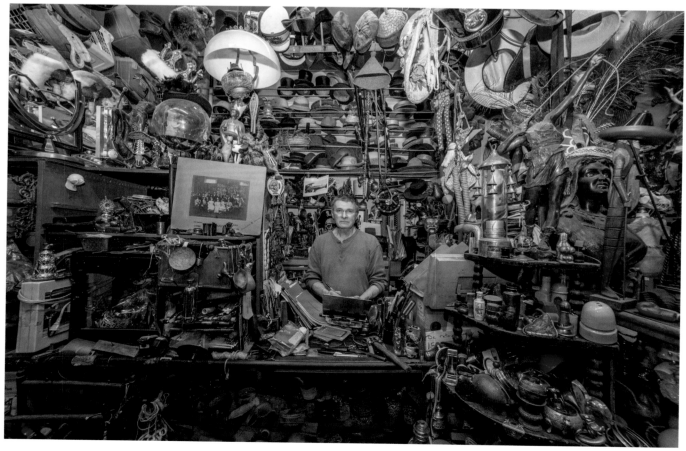

Nothing is for sale in Richard's shop in Griffintown, the Montreal neighbourhood that is home to most of the city's antique stores. Instead, everything is for rent. This way, he explains, each object can have several lives.

THE JOURNEY OF THE OTHERS

Eliane Brum

THE JOURNEY OF THE OTHERS

Eliane Brum

I once met a man who rode a broomstick. Every year, Vanderlei Ferreira would hop into the trailer of a cattle truck and, huddled amongst the animals, hitchhike 600 kilometres to the biggest livestock fair in Brazil. Once he was there, he would announce to anyone who would listen that his broomstick was a thoroughbred horse. He would then take his broomstick to be inspected by the vet, and would spend the rest of his time at the fair galloping through the fields.

People claimed he was mad, so one day I tied my horse up next to his and asked, "Are you crazy?" He looked at me like I was the crazy one and replied, "Do you think I don't know my horse is a broomstick? Of course I know. But isn't making up a horse just so much better?" So said the mad man. It was only years later that I was able to see how Vanderlei Ferreira had so very generously provided me with the best possible definition of life. We are all of us holding broomsticks and dreaming up horses. Life is this, the forever incomplete movement from broomstick to horses.

I'm telling you this story, the story of a man and his broomstick horse, because he takes to its extreme the idea that life is our first work of fiction. This is the tragedy and the beauty of being human. As we stand upon the world's stage, naked and armed with so very little – or in the case of Ferreira, with no more than a broom and his furious freedom – we are faced with the challenge of fashioning our very own existence.

Strictly speaking, there is nothing but chaos and abandonment and certain death. But people dare both to transgress and to create meanings. And if he is wise, he'll spin yarns – with the full knowledge that he'll have to destroy them soon after, before they become repetitive and suffocating. And so he'll go off in search of new stories so that he can lose them all over again, before once more losing himself in the quicksand of a single story. This journey has little to do with the self, but with the idea of constantly uninventing yourself so that you can re-invent yourself differently. Just as it was with Scheherezade, the clever young woman of *One Thousand and One Nights*, we feel that, as long as we are still able to create stories for us to be in the world, we will not lose our heads. Or something even more valuable than a head: a vital life.

This is what The Other Hundred bears witness to. The beginning is of little importance. They will always be the other hundred. The word "other" means more than mere opposition. It presumes a journey, an act of boldness on the part of the one who, by leaving, knows they will return as another. This inner/outer journey demands that we strip ourselves of concepts, preconceptions and worldviews in order to be inhabited by the other's universe in a wholly different experience of being, and to then embark on the journey back, which as a return must also necessarily be the impossibility of returning, because the person who left is already another, both different from the one who left and to the one who went out searching. To take a chance on the other is the most dangerous and most fascinating adventure there is. And to finish this adventure, to find more of yourself, you must lose yourself. Or, in other words, to take off your own self and put on that of the other and so be able to feel your own skin.

The cries of the people of the jungle become the most subversive of cries

This, to me, is the essential purpose of journalism. Without it, you cannot claim to tell a story that goes beyond the author, a real story. Later, I realised that this is also the most critical act of our day-to-day, one that keeps us from succumbing to an imagination-less existence, so that we do not become enslaved by that tenet that claims there is only one way of being, the one that keeps the world the way it is. Life exists only in insubordination. The word "other" contains a negation. In it, permanent insurrection and the displacement needed to change your position are brought to bear. In order to *be*, you must *become* your others.

In the universe of the other – expressed here as a word, as a concept, as an act – there are also the other others. They do not see themselves as poor when they stand before the rich, nor do they feel they even belong on such a scale; and they don't adhere to the clichéd concept of winners and losers, because their transgression takes them beyond winners and losers. They are people who refuse to measure the value of a human life. They break down the hierarchy between the rich and the poor because they do not even acknowledge it. They do not belong to the world of commodities.

I've met these other others in the people of the jungle of Brazil, my home country. Faced with the attempts of governments and of capitalism to turn them into the city's poor, prying them from the Amazon in order to reduce the jungle to pasture, to soy plantations, to mines or hydroelectric power plants, they have declared: "We don't want cars or flat screen TVs. What we want is a healthy jungle." Faced with the attempts to turn them into the clientele of social programs, they refuse to be tamed. In a world that survives through the imposition of a single story, of a homogenous way of existing and of measuring existence, they repeat, time and again, one of the most destabilising phrases there is: "We do not want to be you."

If a world made up of the rich and the poor is to be kept in place, and if inequality is to remain, the poor must continue to want to be rich, even if it will never happen, and the illusion that it is possible for all of us to reach the top of the pyramid must endure. In denying this logic, and freeing ourselves of these desires, the cries of the people of the jungle become the most subversive of cries, because they are not interested in being poor nor rich, nor anything in between. They themselves assert the existence of a world of others in which equality can only be attained through the possibility of everyone being equally different. Each and every one of us an inimitable occurrence repeating itself in the other.

The extraordinary lives in each and every life. There are no ordinary lives, only domesticated eyes. In a world in which the surfeit of images blinds, looking to see is an act of everyday resistance.

Translated by *Julia Sanches*

BRAGA, PORTUGAL

In his workshop on the outskirts of Braga in northern Portugal, Domingos Machado, 78, has crafted thousands of stringed instruments for Portuguese musicians.

His first teacher was his father, who showed him how to make simple guitars and ukeleles that could be sold cheaply at local fairs and markets. Soon, however, he realised that he wanted to work in a different way, devoting time and artistry to each of his creations, producing high-class instruments that would be appreciated by the very best musicians.

He moved to Porto and apprenticed himself to an 80-year-old master craftsman. Returning home, he married and opened his own workshop, then spent decades establishing a reputation as one of Portugal's leading makers and restorers of guitars, mandolins, ukuleles, violas and other stringed instruments.

Photographer
RUI FARINHA

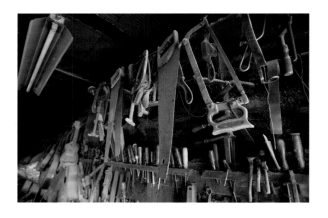

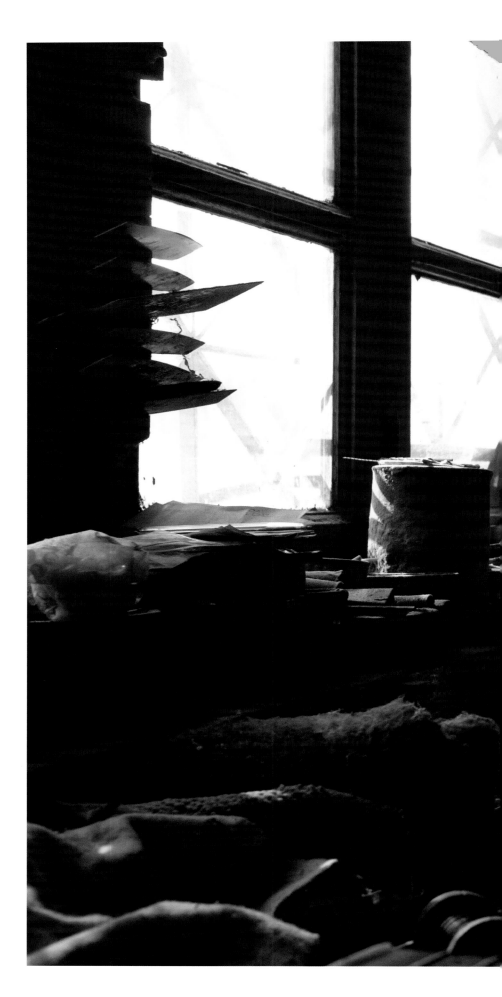

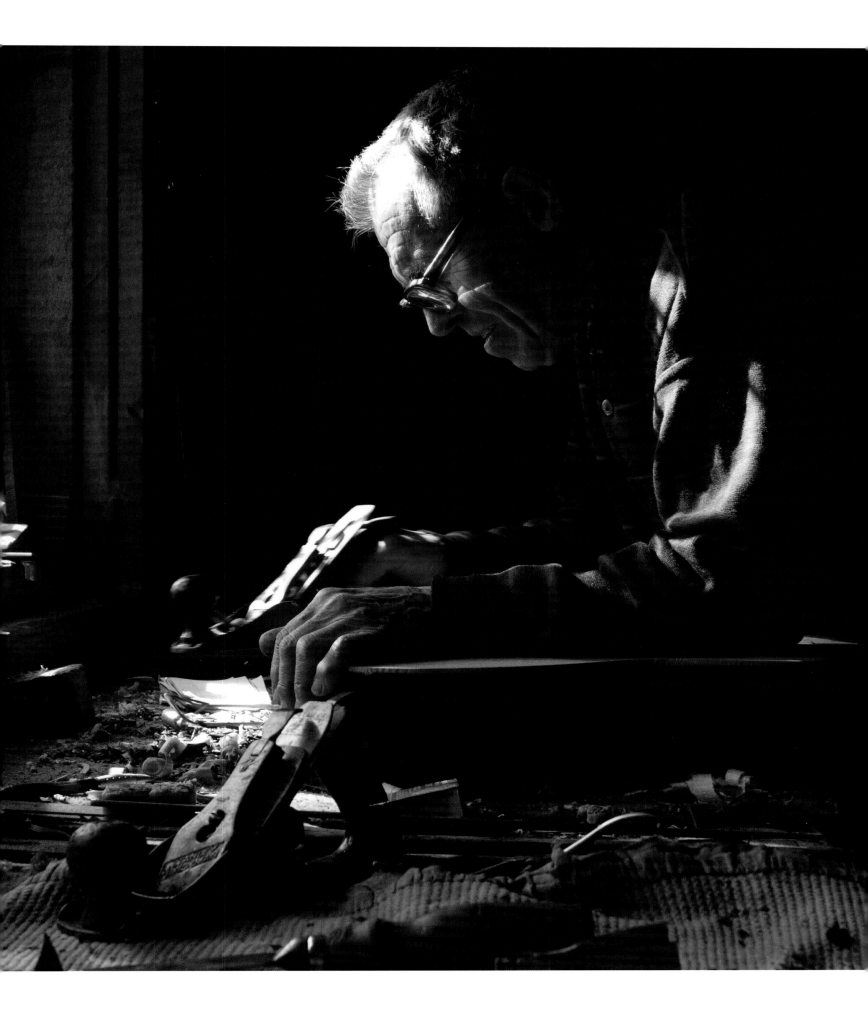

ULLDEMOLINS, SPAIN

Maialen, 27, and Andrés, 35, are the two members of Engrama, a popular band in the virtual world of Second Life. From their home in Ulldemolins, a tiny Catalan village in north-west Spain, wearing headphones and playing electronic instruments, their eyes fixed on a laptop screen, they have given more than 2,000 concerts in the last five years.

Developed by Linden Lab, a company based in San Francisco, Second Life has acquired around one million regular users since its launch in 2003. As well as being a place where people can meet and socialise online, it also has it own currency, the Linden, which can be exchanged with real world currencies such as the dollar and euro.

Through their concerts and a virtual fashion store where their followers can buy "clothing" and other accessories for their Second Life avatars, Maialen and Andrés earn enough to support themselves, Maialen's parents and her sister.

Photographer
EDU BAYER

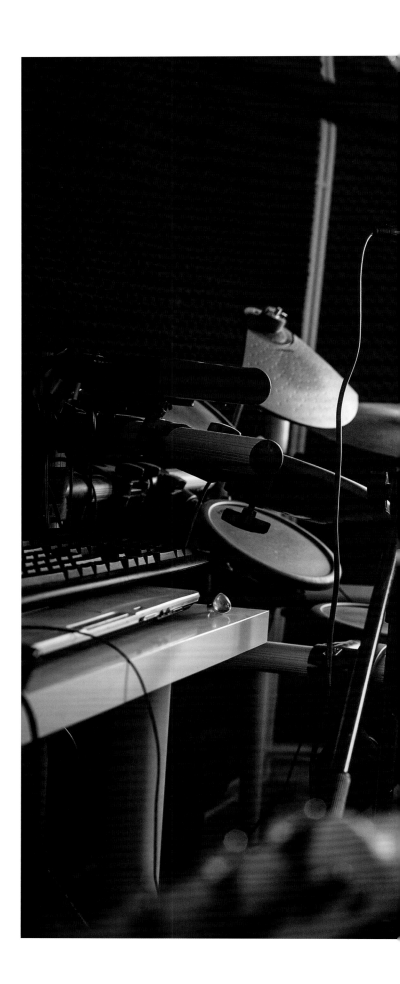

WATCH ENGRAMA ONLINE

www.youtube.com/watch?v=yPg7eBCE7ls

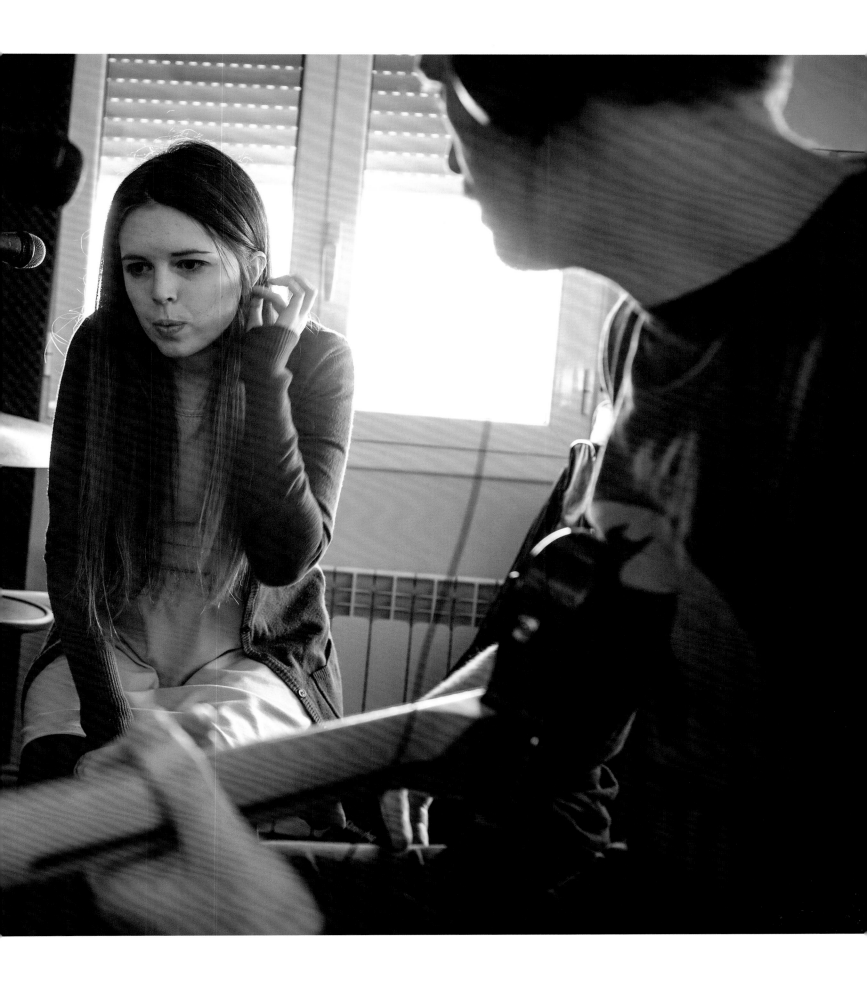

LLANELLEN, WALES

Angela and Robin Gardiner are the owners of AJR Poultry, a family-run farm in Llanellen near Abergavenny, a town in south-east Wales, about twenty miles from the border with England. They started the business ten years ago, and now raise chickens, ducks, geese and turkeys.

Their farm shop, managed by their son James, sells local produce. Angela and Robin, who work seven days a week, also offer a "chicken-sitting" service for owners of poultry who want to go away on holiday.

Photographer
ANDREI NACU

BRITISH CHICKEN CONSUMPTION

In 2013, Britain's poultry industry raised and slaughtered 870 million chickens or other poultry, and imported the equivalent of another 400 million birds.

The British Poultry Council estimates that 95 percent of the 60.9 million people living in the United Kingdom eat chicken, and that they do so on average twice a week – adding up to a total of 6.3 billion occasions on which someone has chicken as part of a meal every year.

Source: British Poultry Council

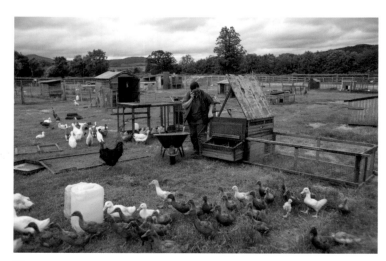

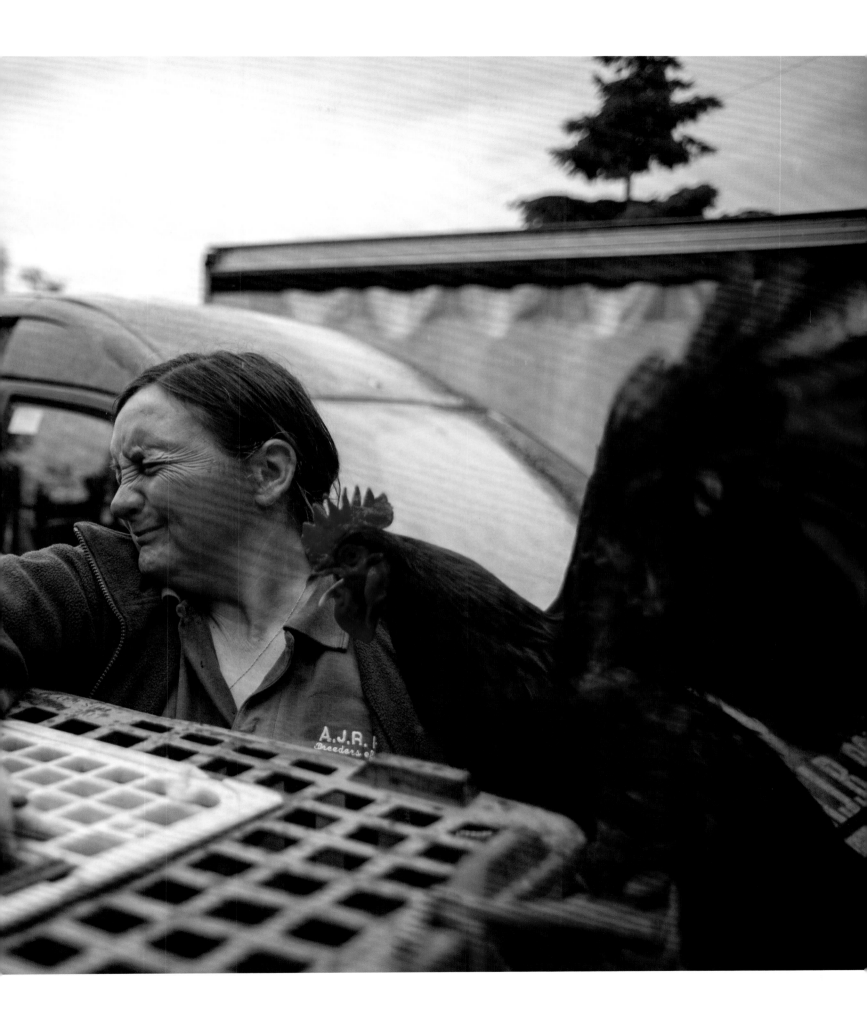

MONT-SAINT-AIGNAN, FRANCE

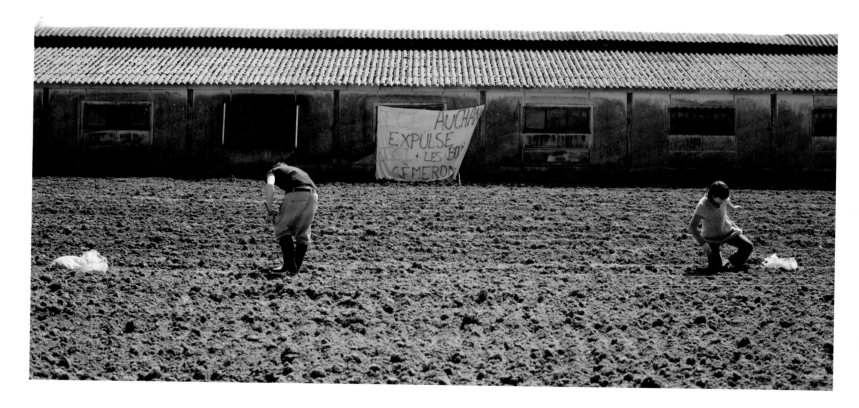

In December 2012, Tatiana Gameroff and a dozen other young activists occupied La Ferme des Bouillons, an abandoned 18th-century farmhouse at Mont-Saint-Aignan, near Rouen in northern France's Normandy region.

Eleven months earlier, the farm and its four hectares of land had been bought by Groupe Auchan, one of France's largest retail companies, in order to build a supermarket at its location. Mobilising support through social networks, the activists gathered enough resources to mount a legal campaign that resulted in the local council re-classifying the farm as a "Protected Natural Zone" in January 2014.

Since occupying the farm, Tatiana and her fellow activists have reintroduced the growing of vegetables and the raising of poultry to its fields, selling their produce at an open market held each Sunday.

Photographer
JOHANN ROUSSELOT

Schorem is an old-school, men-only barbershop in Rotterdam, specialising in traditional haircuts and hot-towel razor shaves. Most of its 15 staff are tattooed, and each has his own slick hairstyle, beard and mustache.

Leen and Bertus, friends for 20 years and barbers for 24, set up Schorem in 2011 as a place where as well as having a haircut or a shave men could talk about football and ex-girlfriends, read gentleman's magazines, or just quietly relax.

Their shop has no appointments system and offers just a limited range of traditional cuts – 22 in total. A haircut takes between 30 minutes and 45 minutes; a shave around 20 minutes. The only tools its staff use are scissors, thinning scissors, clippers and straight razors.

"We aren't hairdressers, we're barbers. We don't want or have anything to do with hairdressing. We cut and shave men and that's it, no bullshit," say Leen and Bertus.

Photographer
ANNE-MARIE VERMAAT

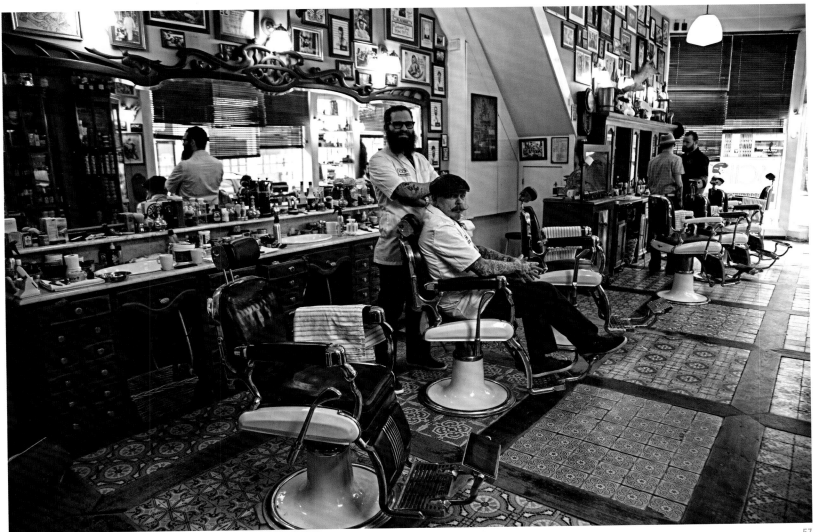

DITZUM, GERMANY

More than 250 boats have been made at the Bueltjer Shipyard since it was founded by Hinderk Gerjet Bueltjer in 1899.

One of the last shipyards in Europe specialising in making traditional wooden boats, the yard, at Ditzum in East Friesland on Germany's north-west coast, is today run by brothers Jan and Gerjet Bueltjer (below), the fourth generation of their family to work there.

Together with a fifth generation – their three sons, Gerjet Junior, Hinni and Andy – and 13 employees, they build and repair fishing boats, sailing yachts, leisure and traditional vessels.

In the mid-1980s, using the help of old drawings the yard started making replicas of old fishing boats, 16 metres long and weighing 45 tons.

The timber used in its boats is prepared by being carefully aged in its main hall. The length of time needed is determined by the thickness of the timber, with around one year needed for each centimetre.

Photographers
PAULA HOLTZ
& YANNIK WILLING

Jan

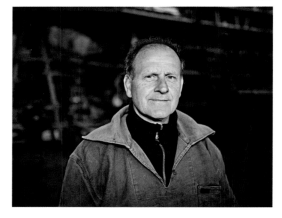

Gerjet

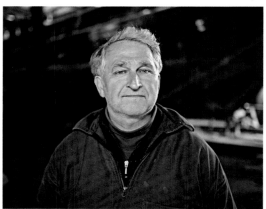

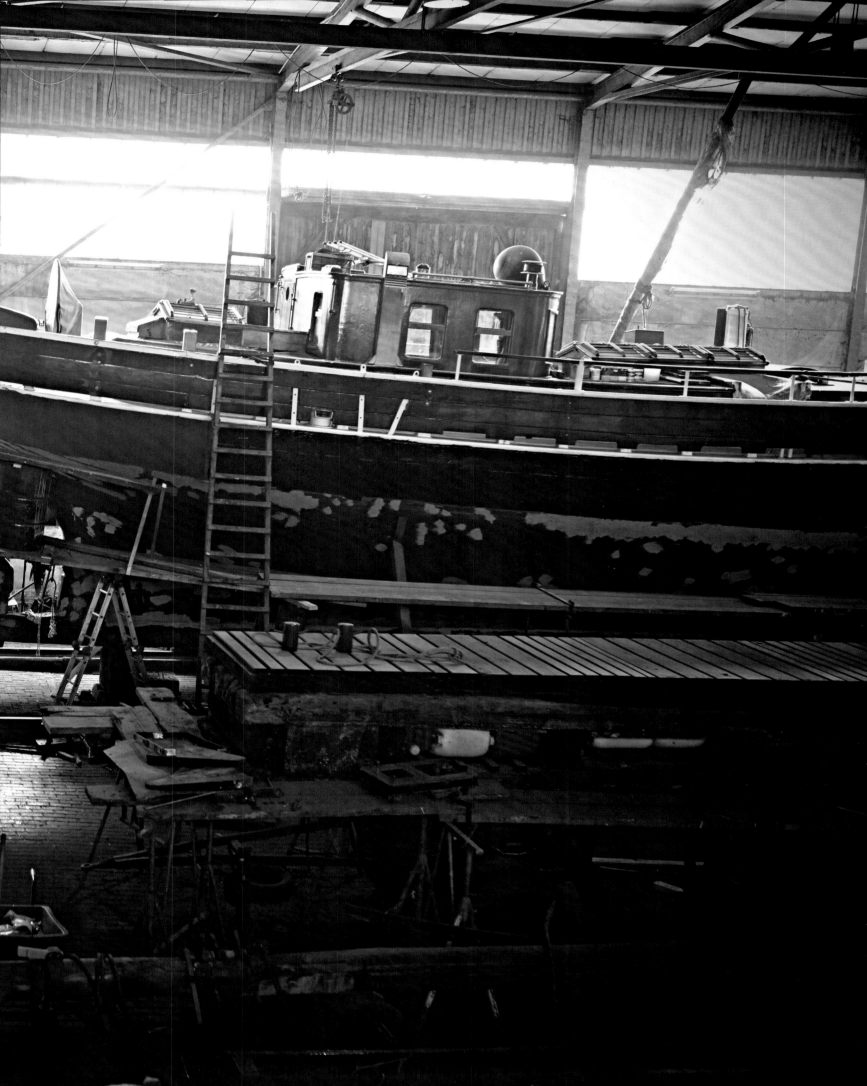

GILLELEJE, DENMARK

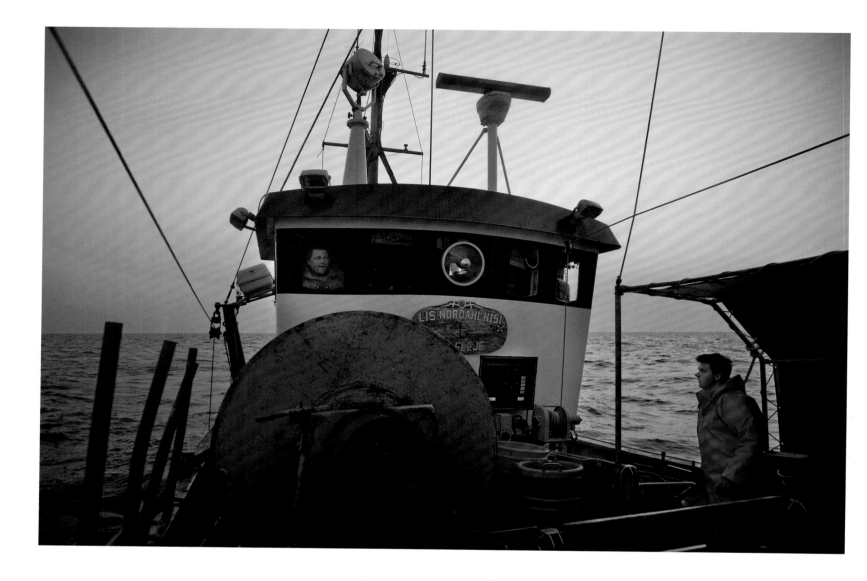

For centuries, fishing has been a proud part of Danish culture. But today, fewer fishing boats than ever before fill the country's harbours.

Gilleleje is no exception. Over the last decade, its fishing fleet has dropped from 58 boats to 25. Everyone expects that number to fall further in the next few years.

One of the few young people in Gilleleje to become a fisherman recently is Kjeld Joergen Andersen, 19. After finishing his education a few months ago, he signed up to work for Carsten Nordahl on a boat owned by Carsten's father, Jan Nordahl.

Everyday, regardless of the weather, Kjeld and Carsten set out with the aim of returning with a full hold of fish. They are rarely successful. After decades of overfishing, the seas around Gilleleje are no longer as bountiful as they once were.

Kjeld sees his future on the sea. He hopes that in two or three years he will have enough experience and money to buy his own fishing boat.

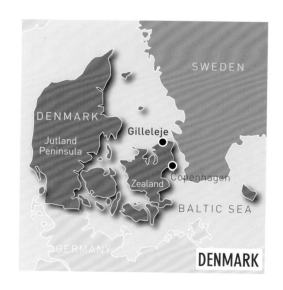

Photographer
NIKOLAI LINARES

Some people sample music, Charlotte Nilsen, 45 samples clothes. An arm from one dress, another from a shirt, buttons from a third garment. Working with an overlock sewing machine, she uses old clothes and rags to create new outfits in just minutes at her company, Feil Farge Produksjoner – "Wrong Colour Productions" – in Tromsø, northern Norway's largest urban area.

Charlotte grew up in Finnmark, Norway's northernmost county, learning how to sew from an elderly lady who lived nearby. She began Feil Farge as a sewing workshop in 1993, expanding it into a production company and factory where young unemployed people can gain work experience as interns.

Charlotte gets her material for nothing, collecting unwanted garments through a bin that anyone is free to donate to. Mostly she makes party outfits. Often she adds details taken from the traditional clothing of the Sámi, the indigenous people who originally inhabited much of northern Norway, Finland, Sweden and the neighbouring part of Russia.

Photographer
INGUN ALETTE MÆHULM

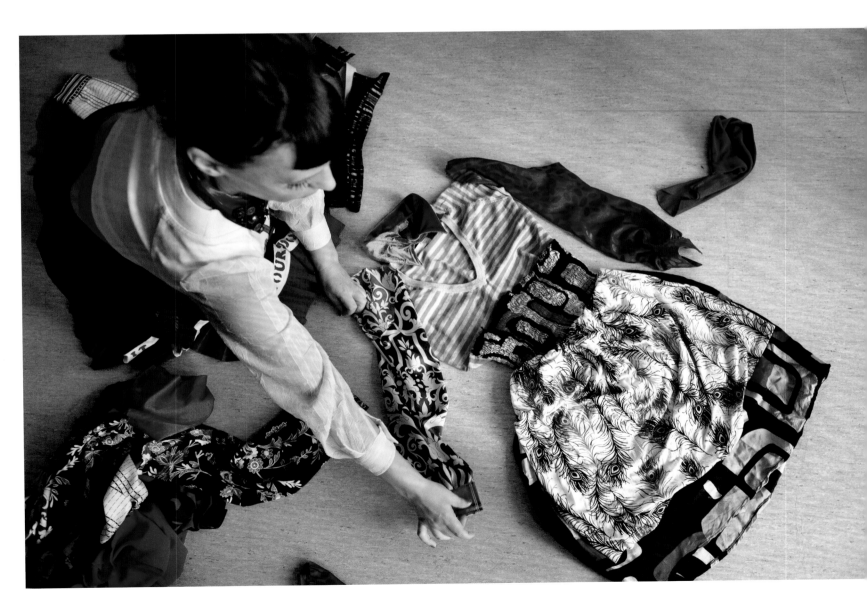

WARSAW, POLAND

With more than one million companies run by women – more than one-third of the country's total – Poland is one of Europe's leading centres of female entrepreneurship. Many of these businesses were set up during the years of Poland's economic transformation after the collapse of socialism in the Soviet Union and eastern Europe. The closure of many large state-owned businesses left many people with no other option than becoming self-employed – a trend which has been maintained since.

Photographer
ISABELLA DE MADDALENA

01

01 Marta Zieba-Szklarska runs Alter Group, a consultancy with offices in Warsaw and Krakow, and is active in a range of projects supporting entrepreneurship in Poland. "Women in business are able to build relationships based on trust, loyalty and quality. For men business is like a war, they are better competitors than us. But I think that women have the advantage and ability to communicate with each other, to cooperate."

02 Ania Chagowska owns Salsa Libre, a dance school in Warsaw. "Apparently the strong character of Polish women is a consequence of the [second world] war. I've been reading a lot about it. For many years women couldn't count on men's support in the family. Many men died during the war, or were in the army, or were taken into socialist prisons. Women had to stand on their own, they had to work and care for their homes and children. This is why we have a tradition of strong feminism."

02

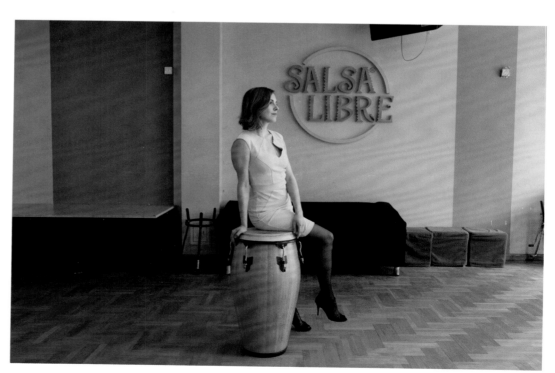

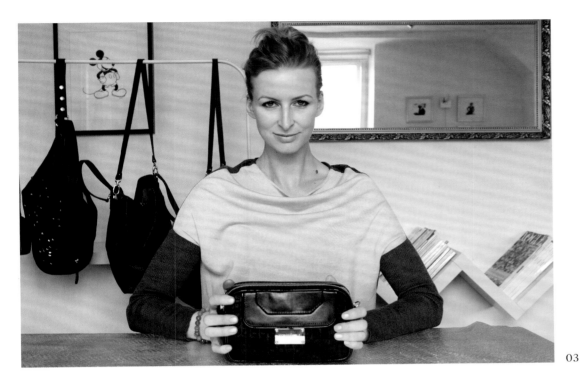

03

04

03 Maria Nowinska is the designer of the Nowinska Bag, one of Poland's most successful leather bag brands. "It was very difficult at the beginning. Warsaw never had an artisan tradition so we had no know-how, no experience to build something, and it was hard to find workers. I lost three years of my life creating my company, I had no private life. But I'm a self-made woman and I learned everything by myself, so now I know that there are no impossible things."

04 Julia Wollner is editor-in-chief of *La Rivista*, Poland's first magazine about the culture, lifestyle and language of Italy. "To be successful, you need to give all you have and put it all on the table. It's not enough to just do your job quietly; you need to give and share your personality, your sense of humor, everything that you are."

GRODNO, BELARUS

Maya Cherkova owns a match-making agency in the city of Grodno in northwest Belarus which has arranged more than 400 marriages between women from her country and men from western Europe.

In Grodno, due to the large number of men who have left to work in other countries, women officially outnumber men 1.4 to one, though in some age groups the ratio can be far higher – anywhere up to seven to one, according to local people.

Maya (far right) trained as a philologist of Slavic Languages, and after the collapse of the Soviet Union in the early 1990s worked as a teacher. The pay, however, was poor – just US$20 a month at the time.

Seeing how many of her women friends were looking for foreign husbands, she decided to set up Belarus's first international marriage agency.

Maya operates more like a traditional matchmaker than a broker, personally screening each woman registered with her company and providing them with any support they may need, such as help with translation, as they look for a partner.

Photographer
JUSTYNA MIELNIKIEWICZ

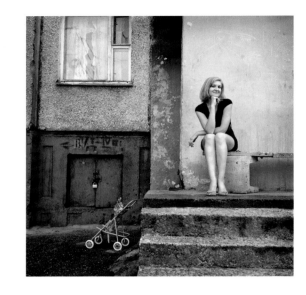

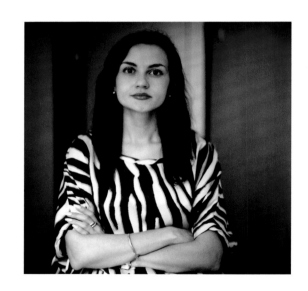

EASTERN SHRINKAGE

Belarus is not alone in having more women than men. Across eastern Europe, men have left their homes to find work abroad, mainly in western Europe.

Males per 100 females

Latvia	84.1
Ukraine	85.7
Lithuania	85.7
Estonia	86.4
Belarus	86.9
Bulgaria	94.9
Romania	95.1

Source: UN, countries

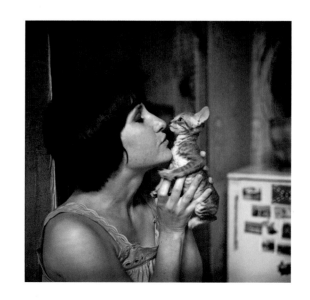

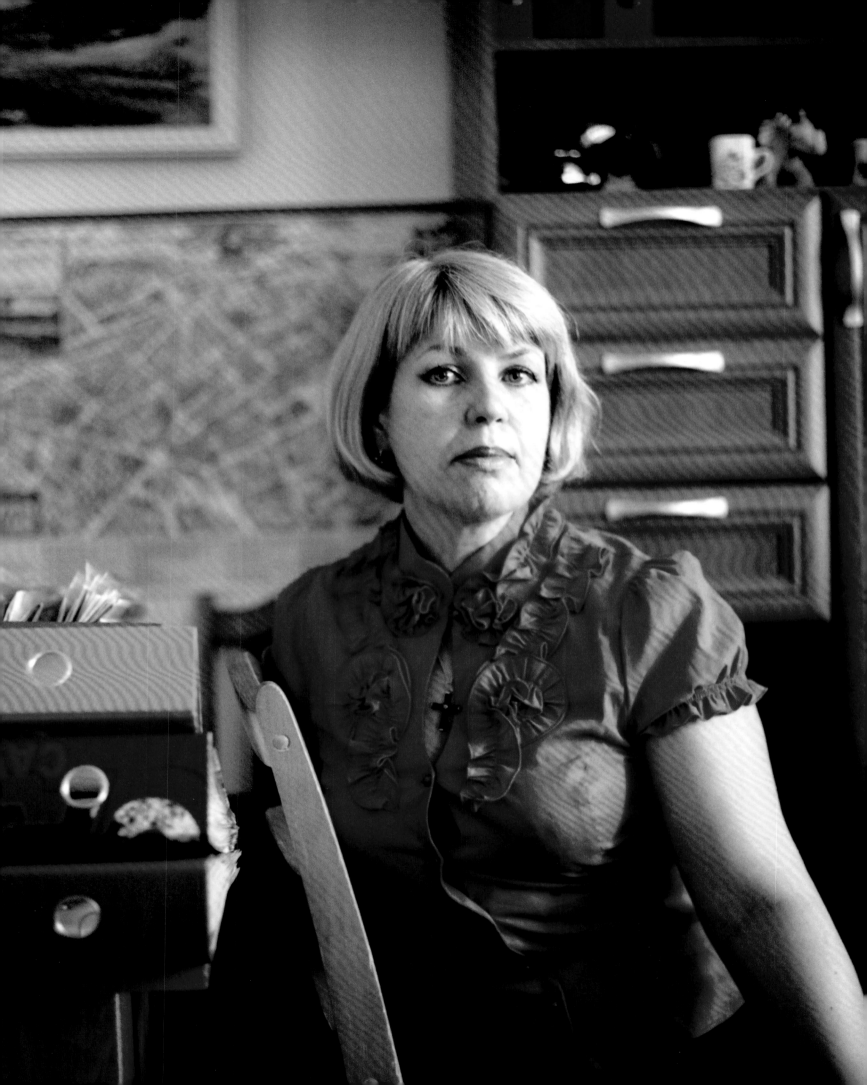

Former ballet dancer Olga Irbe, 29, is a personal trainer who works for herself in Tallinn, Estonia. After finishing ballet school, at the age of 17, she worked as a professional dancer for nine years, performing in Estonia and at festivals across Europe.

After putting some pictures of herself dancing and doing sport on Facebook, people started asking her advice about how to make their own bodies look better. At first, she had no intention of becoming a personal trainer, so she posted advice and suggestions for free. But when the questions kept on increasing she decided to see if she could set up a business.

Today, professionally accredited, she charges her customers €60 an hour. She also runs ballet classes for children from four to six years old.

Photographer
SERGEY MATISEN

GIVING IT A GO

David Goldblatt

GIVING IT A GO

David Goldblatt

Is it just an apocryphal family story? I'm not sure, but of course I want to believe it. The way I heard it is that on the day when Britain declared war against Germany in 1939, my grandfather, who was working in a suit-pressing factory in the East End of London, called my grandmother.

"Flakey," as he called her, "Take all the money we have saved and go and buy every last bottle of Napoleon brandy you can find." Mac, as he was known, was no great military strategist, but he could see a gap in the market coming. Brandy, cognac and other French luxuries were soon going to be in very short supply. Later on, after the Blitz, when the family had managed to scrabble their way out of the East End for the leafy western suburbs of Ruislip, it was said that the boot of Mac's car was a permanent pantry of off-ration eggs and bacon.

My grandmother had arrived off a boat as a young girl in London in 1901, one of the many families of Russian Jews fleeing the misery and persecution of the Pale of Settlement. My grandfather's family had made it out of Latvia and settled in South Africa. There my great grandfather turned his blacksmith skills into setting up Johannesburg's first bicycle factory. Mac made his own way to London in the early 1930s, following his older brothers who had emigrated earlier and set up first a chain of cinemas and then a successful clothes factory at Preston in north-west England. In 1947, they realised that the whole country had been wearing grey for a decade – another gap in the market. They managed to find pink and blue raincoat materials, cleaned up and went home.

Mac stayed in London and opened Vic Chalker – the name of a recently closed grocery shop in Ealing. He got the estate agent to show him round, took the lease with a week to pay and then used old, indeed recently deceased Mr Chalker's phone and name to start filling the shop on credit from wholesalers. Over the next three decades, he went on to try his hand as a bookmaker, sold baked goods, textiles at a market stall, and then ladies coats and dresses.

My father, Ivor, followed in even more eclectic style. First he was a ladies hairdresser with his own salon in south London, then a market trader himself in the post-war boom years. Bankruptcy in the early seventies was followed by a short brush with the high-tech end of the oil industry, then he ran a henna hair colouring company, then he was a professional gambler, then owned a clothes shop, and then became a professional con man. There were plenty of other jobs too, mini-cab driver, poker-room superintendent, used-car trader, but it was the businesses, the adventures, the gambles and the pay-offs that really mattered.

I came of age, politically at least, in the late 1970s as the Labour government was destroyed by the economic crisis and industrial action of that era. Needless to say, Margaret Thatcher's sweep to power was welcomed in our house. At last, it seemed, the entrepreneurial energies of the nation would be let loose, and my family celebrated – myself excepted. I was only fourteen, but I knew something huge and terrible was happening in the body politic.

The economic and social problems of this world cannot be solved without the grit, the energy and sheer chutzpah, the just-give-it-a-go, that I saw from my family

Ten years of political trench warfare ensued as Ivor and I argued it out. Free markets versus social democracy, individual brilliance versus collective action, the need to reward the innovators and risk takers and to punish the slackers. For a decade, we argued over every inch of the neo-liberal agenda. Only ten years of study, culminating in a social science PhD from Cambridge, allowed me finally to get on level terms.

But by then history had moved on, and when the dust had settled on the 1980s, neither Ivor nor I were quite where we had started. Ivor had left the Conservative Party after Thatcher's regicide, and though he remained entrepreneurial to the last, he stopped playing by the rules all together. As I said the professional gambler became the professional con man, and though I do not judge him for his turn of career, I know that it is no model for anyone else.

I was still arguing the case from the Left, but I had also learnt to appreciate the catalytic role of entrepreneurs in a market economy. I still don't think they pay enough tax and I still think the balance of power between capital and labour has shifted so far in favour of the former to leave us living through a moral and economic crisis. But I don't imagine for a moment that the economic and social problems of this world can be solved without the grit, the energy and sheer chutzpah, the just-give-it-a-go, that I saw from my family.

I came to understand how, for the migrants and the marginal, being entrepreneurial – in the broadest sense of that word – is often the only way in which you can transform a perilous situation. I am the beneficiary of the efforts of two generations of entrepreneurs and risk takers, with still much to learn and much to be grateful for.

And in my own small way, I have also found the entrepreneurial streak in me. Seeing a gap in the market, I threw in a regular academic career for a more turbulent life writing about the history and sociology of football. Maybe that doesn't have quite the romance of Napoleon brandy, and it certainly isn't as intoxicating. But I like to think it was my family who helped me find that gap and make the leap – giving them the best payback I can imagine.

FRYAZINO, RUSSIA

At their workshop in Fryazino, a small town just outside Moscow that once lived off its military industry, Boris Bazhenov and Alexander Bobin are creating a small collection of industrial sculptures inspired by the steampunk movement.

Calling themselves Artmechanics.com, the pair painstakingly create giant fish and other animals with inner workings made of cogs and wheels, fins that wave and jaws that rise and fall.

Their flagship model, "Fish House", draws its inspiration from a traditional tale: "A long time ago, a gigantic fish swallowed a person. Unwilling to accept his fate he decided to turn the fish into his house," say Boris and Alexander. Close scrutiny of the model, made from oak, lime wood and burnished metal, reveals a chimney poking through the fish's upper skin.

The "Battering-ram Fish" is another of their creations – a former battleship that escaped to freedom but lost much of its armour on the way, say its creators.

Boris and Alexander spend up to nine months making each of their models. They have finished four and are at work on another five. Most of their models have been sold to companies or bought by individuals as gifts.

Photographer
VLADIMIR FILONOV

An early precursor of the steampunk movement: French illustrator Albert Robida's "Rotating aerial home", drawn in the late 1880s.

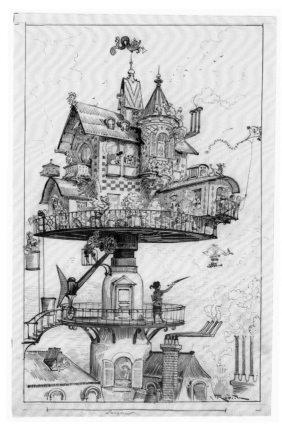

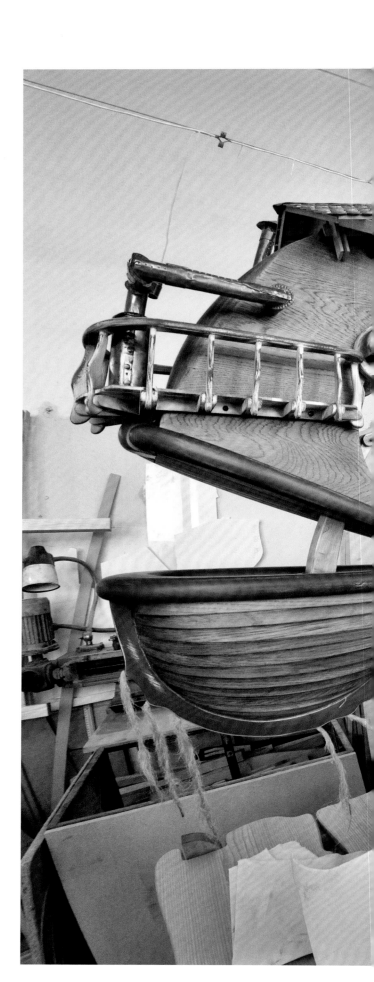

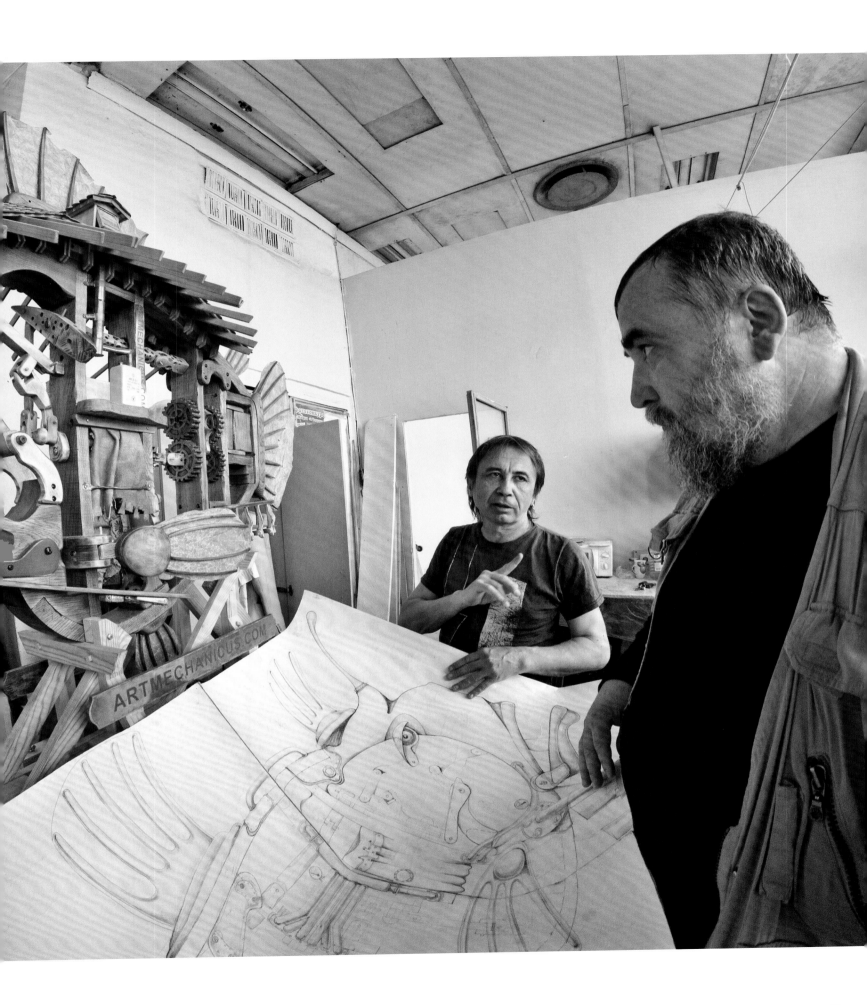

BODVALENKE, HUNGARY

In 2009, Bódvalenke was a grey, desolate place. Average monthly income was less than €60, mostly from social benefits. Its population of 230 people – 95 percent of them Roma – had few prospects.

That year, however, the village, located in north-east Hungary, near the border with Slovakia, launched its "Fresco Village Project", inviting well-known Roma artists from across Europe to come and decorate the exterior walls of its houses with murals.

Today, thanks to the work of more than a dozen different artists, well more than 30 murals have been completed, their themes include tales from Roma folklore, religious scenes and depictions of everyday village life.

The village's current goal is to attract more tourists to visit Bódvalenke, though a lack of funds is hindering development.

Photographer
ZOLTAN BESE

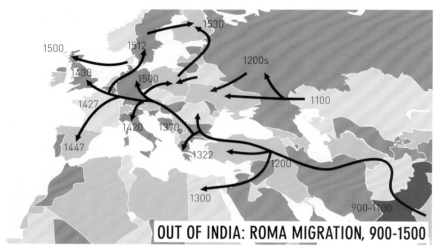

OUT OF INDIA: ROMA MIGRATION, 900-1500

Source:John Haywood, *The Great Migrations*

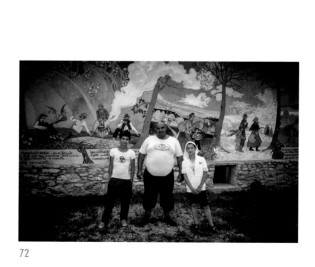

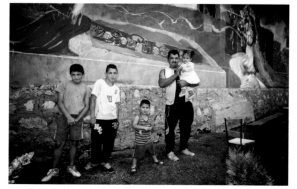

CERTEZE, ROMANIA

Amoraritei Leonard and Frandos Aurel take a break from renovating an apartment in central Paris. Both come from Certeze, a village near Romania's northern border with Ukraine with a long tradition of supplying seasonal migrant workers to other parts of the country.

After the collapse of socialist rule in 1989, many of those workers found themselves forced to look further afield for employment. Travelling and working in small groups, they spread out across Europe, sleeping wherever they could, often in woods or in abandoned houses.

By the early 1990s, France, and especially Paris, had established itself as a favourite destination. Most worked as labourers on construction sites, saving every euro they could and sending their money back home to support their relatives.

As they became more established, moving from casual labour into full-time jobs, and in some cases starting their own firms, many of them brought their wives and children to live with them. Romania's entry into the European Union in 2007 helped smooth documentation procedures.

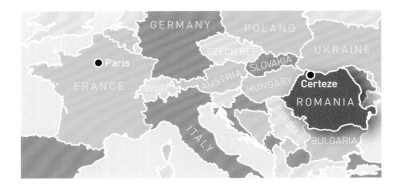

Today, Certeze is one of Romania's richest villages. Every August, when its overseas workers return home for the summer holidays, luxury cars fill its cramped streets and alleys.

ATHENS, GREECE

Nikos Drandakis launched Taxibeat, a mobile phone taxi-hailing app that helps people find taxis, in his home city of Athens in 2011. The app lets people see not just what taxis are available near them, but also gives ratings for each driver and other information such as their car model and languages spoken.

Taxibeat's revenues come principally from independent taxi drivers, who pay a small commission on all business the app brings them. Passengers pay nothing to use the app. Ratings go in both directions, with passengers rating drivers and drivers rating passengers.

The hardest thing to start with, says Nikos, was getting a critical mass of drivers and customers. Greece's economic problems helped here. As well as pushing down software writers' salaries, taxi drivers were keen to explore new ways of recovering some of the business they lost after the country's economy collapsed during the global financial crisis.

Nikos is now taking Taxibeat to other countries both across Europe and also in Latin America, where it is becoming increasingly popular in Rio de Janeiro and São Paulo in Brazil and in Mexico City.

Photographer
FRANCESCO LASTRUCCI

Nikos at his office in Athens, the Greek capital.

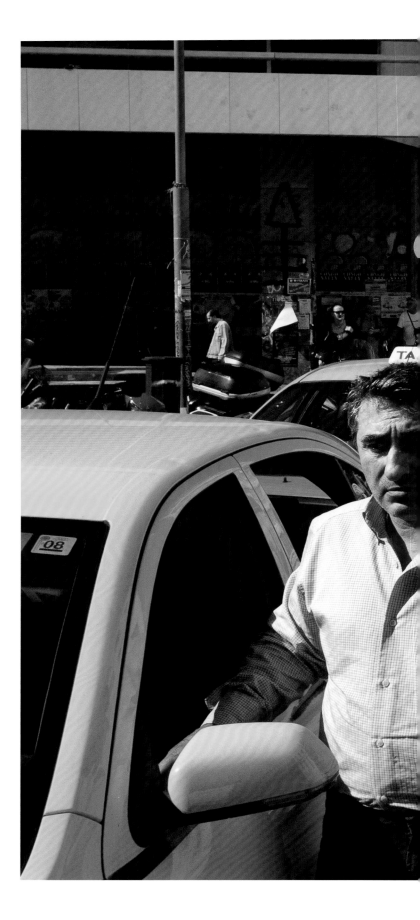

Taxi drivers pay Taxibeat a commission of €0.50 for each passenger the app brings them.

For more than sixty years, Muslims from across Sarajevo, the capital of Bosnia and Herzegovina, have marked the end of each day's fasting during Ramadan by eating somun bought from the city's Poricanin Bakery.

Today run by Amela Mujezinovic, who took over the business in 1995 from her father, the bakery has made somun, a kind of pitta bread popular across much of the eastern Mediterranean region, at its current site since 1953.

The bakery operated throughout the nearly four-year-long siege of Sarajevo from 1992-1996 that followed Bosnia's declaration of independence from Yugoslavia. At the start of the war, Bosnian Muslims accounted for around half of Sarajevo's population; today, they make up nearly 80 percent.

Photographer
ELISA CHIU

ETHNIC MIX

Bosina & Herzegovina's religious breakdown, percent	
Muslim	40
Greek Orthodox	31
Roman Catholic	15
Other	14

Source: CIA Factbook

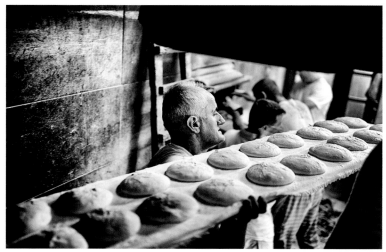

LJUBLJANA, SLOVENIA

Three years ago, in the wake of the global financial crisis, three young Slovenian women, Sarah and Marjeta, both 27, and Sanja, 26, launched a roller-skate business both to earn some money and to put some joy back into people's lives. Naming their company Esemes after the initial letters of their three names, they pooled their savings and imported 100 pairs of skates from China.

Since then they have become familiar figures promoting their goods at roller-skating events around Ljubljana, the capital of Slovenia. Although sales are rising, especially in the warmer months of the year, they have yet to open a shop. Instead, customers can either buy skates at Marjeta's apartment or through the trio's website, kotalke.si, which takes its name from the Slovenian word for roller skates.

Photographer
NIK ERIK NEUBAUER

Source: Library of Congress

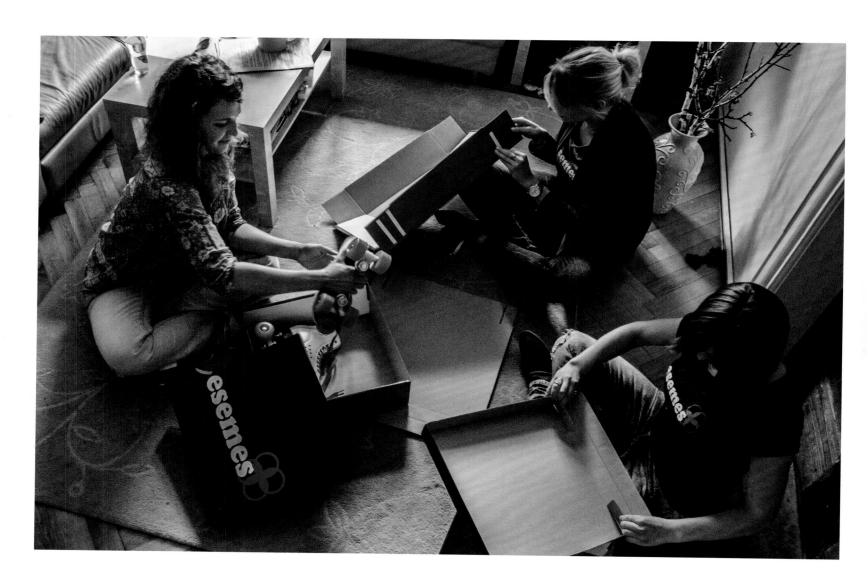

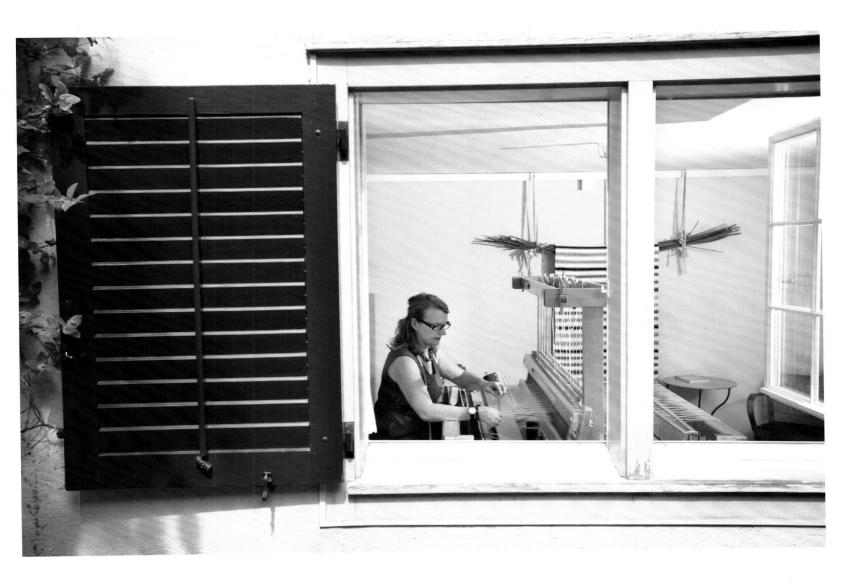

For generations, Finnish women have made rugs from recycled fabrics and other materials using skills learned from their mothers. Anna Saarinen continues this tradition in Zurich, a city she moved to from Finland more than two decades ago.

After a career in marketing and raising a family, in 2010 she bought a loom and installed it in a tiny studio. Drawing inspiration from old rug designs and the colours of Finnish nature, especially those of the nightless summers of the far north, she began to create a collection of carpets. In May 2014, she opened a showroom in Zurich where she now has two looms.

Anna still keeps her first studio, mainly as a storage space for raw materials. Every now and then, when the weather is good, she invites a group of women to the studio's backyard to continue a Finnish tradition of cutting old bed linen into strips which she will later weave into rugs.

Photographer
SANNA HEIKINTALO

For 20 years, Nihad Cengic has divided most of his life between Bologna and Sarajevo, restoring art works in mosques, churches, cathedrals and other buildings.

Born in 1965, he grew up in what was then Yugoslavia, studying first at Sarajevo's Artistic Gymnasium and then training as an art restorer at the University of Applied Arts in Belgrade.

When the Yugoslav wars reached Sarajevo in 1992, the city began what would be Europe's longest siege since the second world war. With several friends Nihad formed the "Cultural Rescue Brigade", a group dedicated to saving art works from destruction. Over the next few years it played an invaluable role in protecting the city's cultural heritage, including rescuing thousands of antique books from a fire at the Sarajevo library in 1992.

In 1994, two years before the siege ended, Nihad travelled to Venice to attend a Unesco conference on war art damage. Invited to remain in Italy, he set up home in Bologna with his wife and three daughters.

Since peace returned to the countries of former Yugoslavia in 1999, Nihad has restored damaged art works in Sarajevo and at other locations across the Balkans, including Kosovo and Albania, where he also worked as a Unesco-supported art teacher.

Photographer
MASSIMO SCIACCA

NIHAD'S JOURNEY

HAMRUN, MALTA

Yonas Oukubamichael was 20 when he fled war and persecution in Eritrea in 2004. He paid smugglers to take him across the Sahara to Libya and then put him on board a rickety boat of illegal migrants all searching for a better life in Europe.

The boat made it as far as Malta. After spending several months in a detention camp, Yonas started working 18-hour days: at a vegetable shop in the daytime and as a dishwasher at night. By 2011, he had saved up enough to open his own restaurant, Selma, serving Ethiopian and Eritrean cuisine in Hamrun, a small town just outside Malta's capital, Valletta. "My Maltese friends would always ask me what Eritrean food was like, so I would cook for them. Eventually I was cooking so much that it just made sense to open a restaurant," he says.

Today he employs three staff, with his Maltese girlfriend, Stephanie, helping out whenever things get particularly busy. He still works long hours, getting up at 5 o'clock each morning then spending the rest of the day hurrying between his restaurant, its kitchen and a chill-out lounge he's opened next door, running his current business and planning his next one – a larger restaurant in Bugibba, one of Malta's primary entertainment and nightlife hotspots.

Photographer
DARRIN ZAMMIT LUPI

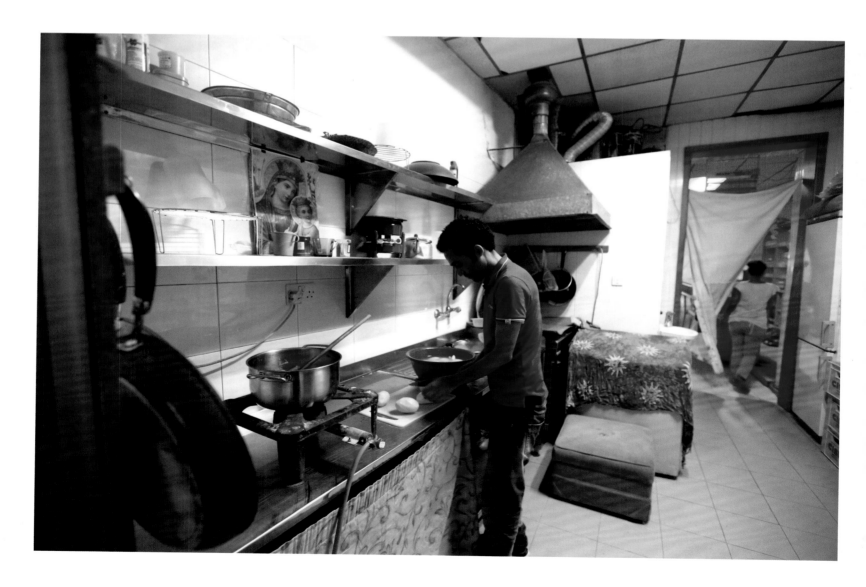

TIME AND CHANCE

Tolu Ogunlesi

TIME AND CHANCE

Tolu Ogunlesi

Every morning in Africa a gazelle wakes up. It knows it must run faster than the fastest lion or it will be killed. Every morning a lion wakes up. It knows it must outrun the slowest gazelle or it will starve to death. It doesn't matter whether you're a lion or a gazelle, when the sun comes up you'd better be running.

– Traditional proverb

Let's start with irony. To qualify for admission to the ranks of The Other Hundred Entrepreneurs, you have to be a mover – a striver, a hustler, a chaser or a runner. But the very nature of still photography, freezing life into a manageable and meaningful frame of visual reference, means that we – the viewers – are compelled to experience and interact with these subjects in a state of suspended activity, removed from their default mode of doing and striving.

In many of the photographs in this book, the subjects have posed for the camera; in that instant in which the shutter sits in judgement over their lives – imagine the click as the noise of a gavel banged swiftly and mercilessly – they have surrendered their energy to the camera's roving eye and its whirring processor.

Consider the young bookseller in South Africa who sits on a kerb, between a pile of books and a No U-turns sign. If he is like the itinerant book sellers I know from the streets of Lagos, this photo-op is perhaps a rare moment of rest for him, a welcome diversion from an existence in which he flits between cars, praying for traffic jams with the same faith with which farmers pray for rain, and thrusts his wares at the faces of potential customers who are able to stare at him without seeing him.

There he is, in the moments just before this forced photographic repose, listening for those trademark whistling and hissing sounds by which people summon street traders, searching amidst a multitude of faces for that fleeting expression of interest which would tell him to linger by this window but not that one.

The difference between him and that millionaire in the back seat of the limo that has just rolled past is a simple one. It's not in their ambitions, or in their energy, no. It's in the fact that one of them has, as we say in Nigeria, "arrived", and the other not only hasn't, but probably never will.

This is how we have learnt to measure striving: not by what goes in, but by what comes out; not as the ongoing daily drama of doing and hoping, but as a dream fulfilled or aborted.

Only those who arrive are feted.

The problem with this way of seeing the world is it fails to acknowledge a simple and obvious truth: that the circumstances that produce the exaggerated distinctions between the Forbes 100 and The Other Hundred, are mostly due to chance.

Born into a different time, place or family, any of The Other Hundred – who cannot in any way be accused of not being passionate enough about what they do – might

You have to be a mover — a striver,
a hustler, a chaser or a runner

today be living the life of hedge funds and IPOs and family inheritance. And vice versa. Bill Gates or Warren Buffett could just as easily have ended up painting masks for tourists or busking in train stations.

By focusing on the subjects who haven't "arrived", and never might, regardless of how hardworking they are; these photographs give us a much-needed reality check, — a subtle reminder of the starring role that serendipity plays in the grand narrative of human existence.

By highlighting the striving in the lives of people we wouldn't consider successful or influential by the capitalist standards that underpin our world, we get a chance to question the theory that hard-work is what makes all the difference; a chance to un-believe the false and often unquestioned assumption that the 1 percent and the 99 percent are separated by a gulf of indolence.

Keeping this in mind, it seems to me that the most sensible way of going forward would be for us to focus on the striving — the thing that we are all guaranteed, while we live — and not the arriving — which time and chance randomly decide.

Accepting this is what allows us to celebrate The Other Hundred with the same passion that we celebrate the Forbes 100. The value they offer is in what they do, not what they have earned doing it.

Take the example of our South African bookseller whose striving brings benefit to himself and others. For his customers, he is a middleman, offering, through his stash of books a chance to escape the tedium of reality.

For himself he is a creator of streetside opportunity — earning enough, he says, to meet his needs. But is he also saving the rent deposit for a proper bookstore, within whose walls he wouldn't have to be summoned him with a hiss, or stared right through like he didn't exist?

Maybe at the end of the day it doesn't matter whether you are a lion or a gazelle; what counts is running as fast as you can, knowing you have put in your best.

Even when he was a student, Fahmi Fersi, 31, knew he wanted to run his own business.

Thinking of how he could get going without needing a big investment, he decided the best thing to do would be to start an online sales company.

In 2006, during a trip to China paid for by his father, a Chinese manufacturer of ink and toner cartridges asked him about the possible market for its goods in Tunisia.

He returned home and did some research. Deciding the demand was there, he borrowed 6,000 dinars (about US$4,500) from his father, designed a website, rented a small store in Tunis and took US$300 worth of ink cartridges from the Chinese company on consignment.

Today, Fahmi runs his business by buying on credit, selling for cash and holding as little inventory as possible. He delivers orders to customers around Tunis on his scooter; those further off he sends by post.

After business fell off sharply as a result of Tunisia's Jasmine Revolution of 2010-11, he added computer maintenance, web hosting and web design to his services.

Still unable to afford to hire any staff, he handles almost everything himself, with a little help from his wife, whom he married two years ago. They are now expecting their first child.

Photographer
CHEDLY BEN IBRAHIM

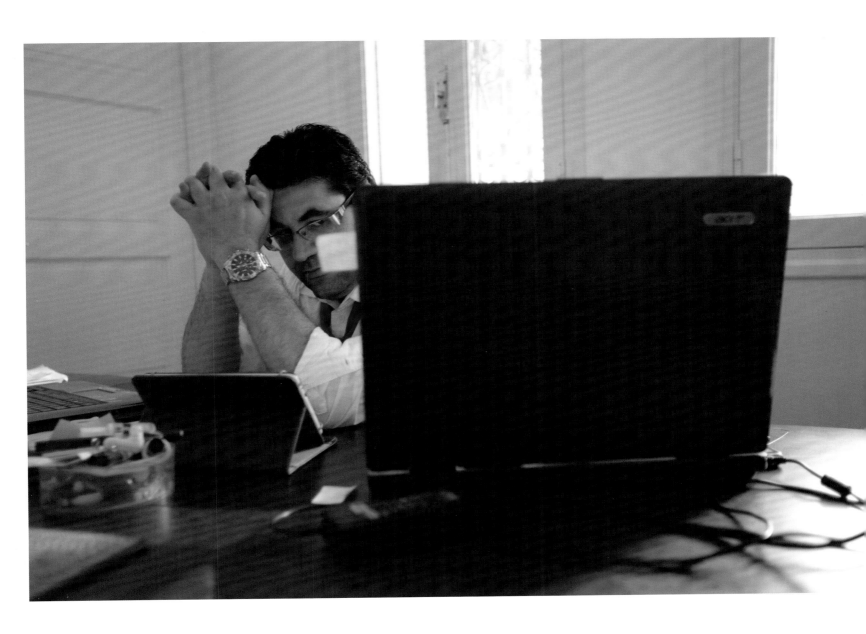

DAKAR, SENEGAL

Fatou Sylla and Fatou Camara founded their own car repair business, Fatou Fatou Mercedes Garage, after completing a mechanics training programme.

Forced to spend their first few years moving from one temporary premises to another in Dakar, the Senegalese capital, they now have their own garage, where they work with three male employees.

They would love to employ more women, but finding any with the right qualifications and experience is hard. Dakar's Centre for Professional and Technical Training on average graduates just one woman a year from its car repair programme.

Senegal has two other well-known female-run automotive businesses: Femme Auto, another car repair firm, and Taxi Sisters, a taxi service.

Photographer
ANTHONY KURTZ

CAR OWNERSHIP

Per 1,000 people

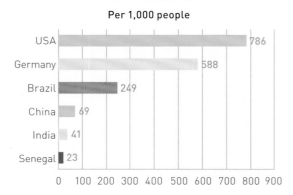

USA	786
Germany	588
Brazil	249
China	69
India	41
Senegal	23

0 100 200 300 400 500 600 700 800 900

Source: World Bank

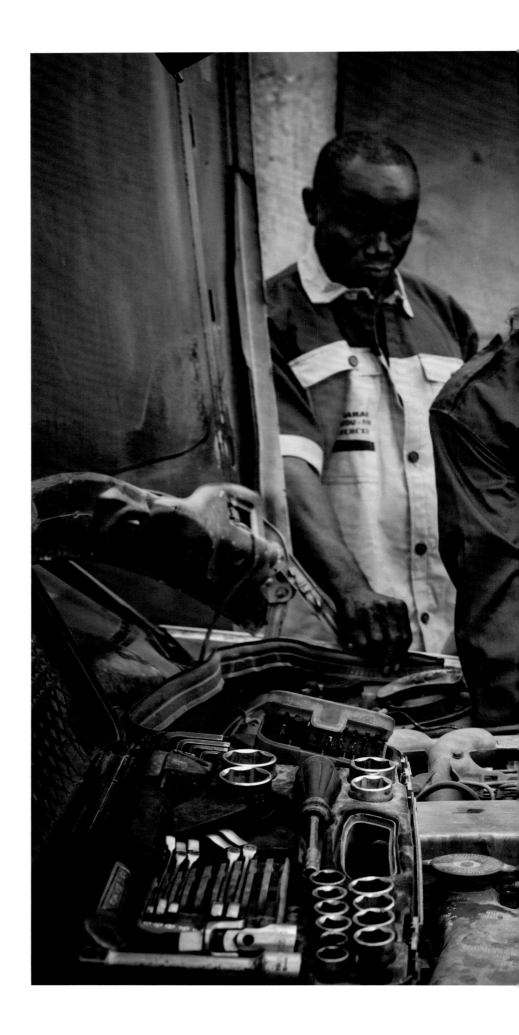

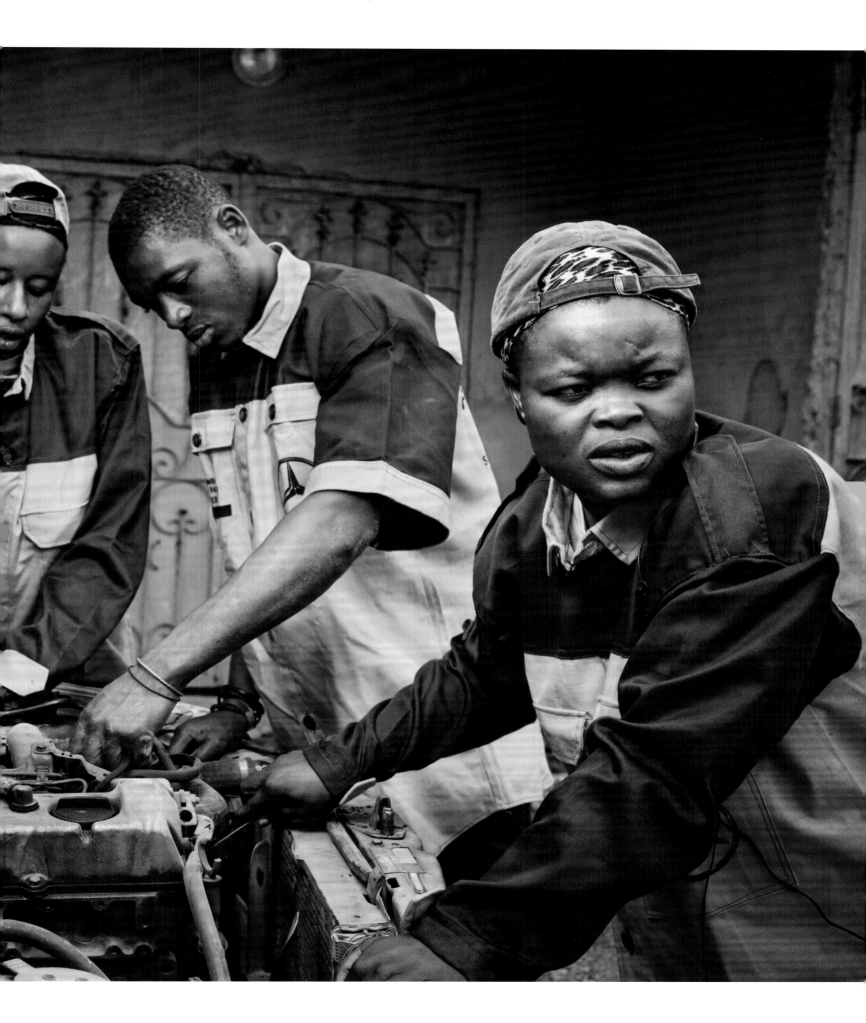

BANJUL, GAMBIA

Momodou Woury Bha, makes djembes in Banjul, the capital of the Gambia.

Originally from Guinea, he learned how to make these rope-tuned drums from a fellow Guinean after he arrived alone and empty-handed in the Gambia in search of a better life ten years ago.

For the last five years, Woury has made his djembes in Banjul, starting work every day from Monday to Saturday as the sun rises.

Each of his drums is hand-carved from a single piece of hardwood bought in the Senegalese bush then covered in a membrane of rawhide, usually goat or cow.

At first Woury worked alone, but thanks to the popularity of his drums, he now employs three other young men, also all Guineans.

"Guineans have a talent for making djembes, like Malians and Ivorians," he says. "Djembes come from our countries and cultures and we are somehow born with music and dancing in our blood."

As well as making djembes for local musicians, Woury also sells his drums to tourists and local craft markets, and every now and again takes a big order from an African exporter for drums to sell in the United States or Europe.

Making djembes is his work, but when he and his staff need a break, they each grab a drum and start playing. "Life's definitely happier when music is what you make," he says.

Photographer
CLAIRE LADAVICIUS

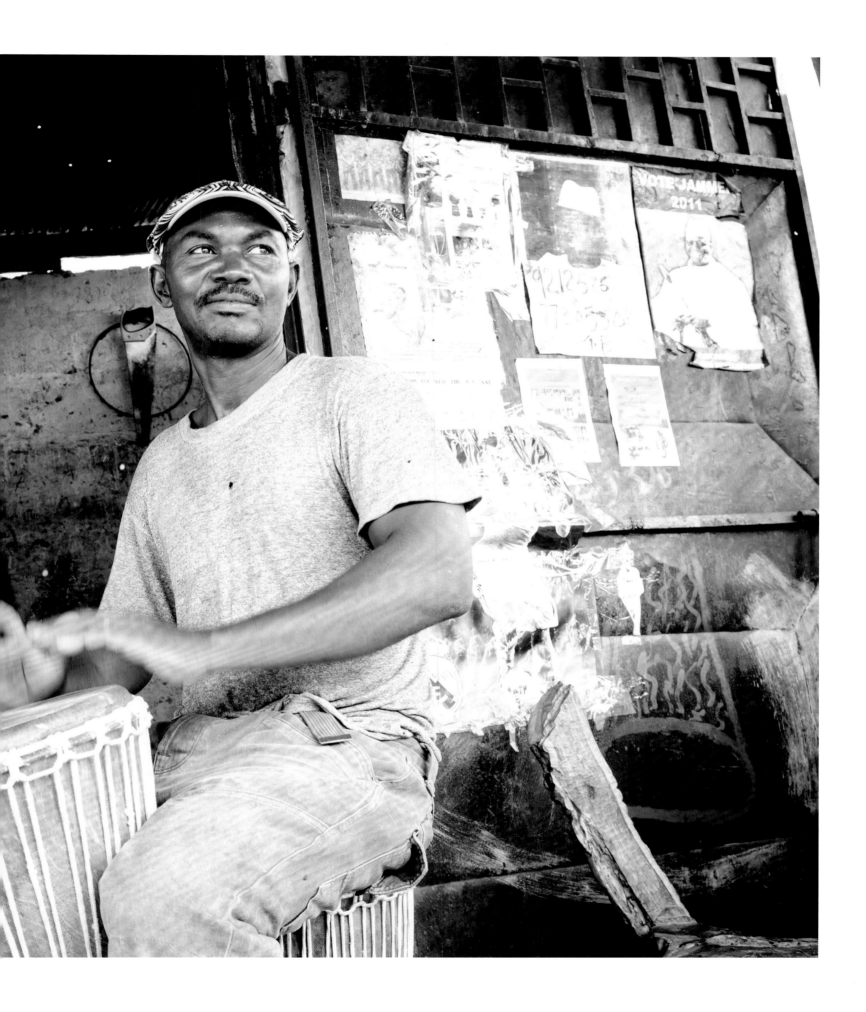

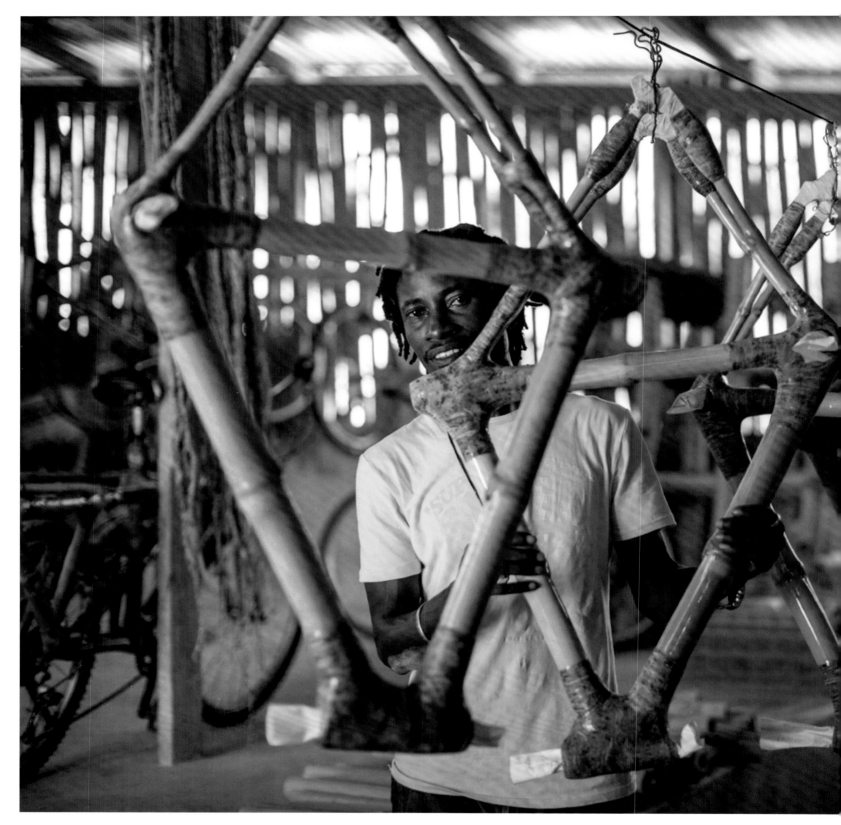

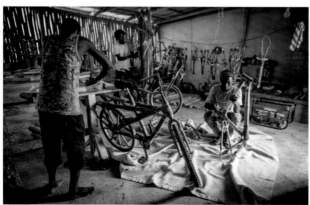

Until 2007, Ibrahim Djan Nyampong sold art and craft materials to tourists visiting the Arts Centre in Accra, the capital of Ghana. But both the money and prospects were poor, so he decided to try something different – making bicycles from bamboo.

Today, he and his team make around 300 bicycles a year in a workshop perched high on a hill, half of which has been eaten away by illegal stone miners, and linked to the rest of the world by a pot-holed, dusty, winding road.

"This is where we could afford to buy land, so this is where we have the workshop," says Ibrahim.

His bicycles sell for around €350 each, mainly to buyers in Europe and the United States. But he hopes that as they become better known and demand rises he can lower production costs enough to allow local people to afford them.

At first, many people thought making bicycles from bamboo was something of a joke, he says, but now people are warming towards the bamboo bike. "Even the very first bicycle I made, we still ride it. They are very strong."

Photographer
NANA KOFI ACQUAH

GETTING TO WORK

Percentage of total travelling by...

	Accra	Shanghai*	Manhattan	Copenhagen
Foot	34	12	8	6
Bicycle	9	16	3	36
Bus or subway	36	27	73	33
Taxi	3	5	0	0
Car	13	15	14	25
Electric powered bike	0	19	0	0
Other/No answer	5	6	2	0

Source: US Census Bureau, city governments, Tongji University
*City centre

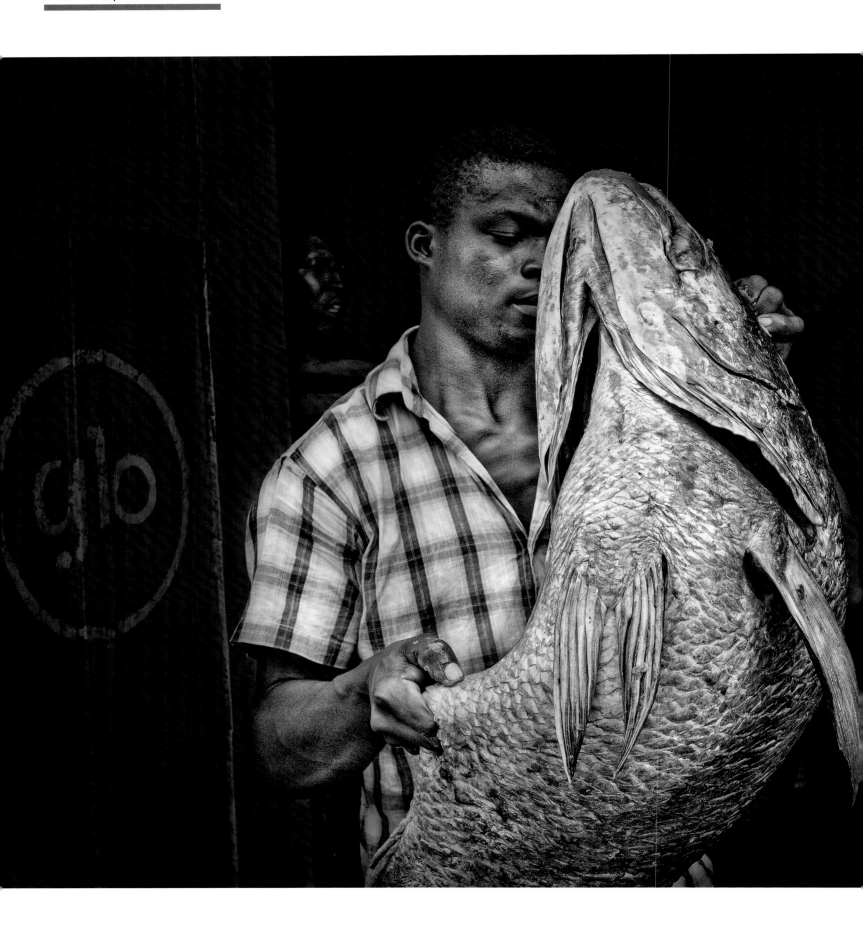

In the late 15th century, the Portuguese made the town of Elmina, on a south-facing bay on Ghana's Atlantic coast, the site of Europe's first settlement in West Africa.

Their initial interest in the port was as a conduit for gold. Subsequently, it was used as a transit point for trafficking tens of thousands of slaves and as an important port for provisioning ships heading south towards the Cape of Good Hope on their way to India.

Today, with a population of 33,000 people, fishing is its principal industry. Its fishing folk organise their work through small cooperatives that share profits equally between their members. Their livelihoods, however, are threatened by fishing fleets from other countries, particularly China, equipped with modern technology.

Photographer
TOMASZ TOMASZEWSKI

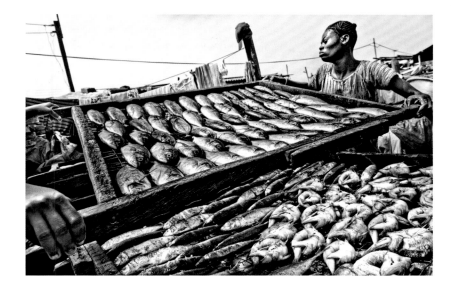

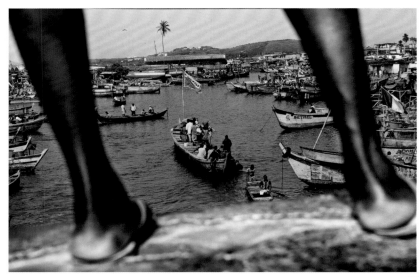

LOME, TOGO

Maggy Lawson, the owner of Manatex, is a successful trader of pagne, the colourful wax-printed fabrics that in Togo and other West African countries are as essential to local life as rice and palm oil.

Few people are successful enough to make a fortune trading pagne, but Maggy's mother was one of them – earning enough to become the first pagne trader to buy a Mercedes-Benz.

Maggy, like her mother, also has a Mercedes in her garage at her home in Lomé, the capital of Togo. She buys much of her fabric from Vlisco, a giant textile firm based in the Netherlands which despite its nationality is closely associated with traditional West African textiles having worked with merchants – among them Maggy's mother – for decades.

However, with 12 yards of Vlisco's fabric costing the same as the average monthly wage in Togo, it can only be used for pagne bought by middle and upper class customers.

So Maggy has gone a step further than her mother and created her own production house, Manatex, that uses her own designs to produce cheaper products aimed at ordinary Togolese. "Vlisco produces for the elite. I produce for the people," she says.

Photographer
FLURINA ROTHENBERGER

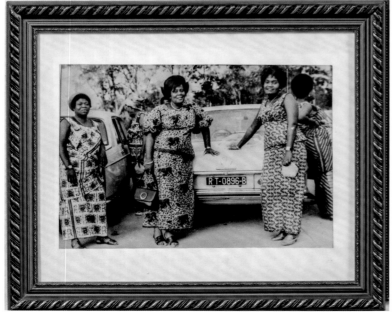

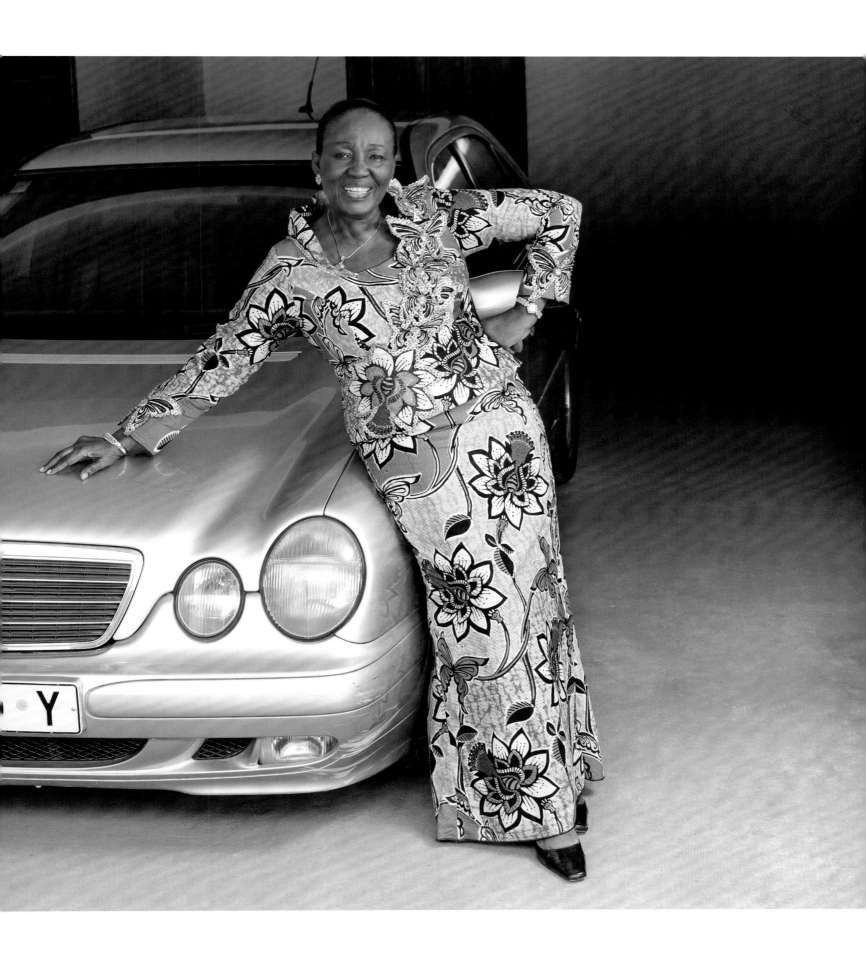

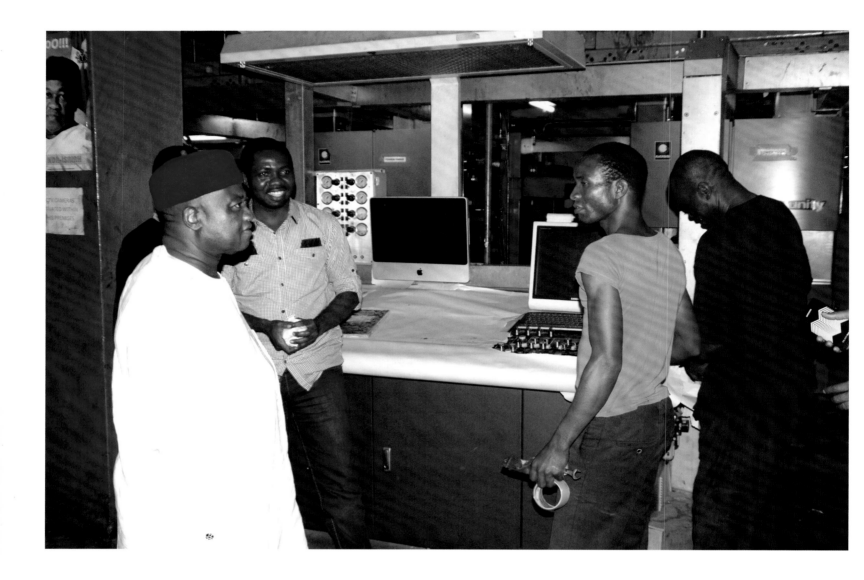

Sam Nda-Isaiah runs Leadership Newspapers Group, one of Nigeria's most successful independent newspaper businesses. Born in 1962 at Minna, a city 100 kilometres north-west of Abuja, the Nigerian capital, his interest in journalism started at the University of Ife, where he was the national editor for *Student Pharmacist*, the official publication for all Nigeria's pharmacy schools, while studying for a degree in pharmacy.

After graduating, he worked briefly for a local hospital and then for American pharmaceutical firm Pfizer before switching to full-time journalism, joining the editorial board of the *Daily Trust* newspaper and then helping revive *The Triumph*, a state-owned newspaper.

His own newspapers' origins stem from a subscription only newsletter, "Leadership Confidential", that he launched in 2003. Aimed at Nigeria's elite, it quickly proved hugely popular, and was followed in less than a year with the launching of *Leadership* and then *Leadership Friday*, *Leadership Weekend*, *Leadership Sunday*, *Leadership Hausa* and a website, Leadership.ng.

His latest ambition is to contest Nigeria's next presidential election, running as the candidate for the All Progressives Congress, one of Nigeria's leading opposition parties. "Know your limits, then ignore them," he says.

Photographer
OYEDELE OMOKAGBO

Claudio Corallo, 63, has forty years of experience producing coffee and chocolate in Africa, working first in Zaire (today Democratic Republic of Congo) and since the 1990s in São Tomé and Príncipe, a tiny archipelago off the coast of Guinea in West Africa.

Born in Florence in northern Italy in 1974, Claudio moved to Zaire when he was 23. After several years working in the coffee trade, he bought a run-down plantation in the centre of the country, reviving it to produce high-quality coffee that he exported to the world.

Forced to leave in the mid-1990s after rebel forces launched a civil war that would end in the toppling of Mobutu Sese Seko's government, he moved to São Tomé and Príncipe, to continue his plantation career, this time growing cacao trees, the plant that produces the bean used in cocoa and chocolate.

Today he grows his own cacao beans on Príncipe, then ships them the 90 miles to São Tomé where he runs a processing plant.

When he started out, his greatest challenge was removing the characteristic bitterness of the variety of beans grown on his plantation. He set up a laboratory beside his home, testing and experimenting with new ways of fermenting the beans, until he eventually came up with his own process for producing bitter-free cocoa. Today, he sells his dark chocolate to gourmet buyers, mainly in Europe, the United States and Japan.

Photographer
ALEX MASI

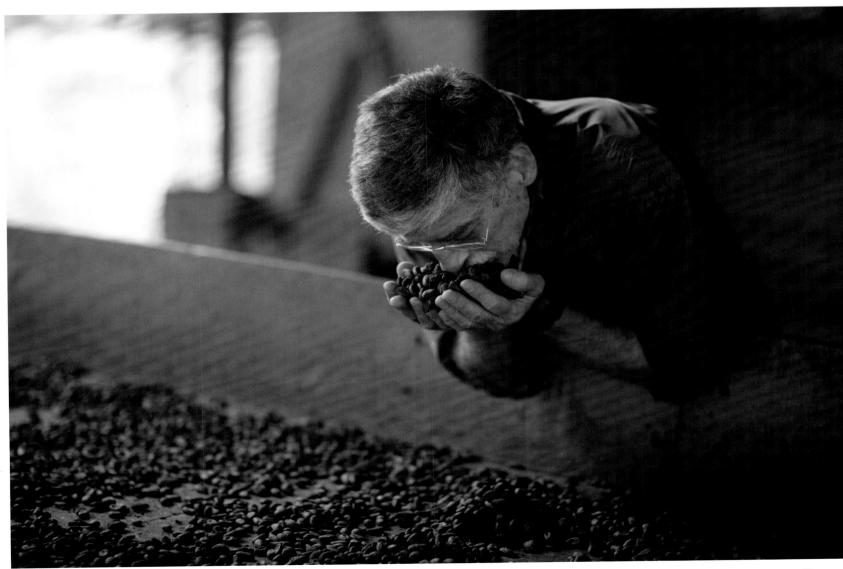

KINSHASA, DEMOCRATIC REPUBLIC OF CONGO

Photographer
FELIX MASI

The Kimbanguist Symphony Orchestra – Central Africa's only symphony orchestra – can trace its origins to 1992 and the collapse of a local airline in Zaire, as the Democratic Republic of Congo was then known. Armand Diangienda, a pilot with a love of Western classical music and a dream of becoming a conductor, lost his job. Finding himself with time on his hands, he taught himself to read music, learned a couple of instruments, and formed a group with a few other members of his church.

Today his group has 200 volunteer members who get together up to six days a week, rehearsing and performing in an empty warehouse across the road from Armand's home in Ngiri-Ngiri, a district in central Kinshasa, the capital of the Democratic Republic of Congo. Using a mixture of home-made and donated instruments, the orchestra's repertoire ranges from Berlioz to Beethoven.

01 Violinist Sylvie Mbela is one of the orchestra's founding members. The mother of four children, she makes a living trading everyday goods.

02 Albert Matubenza is the orchestra's administrator and original teacher. As well as earning money from freelance teaching, he also makes violins for musicians both in the Kimbanguist Symphony Orchestra and in other groups, mostly evangelical churches.

03 Josephine Mashina, one of the orchestra's bass cellists, makes a living selling eggs and omelets at a food stall at Zando market in central Kinshasa. A self-taught musician, she hopes that one day she can own her own home and send her son to study music in the United States. Now 14, he is one of the youngest members of the orchestra's junior group. Josephine has travelled with the group to Italy, France and most recently London.

WATCH THE ORCHESTRA ONLINE

www.youtube.com/watch?v=M-DHGxuLUdQ

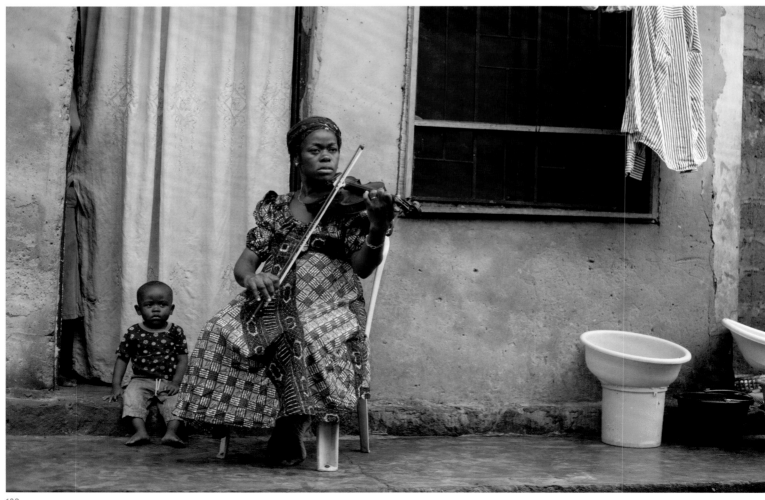

01

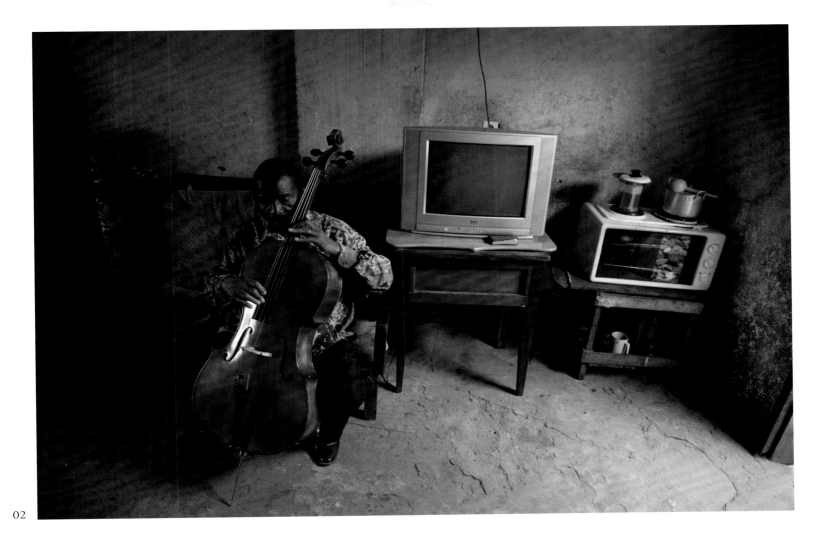

02

03

SOWETO, SOUTH AFRICA

Fashion designer Lethabo Tsatsinyane, 26, and fashion stylist Teekay Makwale, 32, work from a backroom in Soweto, the township set up under South Africa's former apartheid government to ensure a ready supply of cheap labour to work in nearby gold mines.

Members of South Africa's post-apartheid generation, they call themselves the Smarteez. They saw their parents suffer, and don't want to settle for the same. Educated and creative, their goal is to create a fashion brand that embodies a generation that chooses optimism and non-conformity.

"Life is more than just a shack in the township, but that can be a step towards a penthouse in the affluent suburbs of Johannesburg. We want to be the Bill Gates of the future," says Lethabo.

Photographer
NEO NTSOMA

SOWETO

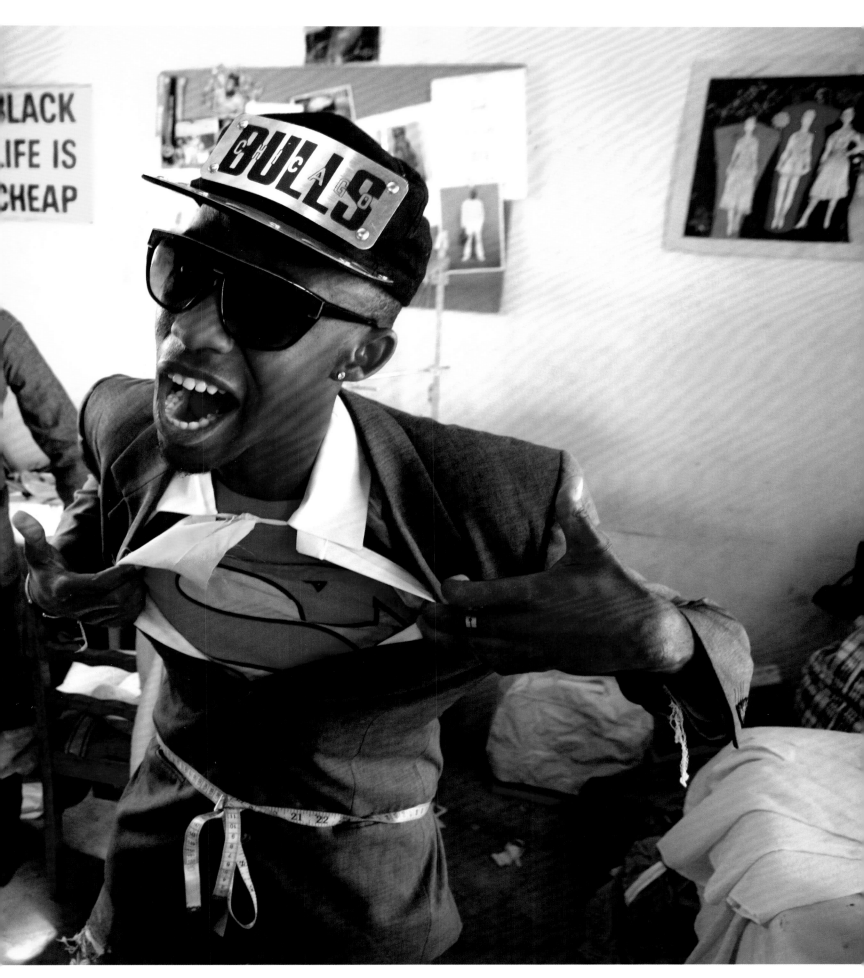

JOHANNESBURG, SOUTH AFRICA

Philani, 24, makes a living selling books on a Johannesburg street corner. To attract attention from passers-by, he offers them free reviews of any of the titles in the pile of works next to him. If someone likes what they hear, they can then buy the book.

Born in Kwazulu-Natal, a province on South Africa's east coast, Philani moved to Johannesburg in his early teens. He says he discovered the value of reading after self-help books helped him recover from drug addiction.

He sells his books – most of which are given to him – for between US$2 and US$9 each, earning enough to rent a flat as well as buy enough food to eat. Although he refuses to name his favourite book, John Grisham is his favourite author.

Photographer
TEBOGO MALOPE

WATCH PHILANI ONLINE

www.youtube.com/watch?v=iZIME4mqpyo

BEIRA, MOZAMBIQUE

Many people in Beira, Mozambique's second largest city, rely on bicycles as their primary means of transport, either to get to work or to earn money. India's "Hero" brand remains the most widely used bicycle in Beira, closely followed by models imported from China.

A more recent arrival is Baisikeli – the Swahili word for bicycle – which sells bicycles and spare parts shipped from Denmark to Mozambique at a former petrol station in the city.

Set up by two young Danes, cousins Henrik Smedegaard Mortensen and Niels Bonefeld, Baisikeli collects discarded and broken bicycles in Denmark, refurbishing and selling some in two shops they run in Copenhagen, and sending the rest to Mozambique for sale in Beira.

Profits from the two Danish stores are channelled to Mozambique to train bicycle mechanics.

Photographer
LASSE BAK MEJLVANG

Twelve-year-old Farah learned how to ride after her family bought a bike from Baisikeli. "Before I walked to school and to the market. Now I can take the bike, which means that I do not have to be in the sun for a long period of time," she says.

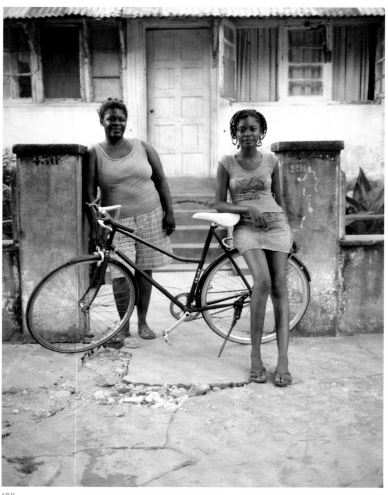

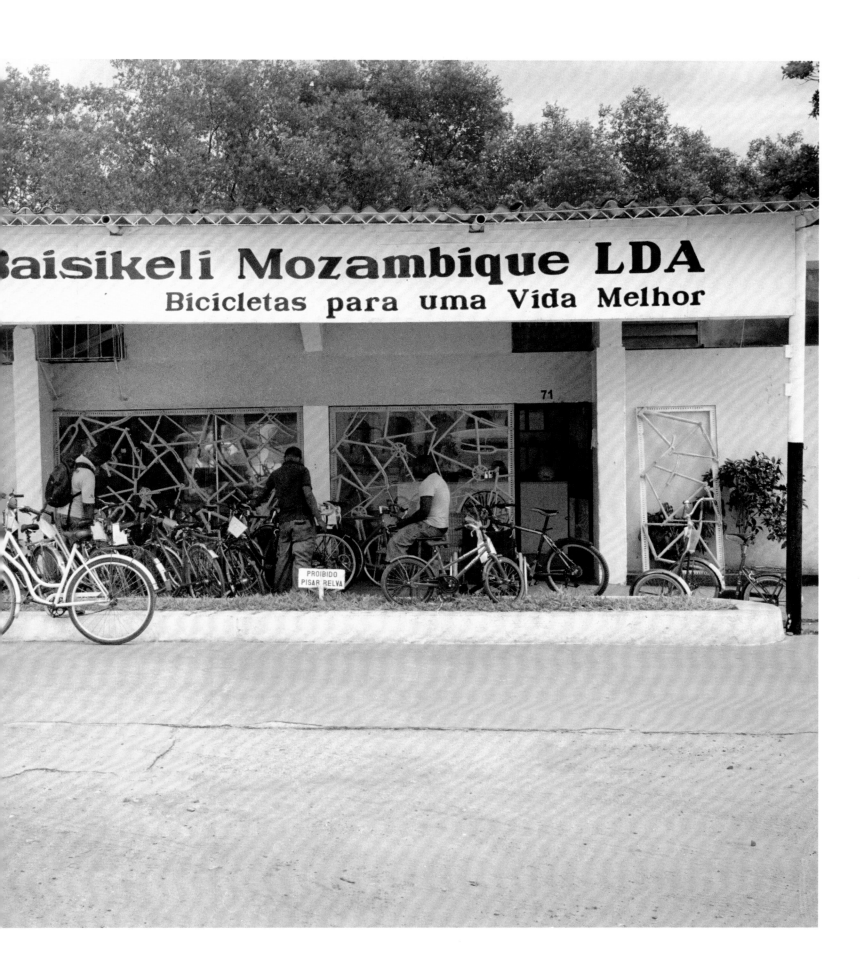

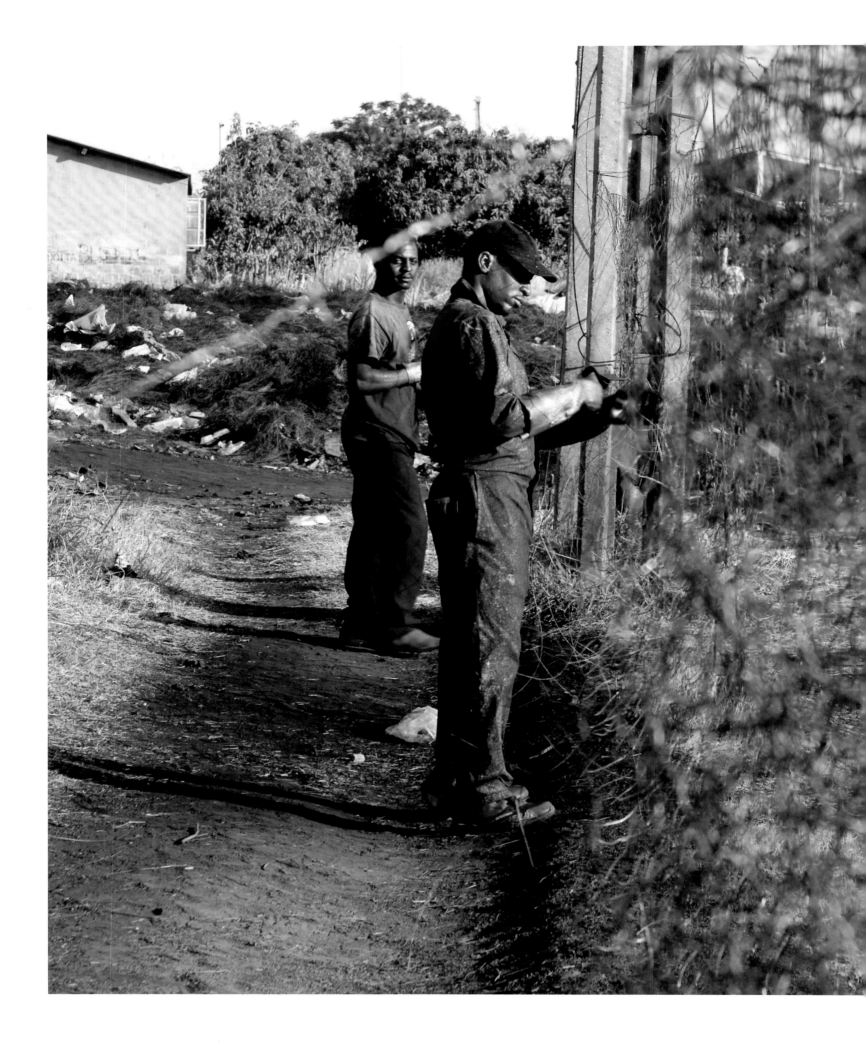

Based in Highfield, a suburb of the Zimbabwean capital, Harare, Jeffrey and Cleopas make low-cost fences that local firms and individuals can afford to buy.

Instead of buying wire, they source their raw material from worn-out truck tyres bought from nearby garages and workshops. They burn the tyres, usually at night to avoid agents from Zimbabwe's Environmental Management Agency, then retrieve the wire from the ashes the following morning.

Instead of renting a space in which to work, they pitch up with their tools by the roadside, weaving their fences in the open all day before finishing them off with a coat of silver-coloured paint.

Sometimes they make fences to order, but more often they make a length of fencing first, then display it by the roadside and wait for a buyer. Often Jeffrey and Cleopas earn less than Zimbabwe's minimum wage, but they get by.

Photographer
NYADZOMBE NYAMPENZA

KASISI MISSION, ZAMBIA

Beneath a rusty ceiling, in a room whose light blue paint is peeling from its cracked walls, Juste Chisenga hands each of his seven-year-old pupils their latest learning aid – ultra-cheap tablet computers with software in Bemba, a language spoken across north-east Zambia.

Known as ZEduPads, the tablets are part of a project aimed at making computers part of the everyday schooling of all young Zambians.

Dreamed up by British-born Mark Bennett, the solar-charged computers make technology accessible to children even where electricity supplies are non-existent. Available in all eight of Zambia's official languages and preloaded with 12,000 classes, the tablets can be used almost anywhere in the country, allowing children to keep track of their individual progress across every subject they study.

Mark arrived in Zambia in 1985 on a two-year contract to work at a computer center at the University of Zambia. He stayed for twelve years, before branching out on his own, first starting AfriConnect, an internet service provider he sold to Vodacom in 2005, and then launching ZEduPad.

Already, 7,000 of the tablets have been distributed across Zambia. "We've spent around US$6 million developing the software," says Mark. "So far, we have had 2.3 million words translated into local languages and a quarter of a million sounds."

Photographer
JAY CABOZ

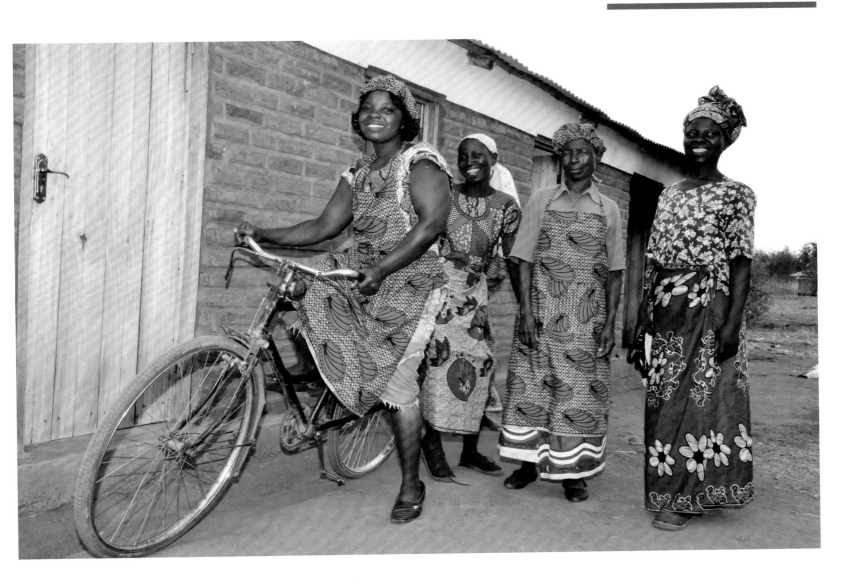

In Mkhumba, a small village in southern Malawi's Phalombe region, a poor area badly affected by HIV/ AIDS, Efelo Layoni is the organiser of a group of fifteen women running the local bakery.

Work starts each morning just after sunrise and carries on throughout the day as one shift of women replaces another.

The women then take turns taking their buns and scones by bicycle the ten or so kilometres to the nearest market. "Our biggest challenge is marketing, we hope to develop that in the future," says Efelo.

Their scones and buns are popular in the area. "The people here lacked the opportunity to buy bread. Now they enjoy our products," says Efelo.

Started in 2011 with funding from Malawi's Evangelical Lutheran Development Service, a key goal of the bakery is to give support to women who have lost or been abandoned by their husbands.

All money made from sales is shared between the group, with each member investing a part of their earnings in a local savings and loans association. Jinny Table, a single mother with four children, says that thanks to the earnings from the bakery she can now afford the school fees, books and uniforms for her children.

Photographer
JOANNA LINDEN-MONTES

Overleaf: Esnat Dokotala puts a fresh batch of buns into the oven at the Mkhumba bakery.ttt

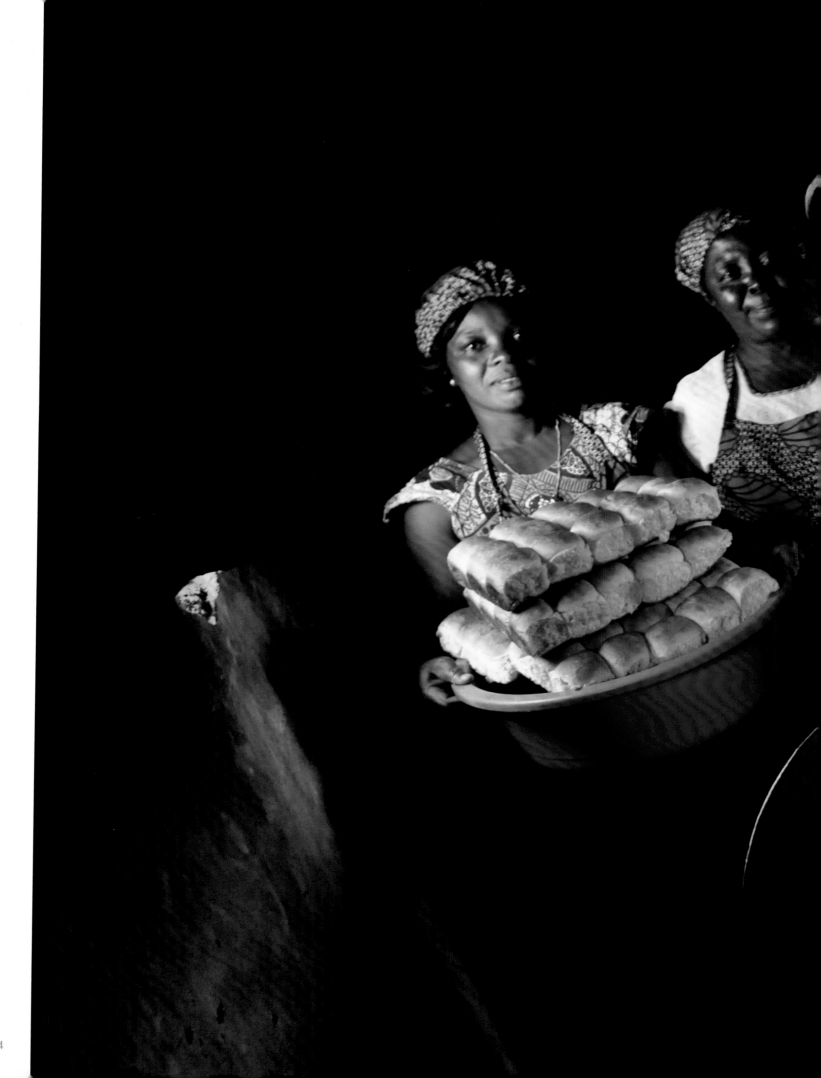

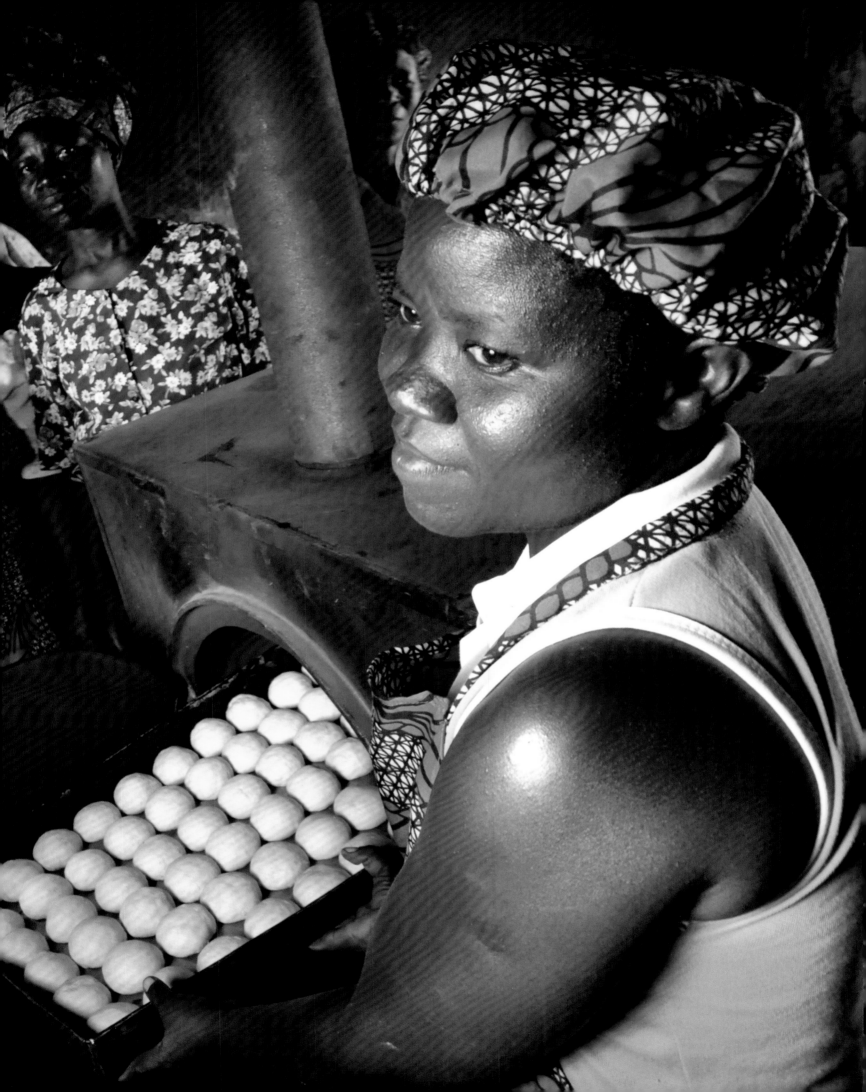

NYANZA LAC, BURUNDI

Dieudonne Kwizera, 37, runs a tailoring business making shirts and suits in Nyanza Lac, his home town in southern Burundi.

Dieudonne started the business in 2013, shortly after returning to Burundi after 15 years of exile living in a refugee camp in neighbouring Tanzania, where his family had fled to escape ethnic violence.

After his mother died in the camp. His father remarried and had two children. Diedonne's father returned to Burundi, but was killed shortly after in a land-ownership dispute.

Left alone to take care of his sister, Dieudonne learned the basic skills of tailoring and married a fellow Burundian.

After returning to Nyanza Lac, he and three other returnees opened a small tailor's shop, sharing costs and sewing machines to keep their costs down.

Today, along with the money made by his wife from a small restaurant she opened next door, Dieudonne earns just enough money to support his own five children and two children from his father's second marriage.

Photographer
CHRIS DE BODE

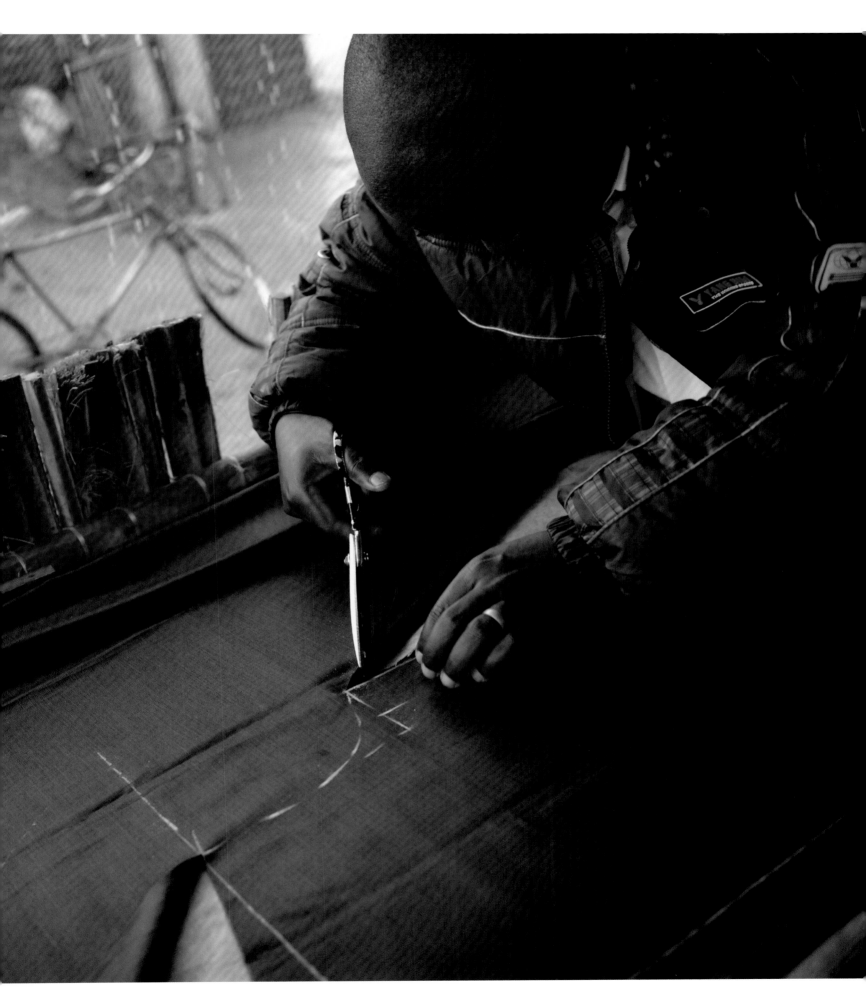

KIGALI, RWANDA

John Munyarugamba, 28, runs Landmark, a tearoom in Kabuga, a largely rural neighborhood of Kigali, the capital of Rwanda.

Originally the oldest son in a family of five, his father, mother and youngest brother were murdered in the mass killings of Tutsi that swept Rwanda in 1994. In the years that followed, John did well at school, earning a full scholarship to study in the United States. But despite graduating with a BA degree in political science from Webster University, he failed to find a full-time job on his return to Rwanda.

Eventually, he decided to start his own business, selling Rwandan tea – made by putting a tea bag into a cup of hot milk – and basic household goods, such as bread and cleaning products.

After his landlord forced him to leave his original premises in early 2014, he reopened at his current location, just a few hundred metres away, a few months later. As well as tea, his menu now also offers snacks and other foods.

John hopes that soon his girlfriend can take over running Landmark so he can start studying for an MBA and then open further businesses. "I survived genocide, this will work!" he says.

Photographer
KRISTIAN SKEIE

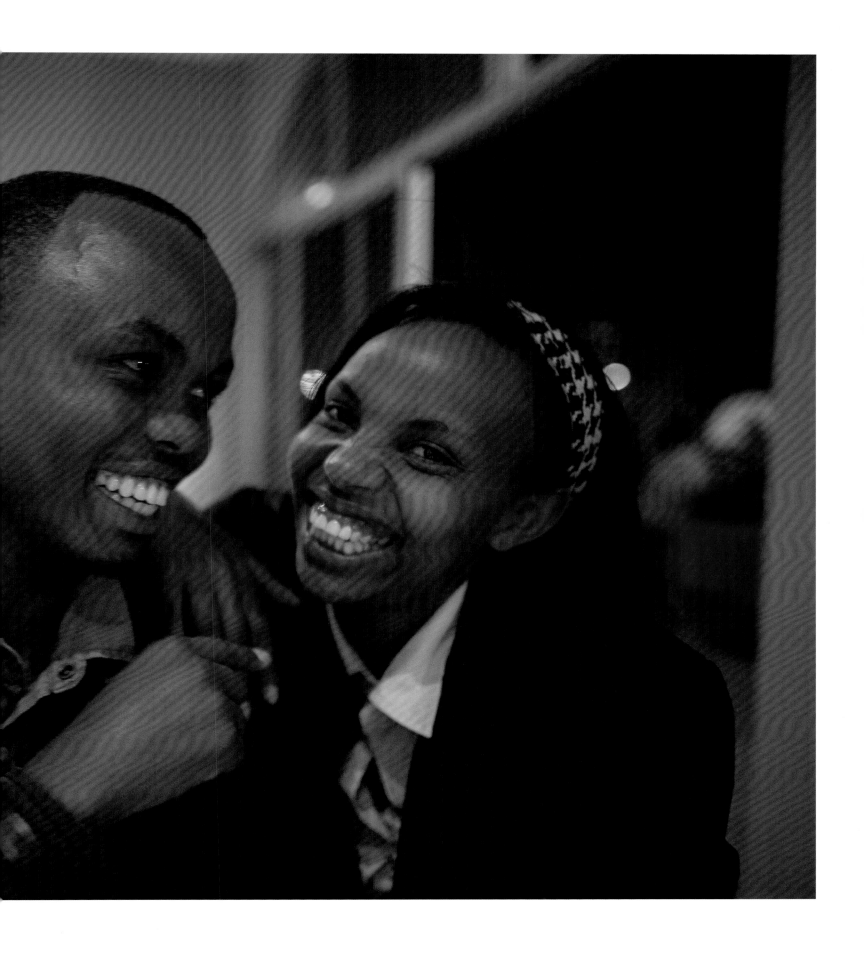

KAMPALA, UGANDA

Cellphone apps that help you argue with a taxi driver or find the cheapest petrol? Multimedia firms brimming with ambitious young video makers? Robot makers who want to transform the way schools teach maths and physics? All these – and much more – can be found on the shore of Lake Victoria, in Kampala, the capital of Uganda.

Supported by business incubators such as Mara Launchpad, based just across the road from Makere University, Uganda's largest higher education institute, a host of digital start-ups run by twenty-something-year-olds are redefining perceptions of their country.

Photographer
CIRIL JAZBEC

Daniel Ogwok, Michael Tukei and Kevin Biretwa are the developers of BodaPay, an Android mobile-phone app that helps passengers negotiate a fair fare with motorcycle drivers by estimating the distance of their intended journey. They are now writing a second app for customers of taxis without meters.

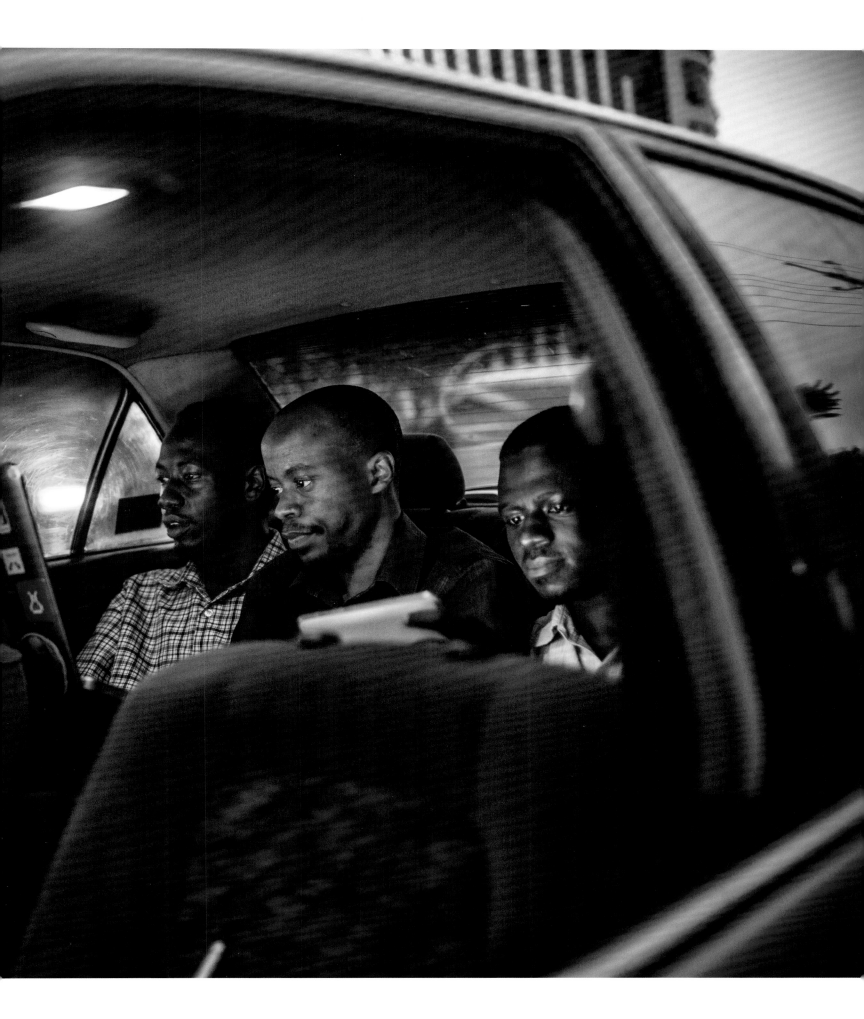

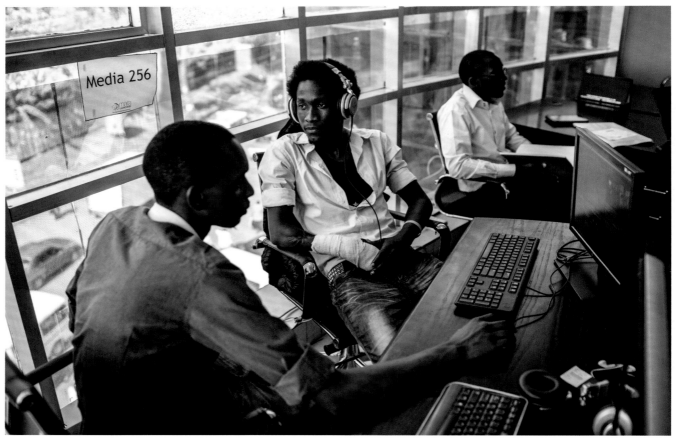

01

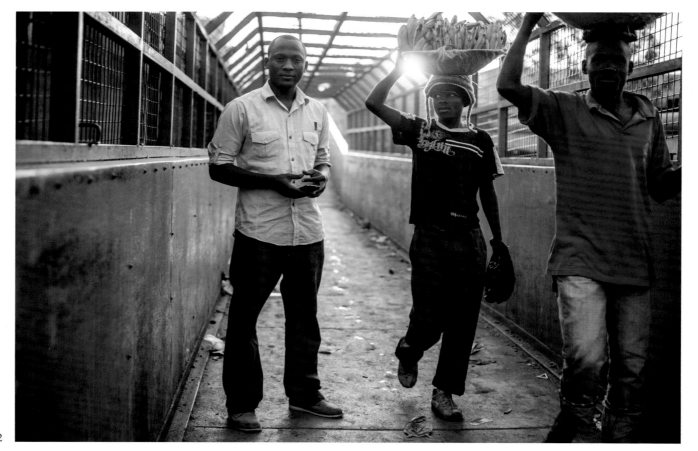

02

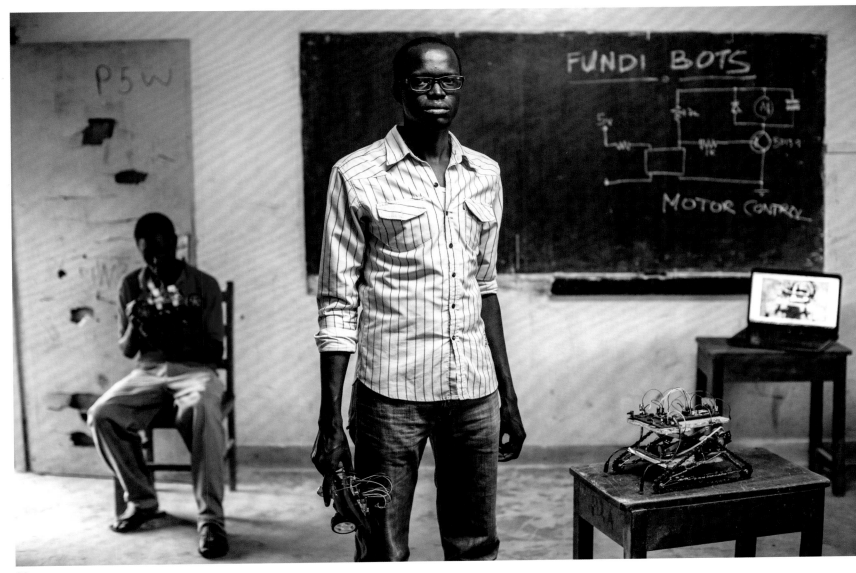

03

01 Jonathan Ochan, an intern at Media 256, a video and multimedia production firm. Set up by Isaac Oboth in 2010 when he was just 20, Media 256's clients include African and international organisations, among them Coca-Cola, the United Nations Development Programme and the Ethiopian Commodities Exchange. Isaac taught himself the skills of video-making by watching online tutorials at a local internet café.

02 Collins Mugume and his business partner David Madra are the developers of Meka.ug, a price comparison website and mobile app that allows users across Uganda to know the availability and best price of things they want to buy. "Meka" means "how much?" in Luganda, Uganda's most widely spoken language.

03 Solomon King is an internet entrepreneur, digital artist and robotics enthusiast. His organisation, Fundi Bots, brings robot kits to classrooms, giving students a chance to gain hands-on experience at integrating their knowledge of mechanics, electronics, programming, physics, maths and other subjects.

NAIROBI, KENYA

Nairobi's *mtumba* – Swahili for "second-hand" – are troves of buried treasure. Open-air markets packed with hundreds of make-shift stalls, they sell every conceivable kind of good – from pots and pans to food and bedding, and, for those willing to spend the time looking, designer brands, antique accessories and high-end fabrics.

Abraham "Abra" Omuka, Haji Mutonye and Ismail Akuku spend much of their time searching *mtumba* across the city in search of goods for Neibaz Fashion House, the male-oriented lifestyle and fashion business they set up straight after leaving high school.

Many of their finds are used to dress and style local musicians, artists, politicians and others. Spin-offs include a website – neibazfashion.com – where Abra and his partners post op-eds and commentaries on Nairobi's latest trends and fashions.

Photographer
KELLY RANCK

CAST-OFFS

Internationally, a quarter of all garments sold – an estimated one billion pieces of clothing – are thrown away every year. That's about 500,000 tons of clothes, the weight of the world's tallest building. The second-hand clothes industry is worth US$1 billion in Africa.

Source: Al Jazeera

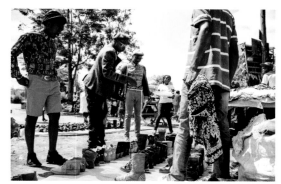

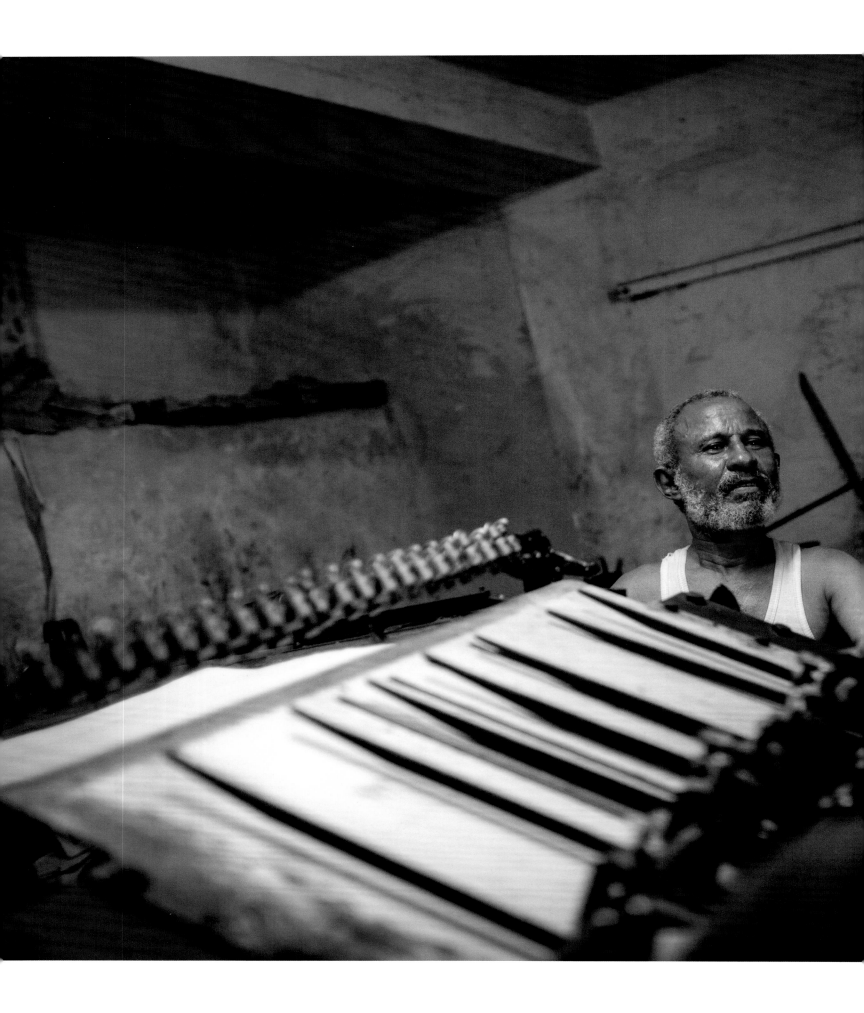

Kasim Sheik Ahmed, 60, has run Daha Printing Press, one of Mogadishu's oldest printing businesses, for 45 years – interrupted only by an eleven-year period when his company was nationalised.

Known to his friends and colleagues as "Tobleno" – Italian for cartoon – because of his wiry frame and sense of humour, he works every day of the week except Friday, from 8 o'clock in the morning to 3 o'clock in the afternoon, always dressed in a traditional Somali *macawiis* (sarong) and a tank top.

Photographer
JONATHAN KALAN

Kasim overseeing the printing of bilingual Italian and English customs declaration forms for Mogadishu's port – identical to those his father produced in the 1960s.

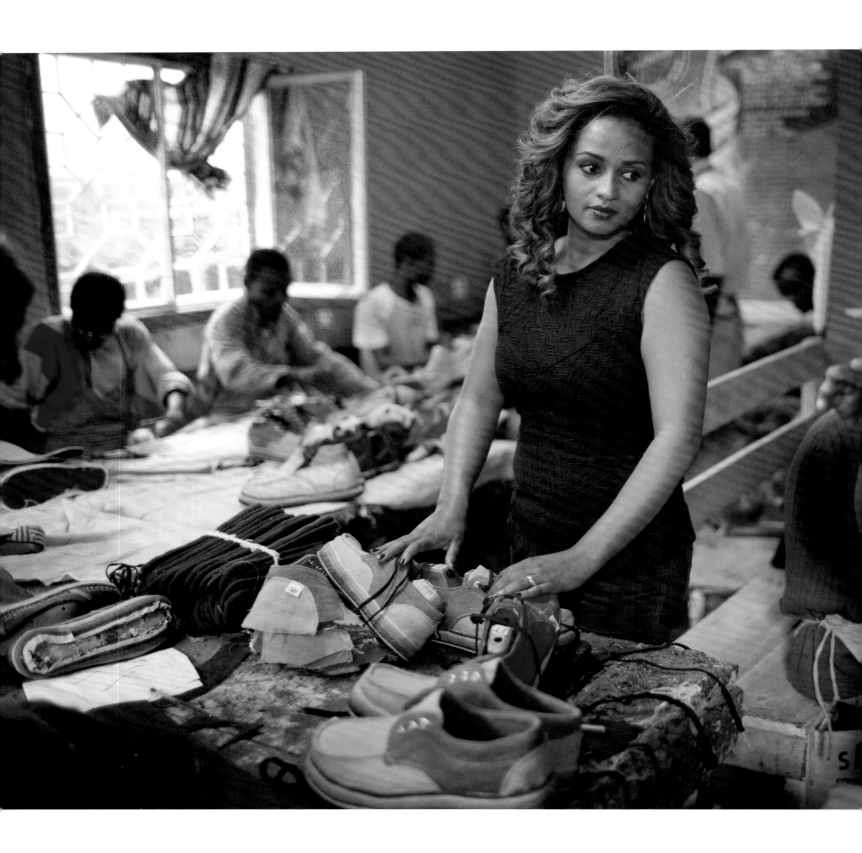

128

Since Bethlehem Tilahun Alemu started her footwear company SoleRebels in 2004 on a patch of her grandmother's land on the outskirts of Addis Ababa, the capital of Ethiopia, the company has expanded every year, with turnover expected to reach up to US$20 million in 2015.

Today, its hand-made shoes are sold in stores around the world, through Amazon and through its own website, solerebels.com – helped in good part by the reputation it has built for itself as the world's first Fair Trade footwear company.

The design of its shoes draws on the boots and other footwear worn by local rebel fighters, albeit with a nod to Western sensibilities. All the company's output is made from old tyres, fabrics using locally grown and processed organic fibres, and other recycled or ecologically sustainable products.

Bethlehem's 75 staff – up from just five when she founded the company – earn four times the Ethiopian wage. Proof, says Bethlehem, that companies in developing countries can move up the value chain by making branded finished goods instead of low-value exports. "SoleRebels is development done right," she says.

FOOTING IT

Price of a pair of men's leather shoes, US$

Venezuela	298
United States	167
Italy	130
Germany	118
Argentina	109
China	99
Japan	90
Ethiopia	67
India	37
Sri Lanka	30

Source: Numbeo.com

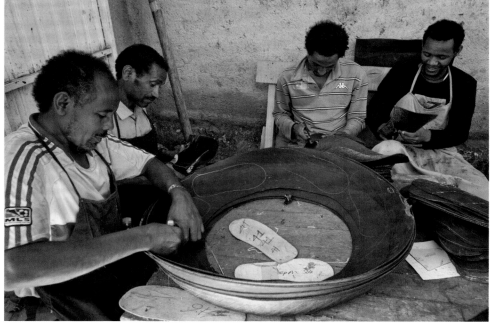

JUBA, SOUTH SUDAN

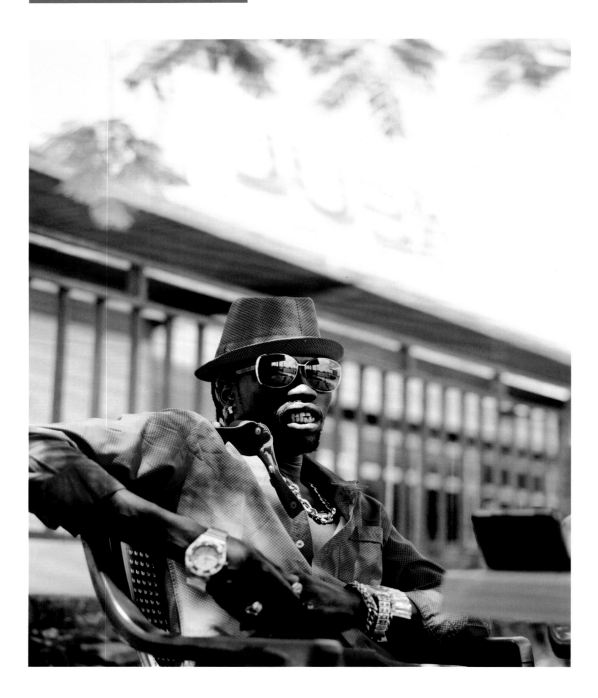

Silver X, 26, is a rap artist and singer based in Juba, the capital of South Sudan, one of the world's newest countries since its establishment in July 2011. "When South Sudan achieved independence I was so amazed," he says. "On independence day there was a four-day concert and I performed at the Cultural Centre. When they raised the flag I was shedding tears, partly for the terrible things that happened in the past, but also for joy."

After Silver X's father died during South Sudan's long struggle for independence in 2000, his mother moved to Uganda, raising him, his five sisters and one brother in Kampala, its capital. He returned to his home country to launch his music career in 2010.

"Last year I was voted best artist of the year by Radio Maray FM, the most popular radio station in the South. I've played in Kampala and all over South Sudan. People think I must be rich, but it's hard earning anything here. The rate of piracy is very high, and we don't have promoters. My album had six songs with six videos and I printed 1,500 VCDs, but people just copy them like crazy," he says.

"I started in hip hop and rap, but people don't understand it. Now I'm doing Zoup-Afro, R&B, pop music... Trying to find an angle which the public appreciates. If you sing what the audience wants they'll stick behind you. I don't want to be a one-hit-wonder."

WATCH SILVER X ONLINE

www.youtube.com/watch?v=zAiDdVFSn_c

THE SPIRIT OF CREATION

Yasmine El Rashidi

THE SPIRIT OF CREATION

Yasmine El Rashidi

There is an idea, a belief – certainly about the part of the world where I come from – that our lives are wrapped up in strife. Not the struggle of the everyday – feeding our children, getting to work, worrying about money, pushing through the day on little sleep – but rather, strife of a violent nature. Over the years, as I have travelled across the world, I have often been asked about what it means to live in Egypt, in the UAE, in Saudi Arabia, in the Sudan, Ethiopia. Tunisia. Is it safe? Can women be there freely? Isn't it oppressive? Are you beaten? What do you wear? Do you dress like this, act like this, speak like this, even when you are back home?

In recent years, that scepticism has started much sooner, long before I even get on a plane. At embassies in Cairo trying to obtain visas there is a sense that we must be characters of a violent nature, that we must be considered corrupt, opportunist, unless we can prove and prove and prove again otherwise. It is assumed that in seeking permission to travel to Europe or the United States we must be going in search of opportunity. Our papers, our proof of commitment to where we come from, our proof of jobs, businesses, entrepreneurship in our communities, often mean nothing.

This narrative, as we all know, was largely conceived in the aftermath of 9/11. The world's media was flooded with the scenes from the World Trade Centre, footage of violence, destruction, death. Associations followed: pictures from the Middle East, photographs of bearded men, of the colour black, of a shadowy entity called "Al-Qaeda". And a set of words: terror, war, Arab, Muslim. The War on Terror began to affect us all. It changed

lives. It changed fortunes. It changed what it meant to be from certain parts of the world.

In this age of "shock culture", the attraction to "catastrophe", to "the sensational", is extreme and becoming more so. As newspaper and magazine publishers and editors will readily admit, the story must "sell". But in guiding what is shared with the world through calculations of business, much of what makes our lives, the stuff of the every day, is left out. There is no single truth but there are many significant truths that the messaging delivered to us around the world each day gives no value to.

We all have sets of memories, photographic slides that collectively make up our view, our panoramas, of the world – short reels stored as archives somewhere in our brains. Some of them are first-hand experiences – snapshots of times and places, events. Others are inherited – from the media, from family albums, and increasingly from social media networks. While together our mental albums form diverse archives, they often overlook so much of the world's difference, and in particular disregard the stories, the voices, that offer glimmers of hope, potential.

Our conditioning, the choices we subconsciously make about what to remember and what to forget, are very much informed by the deluge of images around us, by the narratives we are told, by the stories we hear, read, watch.

I write this and think of a moment in Egypt in 2013. The newly instated interim government had launched a widespread campaign to crack down and arrest members

We are all makers, we are all survivors

of the Muslim Brotherhood and their sympathisers. Checkpoints had brought the city to standstill. One evening, at a small square in downtown Cairo, a march protesting against the government came into confrontation with riot police. Many I knew were at the scene.

For the state media these protesters were trouble-makers, trying to disrupt, to create upheaval. For the opposition press, a peaceful protest was violently dispersed by the oppressive police. To speak to those who only read of the incident, is to receive two, three, four, different sets of accounts. My own memory of that moment, as I trailed the protesters, was of chaos and clouds of gas and dust. Taking refuge on a street corner, I found myself beside an old man and his streetside store – one metre by one metre – selling candies, pencils, envelopes, cigarettes and other odds and ends. Clasping his hands, shaking his head, he turned and looked up, as if to a higher power, asking that the night end peacefully, asking that things not escalate. Please God, he said. My livelihood, my livelihood, Allah protect us. That old man, an entrepreneur in his own right, is the overpowering image in the visual archive I hold of that day.

The photographs that make up the pages of this book fill in the many gaps where the mainstream media and our lives and albums and social networks fall short. They take us beyond the stereotypes and reductive narratives that have come to define so many peoples around the world. They are stories that are about struggle but also about possibility. Stories that illuminate. Stories that take us beyond headlines, beyond status updates, beyond spin.

These are the human stories that help bridge the divides and the misunderstandings of our time. They are the stories that we can all, regardless of age or gender or religion or nationality, relate to and identify with. They connect people around the globe through those most fundamental of principles – that we are all makers, we are all survivors. Men, women, old, young, Christian, Muslim, Jewish. They remind us that across the continents of the globe, beyond the stereotypes, beyond the tragic narratives, is a spirit of creation, of entrepreneurship, that connects us all.

BAHAREYAH OASIS, EGYPT

Ahmed Zahran, 34, is one of the founders of KarmSolar, an Egyptian solar energy business aimed at offering farmers and other people a cheap, reliable and environmentally friendly alternative to diesel powered generators.

To demonstrate what its systems can do, it has turned an area of formerly arid desert around its company's headquarters at Bahareyah Oasis, 370 kilometres west of Cairo, into a model farm irrigated with groundwater supplied by one of its solar-powered pumping stations.

The company, whose name means "fruitful vine" in Arabic, was set up in 2011. One of its key long-term goals is to develop ways of allowing entire communities to live "off the grid" in a sustainable manner.

HOTTEST SPOTS
Average yearly total number of hours of bright sunshine

Over 3000 2000-3000 2000-1000 1000-500 Under 500

Source: Earth Forum, Houston Museum of Natural Science/World Resources Institute

RAMALLAH, PALESTINE

Shehada Shalalda is a violin maker in Ramallah, a town in Palestine's West Bank area. Originally a student of the instrument at the city's Al Kamandjâti music school, after attending a class by a visiting violin maker he found himself becoming more interested in how violins were made and repaired than in playing them.

After shadowing serveral other violin makers who visited the school, he was invited to join a workshop in Italy and then went to study violin-making and repair in the United Kingdom. He gave the first violin he made in Italy to his younger sister, Ala, who has been learning the instrument ever since.

Today, Shehada works full-time making violins for students at Al Kamandjâti, working from a workshop in his home beside the school.

Photographer
DAVID BRUNETTI

Photographer
YAAKOV ISRAEL

For more than five decades, Jacques Fhima has made the world his stage. Born in France, he lived as a teenager in Paris in the early 1960s, squatting abandoned buildings. By day, he delivered prints from a small photo studio to its architect clients by bicycle. At night, he printed photographs he had snapped through the day, creating a visual diary of his life for one of the many radical art groups that dotted the city at the time, Terrain d'Adventure.

Through the rest of that decade and the early 1970s, he enjoyed life with his friends in the city's cafés, museums, galleries, cinemas and theaters. On one occasion, he stumbled over an abandoned gem in the city's 20th arrondissement, a former factory that he and his friends restored and converted first into a studio for making theatre scenery and then into an alternative theatre and cinema in its own right.

Jacques then joined a succession of theatrical groups, travelling and performing across Europe, before moving to Israel in the mid-1990s. After losing all savings in his first venture, a street theatre, he took a job working in Tel Aviv University's cinema department before launching "Jack in the Books", a small shop selling antiques, toys and books. Today, Jacques teaches video art and experimental cinematography in Jerusalem, where he lives with his wife and three children, dreaming of his next adventure.

SHATILA, LEBANON

"Am Fadi" is one of the many women who try to make a living by mending and making clothes in Shatila, one of the most notorious of the dozen Palestinian refugee camps scattered across Lebanon. Having divorced her husband because of his involvement in drugs, she single-handedly raises her children, eking out a living among the 20,000 people squeezed into Shatila's one square kilometre.

In 1992, the camp was the site of a brutal massacre when Lebanese Christian militia massacred some 3,000 refugees over three days. More recently, conditions in the camp have worsened due to a huge influx of Syrian refugees displaced by the fighting in their country.

Photographer
ZANN HUZHEN HUANG

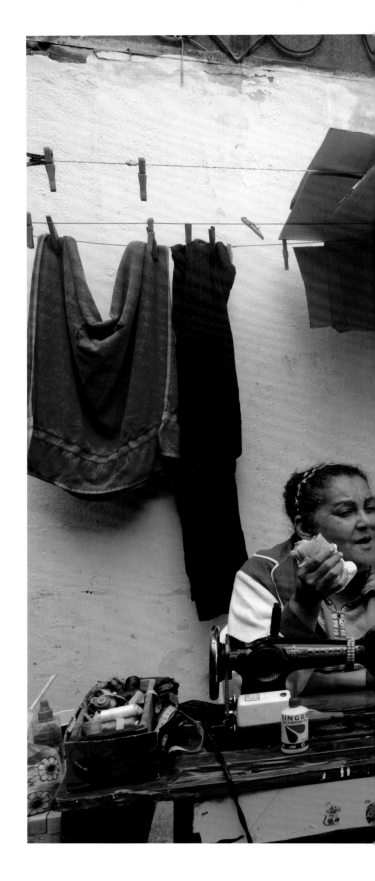

PALESTINIAN REFUGEES IN LEBANON

	CAMP	REFUGEES
1	Nahr el-Bared	27,000
2	Beddawi	16,500
3	Wavel	8,000
4	Dbayeh	4,000
5	Shatila	8,500
6	Mar Elias	600
7	Burj el-Barajneh	16,000
8	Ein el-Hilweh	47,500
9	Mieh Mieh	4,500
10	El-Buss	9,500
11	Burj el-Shemali	19,500
12	Rashidieh	27,500
	Others	265,900
	TOTAL	**455,000**

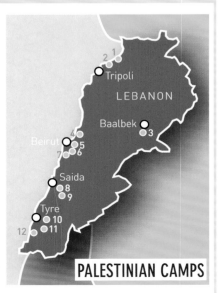

PALESTINIAN CAMPS

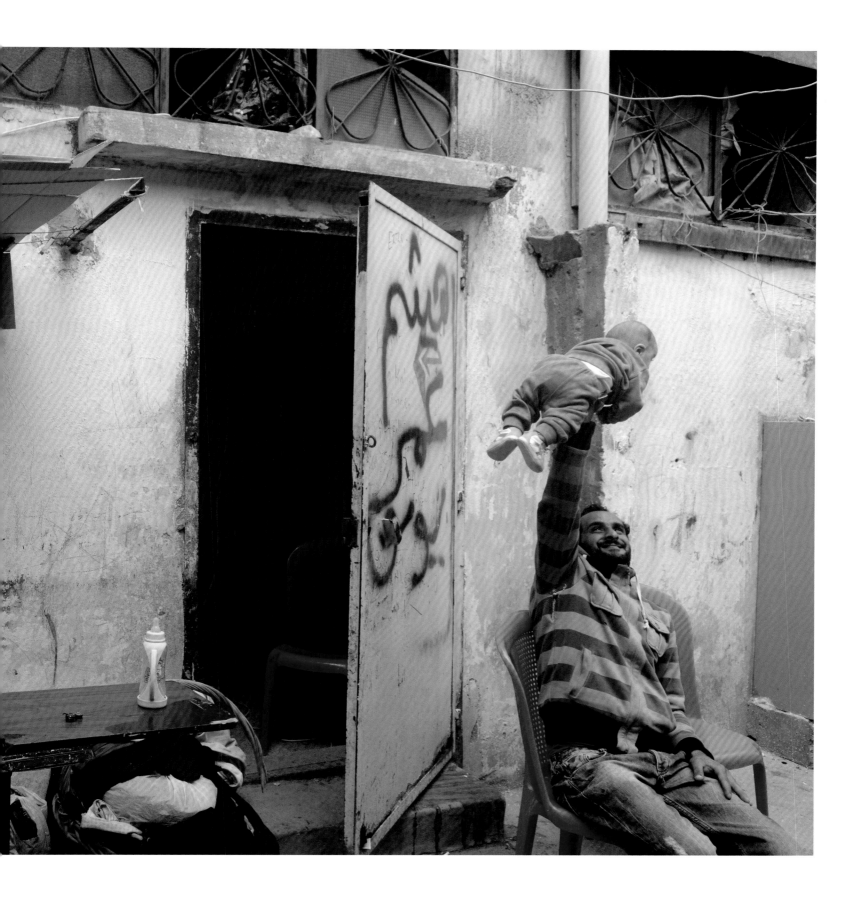

AZRAQ, JORDAN

When bombing and ground attacks from Syrian government forces came to their village of Maqsar Lalhsan, Hammoud Banikhaled along with his mother, wife and five children packed up what they could carry in their arms and fled during the night.

After a harrowing journey, they made their way into Jordan, through the Za'atari refugee camp to the dusty roadside town of Azraq. Hammoud was reluctant to rely on the minimal support from aid agencies working to support Syrian refugees, and so he started a service supplying laban, a kind of yogurt, to his neighbours.

Hammoud buys goats milk from local shepherds, then with the help of his entire family he processes it in his home to make a range of yoghurts and cheeses, producing more than 150 one-and-a-half-litre buckets per week. In this kitchen his family's women process the laban, while outside his sons run deliveries and collect orders. To help make ends meet, all the male members of the family have extra jobs. With no school to attend, Imran, 6, works each day at a local shop, and Omar, 16, works as a renderer and labourer.

Photographer
DAVID MAURICE SMITH

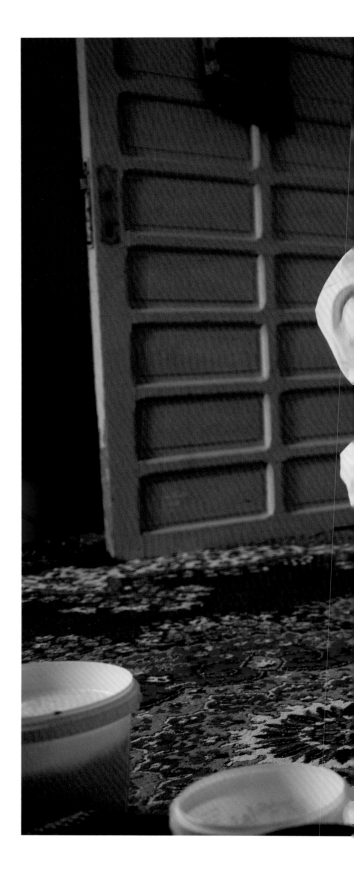

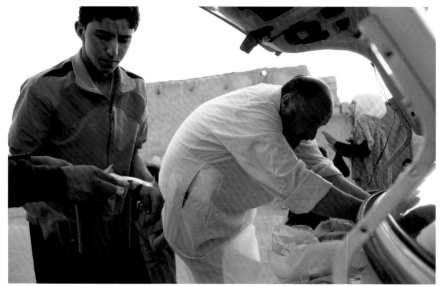

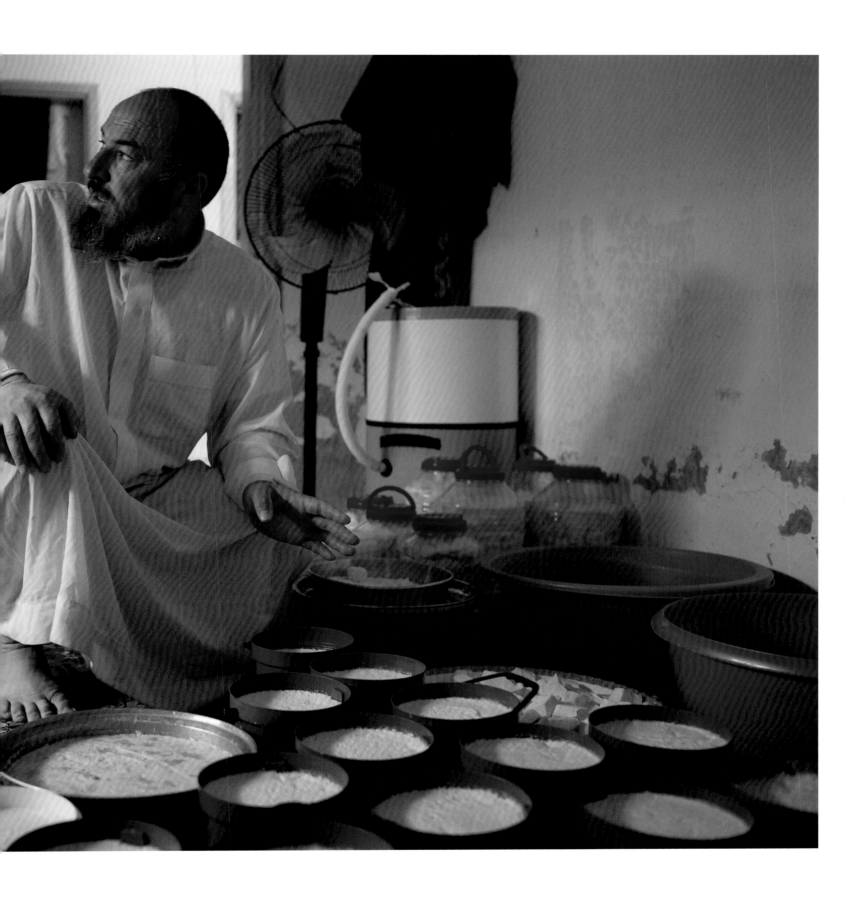

BAGHDAD, IRAQ

Iraq Builders is a volunteer group of doctors, pharmacists, engineers, workers, businessmen and other Iraqis who rebuild damaged or destroyed homes in and around Baghdad, the capital of Iraq.

Its origins date to December 2012 when a fierce storm tore the roofs off the homes of many poor families across the city. Surveying the destruction, doctor Elaf Mohammed and his friend Zaid Zahed Hussein, posted an announcement on Facebook, asking people to join them the next day serving meals and distributing materials at a local school.

After 123 people turned up to help, Elaf and Zaid decided they had the nucleus of a group that could do much more. For their next mission – also conducted by volunteers rallied through social media – they rebuilt the roof that had been torn off the home of a widow and her seven children, and gave themselves the name Iraq Builders.

Their group now numbers some several hundred members, who between them have repaired or put new roofs on more than 44 homes of families in need.

Photographer
ALI IMAD

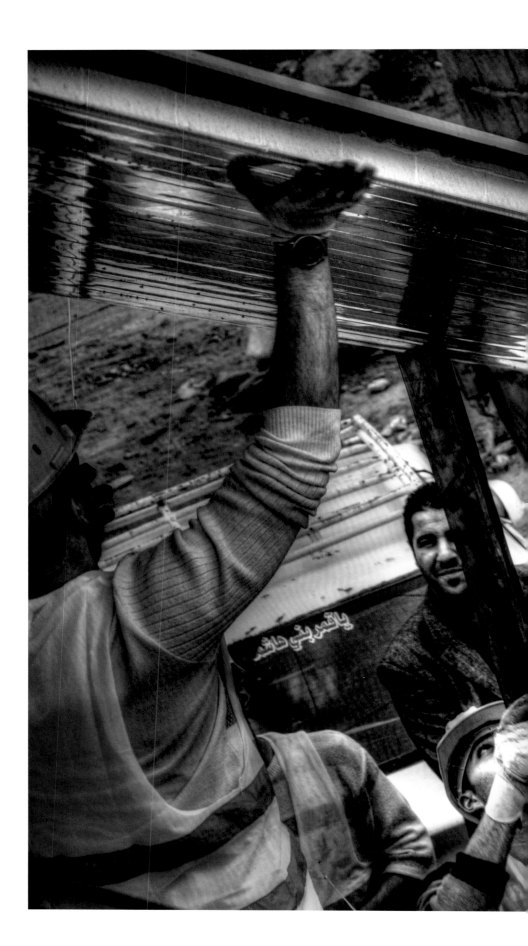

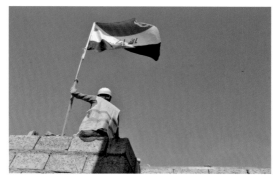

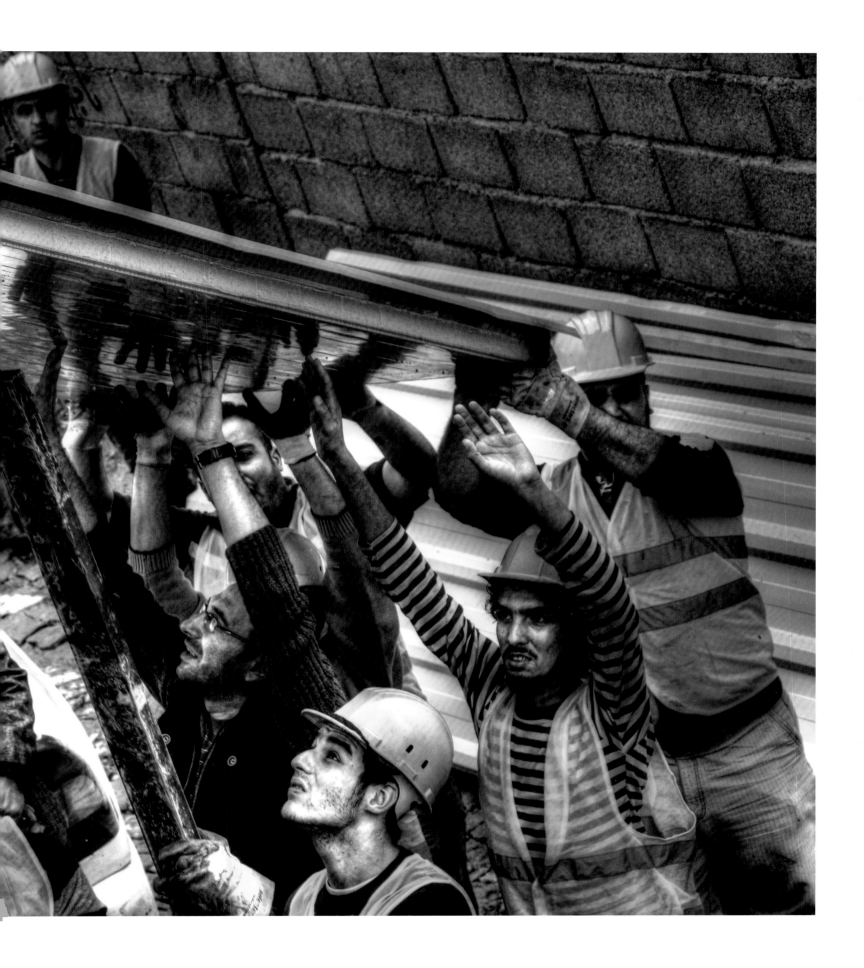

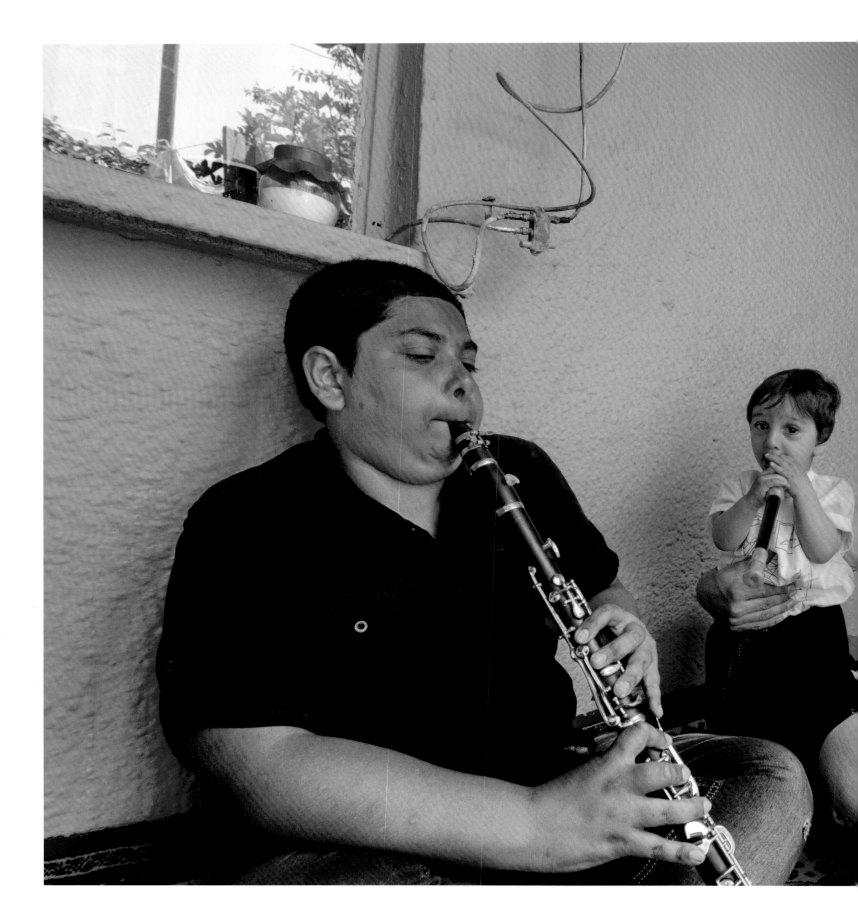

Kerem's younger brother, Sahin, though still at school, also wants to be a musician like his brother.

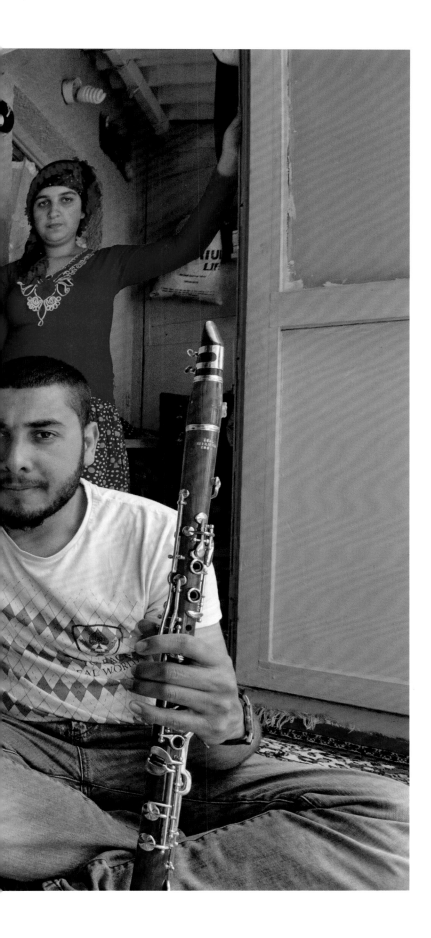

Kerem Alar, 25, is a young clarinetist. A member of the country's Roma minority, he plays solo at weddings and other events such as henna nights where brides prepare for their weddings by decorating themselves with temporary tattoos.

On such occasions, he can earn around US$100 for a day's work – good money for a member of the Roma community. But the work is irregular, usually occurring only on weekends between May and September.

When he is not performing, Kerem works in a factory. For many Roma in Turkey jobs are hard to come by. Collecting recyclable materials or being a musician are two common ways of making a living.

Sometimes Kerem performs by himself, at others a small group of friends accompanies him playing tambourines, darboukas and other types of traditional drums. His goals are to make music his main source of income and earn enough to buy a house where he can live with his wife and children.

Photographer
AYDIN CETINBOSTANOGLU

Every morning before sunrise, Kerem's mother sorts through the garbage thrown out onto nearby streets. The paper and plastic she gathers can earn her around US$15-20 a day from local recycling businesses.

QUBA, AZERBAIJAN

At the foot of the Caucasus Mountains in Quba, a district in north-east Azerbaijan, Anar runs a small company that collects rocks and gravel for use in concrete. Like him, most of his 16 workers are exiles from Nagorno-Karabakh, a region of south-west Azerbaijan that has been administered by neighbouring Armenia since the two countries fought a brutal war over who should control it from the late 1980s to the mid-1990s.

Anar, now in his mid-thirties, left Nagorno-Karabakh as a child, moving with his father to Baku, the capital of Azerbaijan. After studying international relations, he briefly lived in Russia, where he married and had a child, before returning to Azerbaijan to take over his father's gravel-making business. For accommodation, his workers use shipping containers; those who have families see them at most once a month.

Photographer
NICOLA ZOLIN

DINARAN, IRAN

Near the village of Dinaran in the mountainous border region of north-west Iran's Chaharmahal-va-Bakhtiari province, Gholam Hossein and his family farm land beside a deep river canyon.

Twice a year their work is disturbed by the arrival of tribes of Bakhtiari nomads moving their herds of sheep, goats and other livestock from their winter quarters to their summer quarters each spring, then back again each autumn, a journey of 400 to 500 kilometres in each direction.

With the nearest river crossing 15 kilometres away, Gholam and his seven sons decided a few years ago to offer these nomads a quicker way of getting to the other side, building a cableway using steel hawsers and pulleys.

Gholam's system can transport up to 1,000 livestock daily. He charges a third of a dollar for each sheep or goat carried, with people and their possessions transported for free.

"These nomads usually cause damage to our farmland. Using our pulley system both protects our land and reduces their travel time by at least one day. It's a win-win business," says Gholam.

Photographer
SEYED ESMAIL MOUSAVI

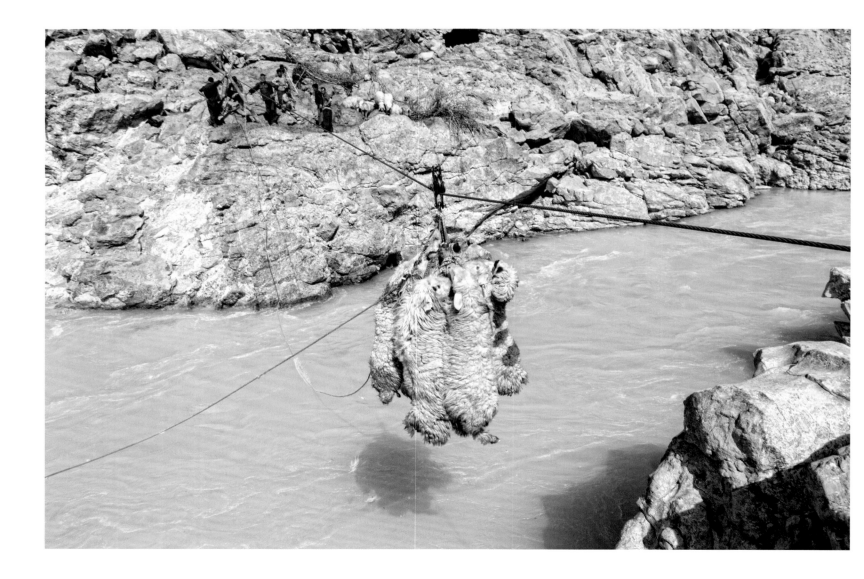

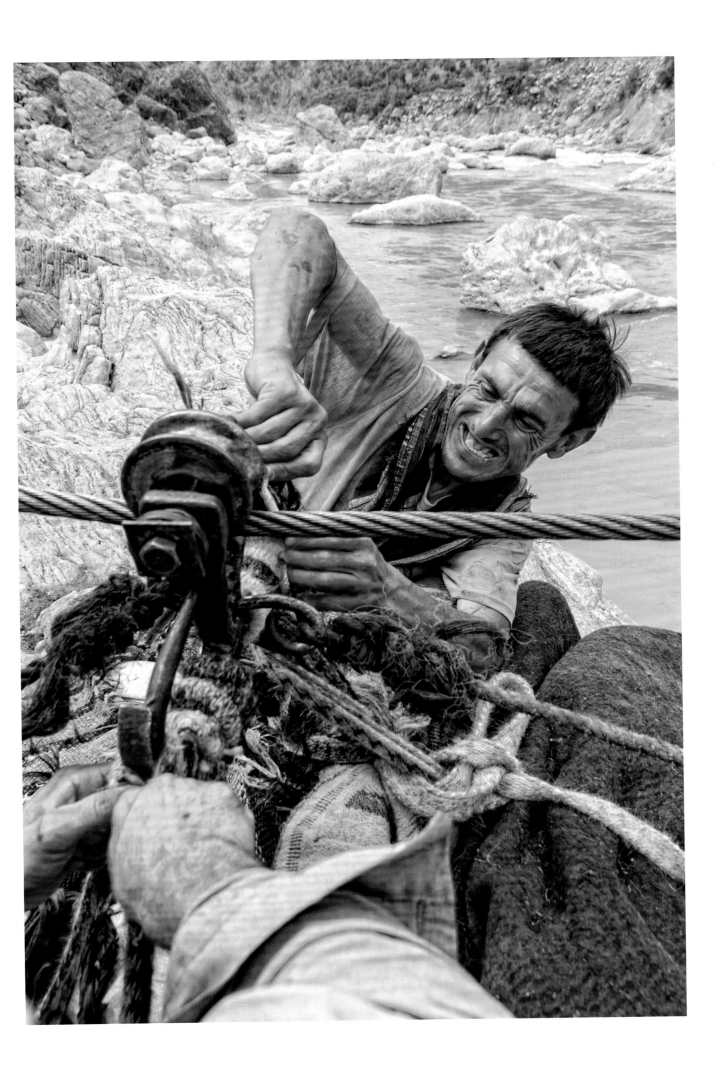

Ala'a Aldurazi, 26, is a full-time football coach working for Bahrain's Football Academy.

Long a fan of the world's most popular sport, she set up her first football team with a group of several other young women just after leaving University College of Bahrain with a degree in engineering management.

To improve the standard of her team, Ala'a started using coaching exercises she found on YouTube.

Shortly after, a small football academy invited her to work as a volunteer assistant coach, which in turn led to her taking a coaching course run by FIFA, football's world governing body.

Suitably qualified, Bahrain's Football Academy then offered her a contract to coach under-fours, making her one of the country's handful of professional female football coaches.

Photographer
HUSSAIN ALMOSAWI

Nathalie Haddad, 36, supplies healthy meals aimed at countering unhealthy eating habits that have raised obesity, diabetes and heart disease to worryingly high levels across the United Arab Emirates.

Raised in Abu Dhabi, the UAE's capital where her parents had moved to from Lebanon almost five decades ago, Nathalie worked as a dietician after studying at Lebanon's American University of Beirut and at McGill University in Canada. She set up her first business, Right Bite, in Dubai, the UAE's most populous city, in 2004, creating a menu of meals that reinvented traditional recipes using healthy ingredients and cooking techniques.

Today, Right Bite has 150 full-time staff, who between them make and deliver 2,500 meals a day to clients' homes and offices. It also runs a nutrition centre which offers counseling from dieticians and provides catering and school meal services.

From Right Bite, Nathalie has branched out into restaurants, opening Nathalie Café, a restaurant in Abu Dhabi, and Smart Bite, a "grab-and-go" retail outlet offering healthy fast-foods in Dubai. Next up is a second Nathalie Café, due to open in Dubai by the end of 2014.

Photographer
IMRAN AHMED

OBESITY

Percentage of all adults

Saudi Arabia	43
UAE	37
Jordan	33
USA	33
Egypt	30
Tunisia	12
Lebanon	11
China	6
India	2

Source: The Economist, CIA Factbook

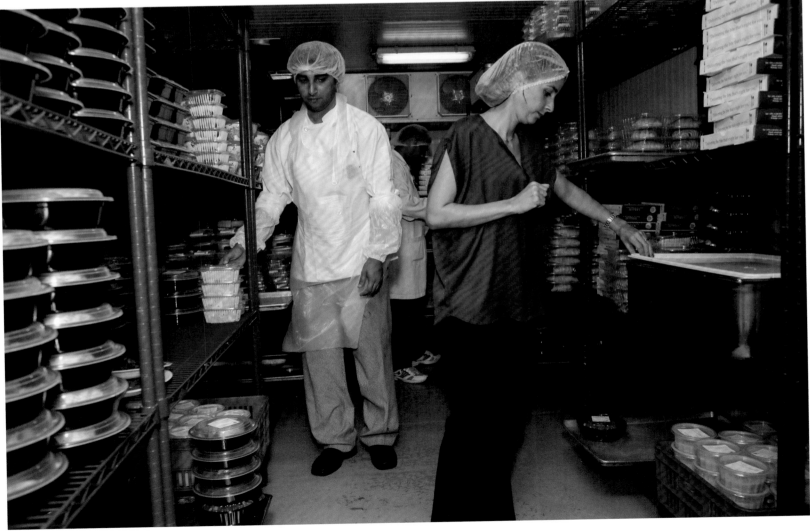

SUKKUR, PAKISTAN

For 40 years, Muhammad Arif, 62, has specialised in producing a traditional block-printed cloth known as *ajrak* in the city of Sukkur in Pakistan's southerly Sindh province.

Working with six of his ten sons and two of his grandsons, Muhammad produces up to 20 *ajraks* daily using a centuries-old production method. After first being treated with soda, the fabric, usually cotton or silk, is steamed for a day, then further processed until it acquires its distinctive light beige hue.

Finally, it is covered in intricate geometric patterns printed using carved wooden blocks and natural dyes made from local plants and minerals. The most common colours used are indigo, red, black, yellow and green.

Ajraks are an important part of Sindhi culture, used as hammocks and slings for infants, and as turbans, shawls and scarfs by adults. They are commonly presented to guests as gifts, and at funerals one is usually placed upon the deceased's casket.

Whether *ajraks* will continue to be produced in the traditional way is uncertain. Some *ajrak* makers are cutting corners by skipping stages in the production process, others are printing cheap silk-screen versions. Much will depend on the commitment of people such as Muhammad's sons and grandsons to preserve the painstaking, labourious techniques that are rooted as much in artistry as making a living.

Photographers
MUHAMMAD JAHANGIR KHAN

TEXTILE DEPENDENT

Textiles are the backbone of Pakistan's manufacturing sector. Although responsible for one-tenth of the country's GDP, they account for just under half of its manufacturing output, just over half of all its exports and for four out of ten jobs in the country.

Source: Ministry of Textiles Industry

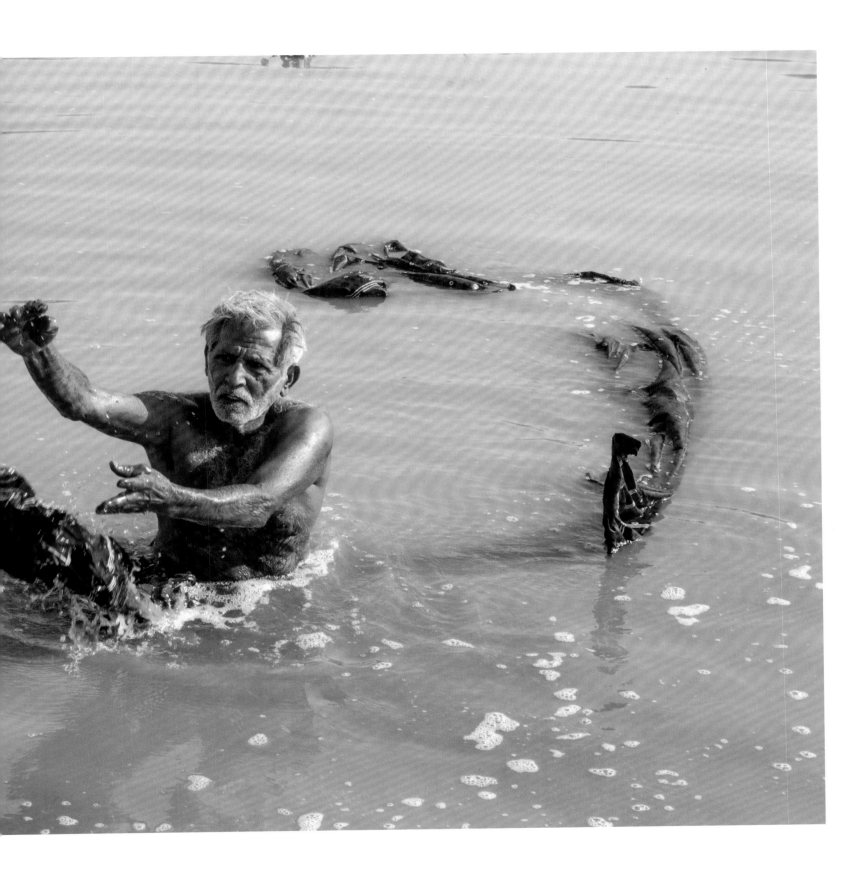

KABUL, AFGHANISTAN

Kamila Sidiqi learned tailoring and embroidery out of necessity. During Taliban rule, when women were banned from working, she helped her family survive by selling the clothing she and her sisters designed, sewed, and embroidered. By the end of the Taliban era in 2001, 150 women were receiving their salaries from Kamila. She was only 18.

After the Taliban regime fell, Kamila found work with NGOs that arrived on the heels of NATO troops, first at the International Organization for Migration and UN Habitat, and then with Mercy Corps as a business trainer.

In 2004, she saw an opportunity to launch her own business, Kaweyan, that could train people how to write business plans, create budgets and learn all the other necessary skills to start a firm of their own.

She sent out a marketing email and quickly won her first contract, a week-long training programme for illiterate women in Bamiyan province. Her second contract was to train an all-male group of senior employees in Herat. Sceptical at first, they were soon won over by Kamilas' self-confidence and knowledge.

Kaweyan now has more than 100 staff and three divisions – business development, import/export, and logistics – and has carried out 43 projects in all provinces of Afghanistan.

WORKING WOMEN

Women are starting to establish themselves as part of Afghanistan's mainstream work force, especially in Kabul, the country's capital. Currently, about one-quarter of Afghanistan's parliament and government employees are women. That share is forecast to reach 40 percent by 2020.

Source: Ministry of Women Affairs, Government of Afghanistan

Photographer
ANNA LOSHKIN

Saradedbek and his family run a local restaurant in Istaravshan, a city overlooked by hills in northern Tajikistan. Their customers include everyone from policemen to gypsies. He and his son serve the tables, taking orders and collecting money. His wife and daughter prepare the food in a tiny kitchen, helped by Ayna, 24, their kitchen hand.

Istaravshan is one of the oldest cities in the country, with a history of more than 2,500 years. But like most of Tajikistan it has yet to recover from the collapse of the Soviet Union. With average annual incomes of just US$200 per person, many of its residents have left to work illegally in Russia. Those who remain often turn to crime, such as smuggling drugs from Afghanistan, or corruption to augment their income. Happy, united families such as Saradedbek's are rare.

Photographer
KAROLINA SAMBORSKA

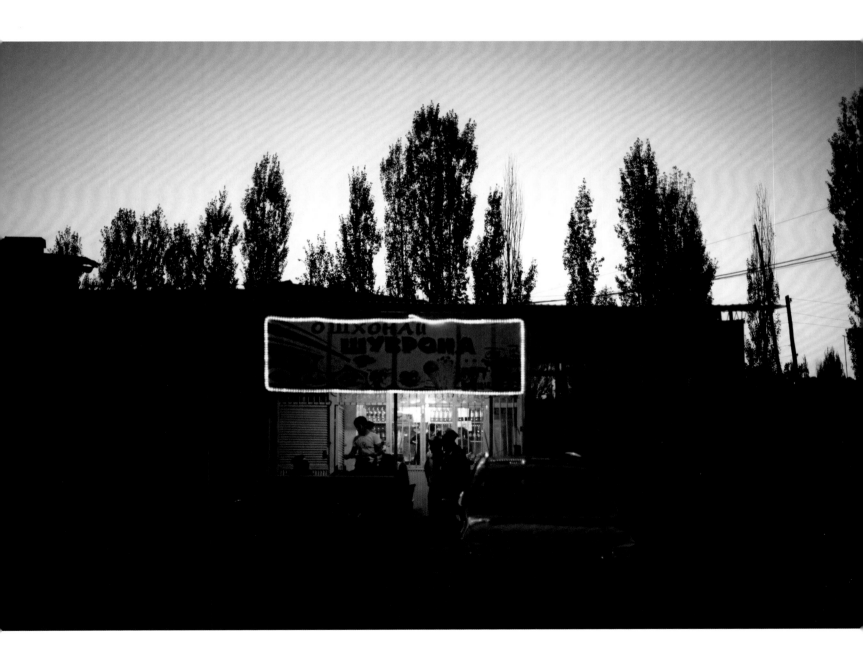

TOKMOK, KYRGYZSTAN

Sukhrab Bazarbaev, 42, is a self-employed butcher with two shops in Tokmok, a city of 50,000 people in northern Kyrgyzstan. One of the country's small Uighur minority, he sells only halal beef, though he himself is not a Muslim.

He starts work each day at 8 o'clock, cutting up several beef carcasses. He and his brother then sell his meat until 5 o'clock in the afternoon. He rents his two shops, but owns his own refrigerators and mincers.

Sukhrab started his business in 2010 after spending a year serving as an apprentice to a local butcher. Today, he earns around US$500 a month, well above the national average wage of US$200, and enough for him to take good care of his wife and two teenage sons.

Photographer
ELENA SKOCHILO

MEAT EATERS

Kg of meat eaten per person, 2011	
United States	118
Argentina	102
China	57
Kyrgyzstan	37
India	4
Source: FAO	

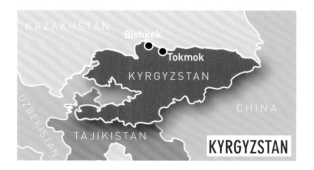

KYRGYZSTAN

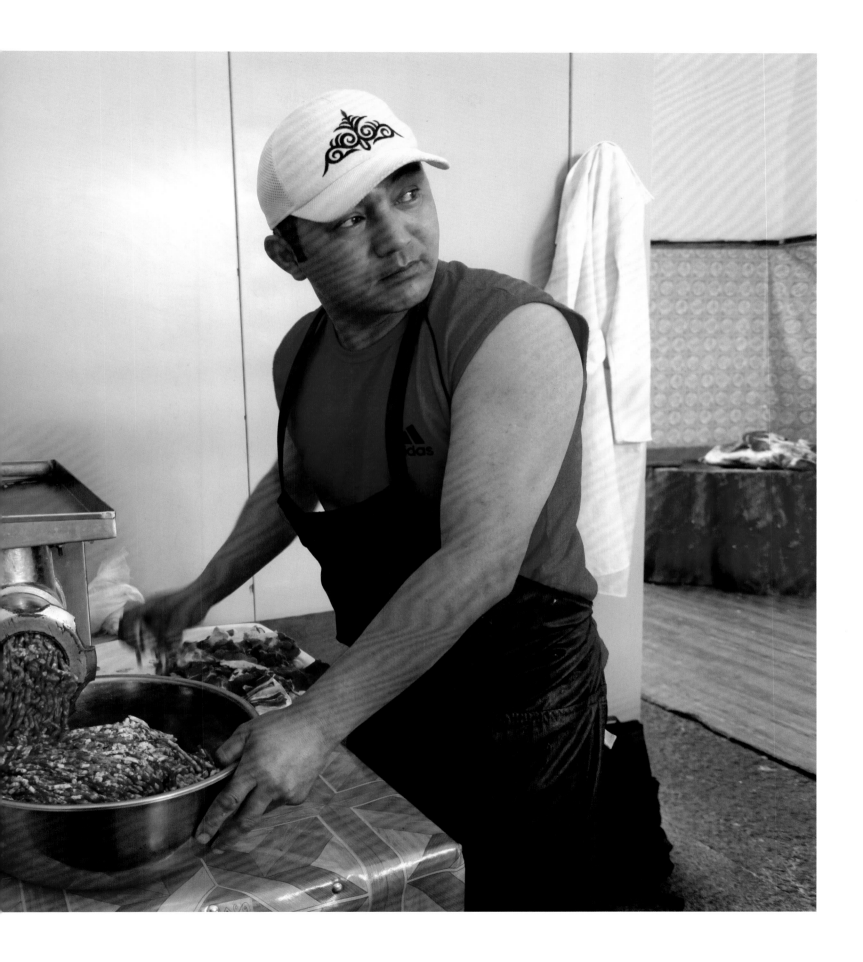

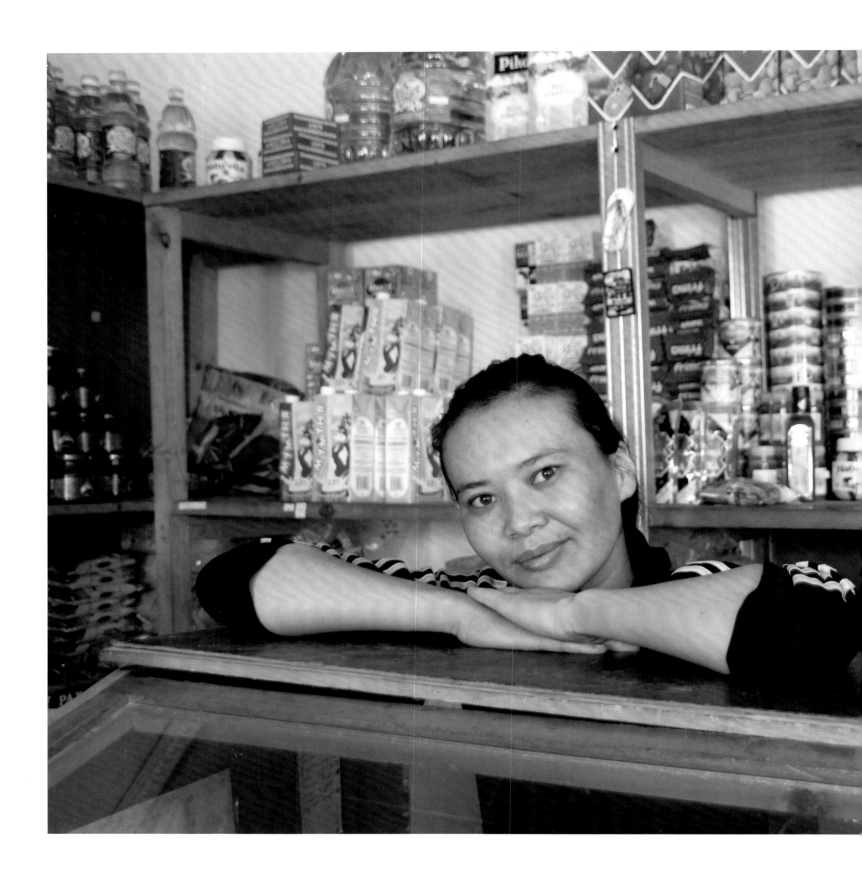

"I'm not a millionaire, but I have a happy family," says Nurgul Rysbekov, 28, who gave up the lights and bustle of Kazakhstan's largest city, Almaty, for her hometown of Kegen, where she started its first and only 24-hour convenience store – Dako, named after her sister.

Nurgul studied food technology in Almaty, but after working in a chocolate company for six months, she returned home to Kegen, a small town in south-east Kazakhstan near the border with Kyrgyzstan.

That was five years ago. Today, Nurgul and her mother, Zeena, take turns working the night shift in her shop. Her father, Nabi, a poet, helps out during the day. Her brother, Almas, is an assistant judge who eats his lunches with her in a small room next to the shop. During coffee breaks, Nurgul and her father practice shooting.

Nurgul hasn't taken a holiday since she opened her shop. "The people in the town say 'well done' to me when they see my young business," she says. "I like being busy! In the future I hope to have many businesses and many friends."

Photographer
PHILLIPPA STEWART

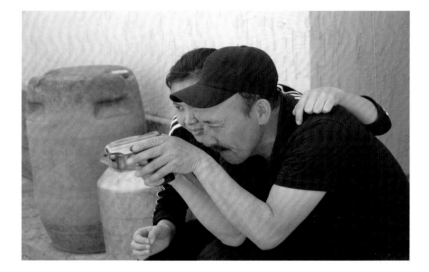

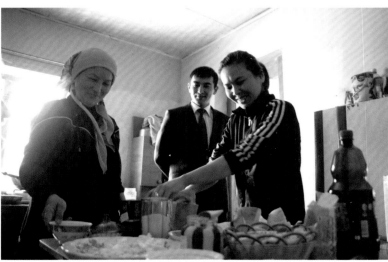

ULAANBAATAR, MONGOLIA

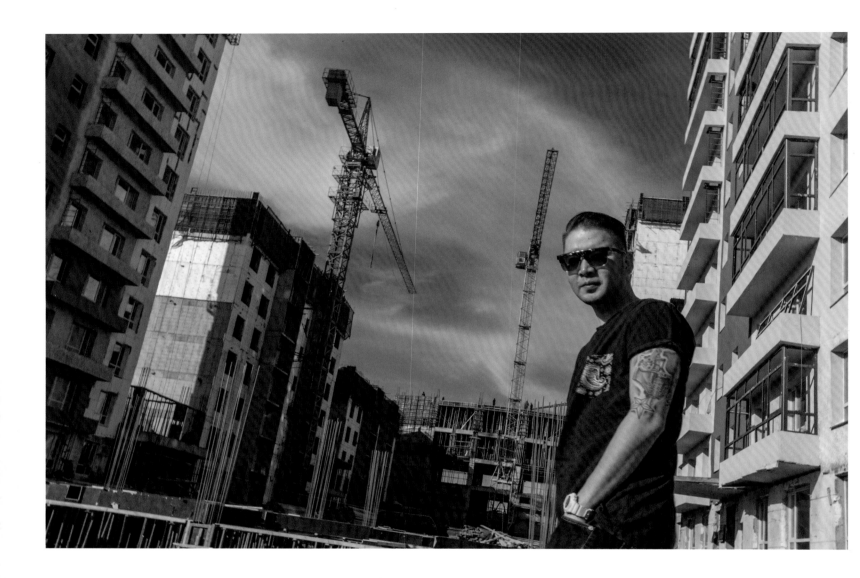

Batbilig Tungalag spent his teens and early twenties studying his way around the world, first attending high school in Moscow, then taking a degree in business administration in the United States, and finally acquiring an MBA in London.

Returning to his hometown, Ulaanbaatar, in 2008, he struggled to find work. Using US$50,000 borrowed from relatives, he set up a company supplying drill heads for use in mineral exploration. After that business briefly boomed, then collapsed, he decided to try his hand at building. Today he runs a construction firm making low-cost apartments. His target market is the hundreds of thousands of people living in the tent districts that surround the Mongolian capital.

His biggest struggle is getting hold of building materials. Big companies have a stranglehold on supplies, he says, meaning he has to import almost everything from China or Russia.

Though he claims to live a simple life, Batbilig drives a Lexus 570, a status symbol for many rich Mongolians.

TENT CITY

Despite the efforts of construction firms such as the one run by Batbilig, well more than half of Ulaanbaatar's 1.3 million people live in districts filled with gers, Mongolia's traditional round tents. Most of these residents have moved to the city in the last 15 years in search of work and better living conditions, leading to Ulaanbaatar's population rising nearly two-and-a-half-times in the last 35 years.

Source: Asia Foundation

Photographer
SVEN ZELLNER

MARKET MAKERS

An estimated two-thirds of North Korea's working population rely on their own initiative, skill or luck to make a living. Most of these people farm small-scale plots of land or run small businesses connected with the unofficial market economy. No precise statistics exist on how much they earn, but observers suggest they get by on around US$25–30 a month.

Source: nknews.org

More and more privately owned stalls have sprung up over the past few years in cities across North Korea. Some sell home-prepared foods such as dried fish, home-made lemonade and ice cream, others every-day items imported from neighbouring China.

By some accounts, since the 1990s informal markets have become the main source of income for two-thirds of the North Korean population. Even so, securing the basic necessities of life remains difficult for most North Koreans. According to the UN's World Food Programme, only 16 per economic revolution cent of households in the country of 25 million people had "acceptable food consumption" in 2013.

Photographer
OLAF SCHUELKE

A street-side ice-cream vendor in Pyongyang, the capital of North Korea. Her ice cream, apparently made from milk, sugar and water, had little flavour other than sweetness.

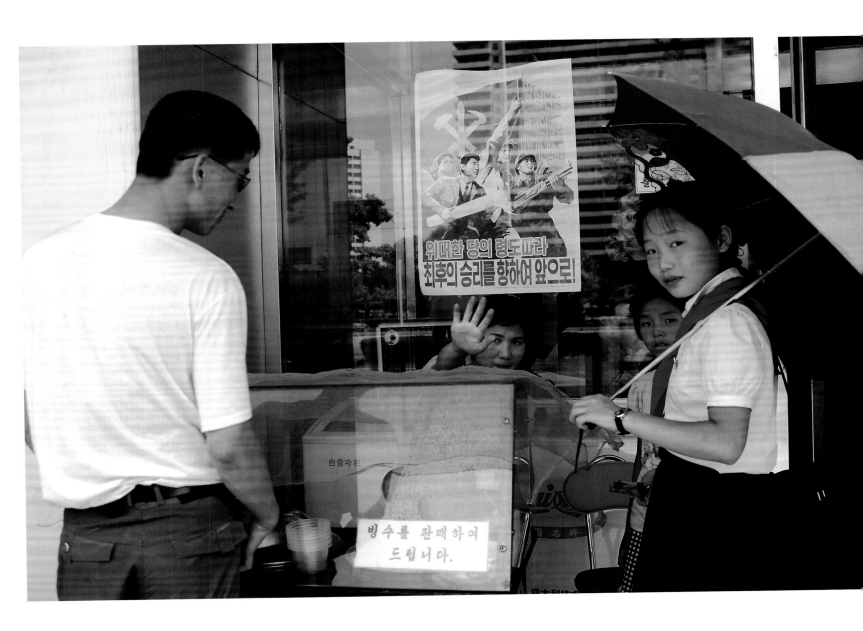

SEOUL, SOUTH KOREA

Until the early 1990s only a handful of North Koreans found their way to the South each year. But the terrible famine that began in the middle of that decade saw hundreds of thousands of people start streaming across the border into north-east China. Many were returned by the Chinese authorities, but a total of around 26,000 found their way – usually via Mongolia or south-east Asia – to South Korea.

For many of these arrivees, dreams of prosperity in the South have yet to materialise. Work can be hard to find, and setting up a business can be an intimidating prospect for anyone raised in a country where the state is expected to deliver cradle-to-grave support. But a few, helped by a growing network of support organisations, are succeeding in starting out on their own.

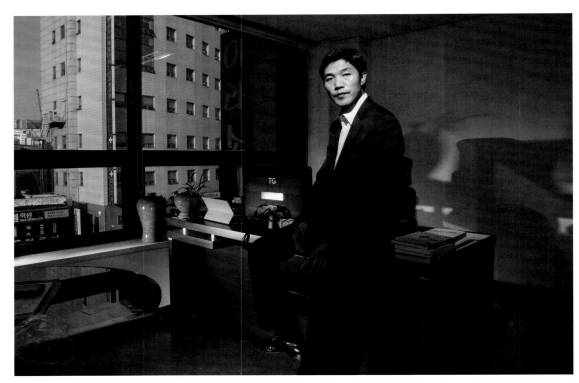

01

NORTH KOREAN REFUGEES ENTERING SOUTH KOREA

Since the end of Korean war in 1953, some 26,000 North Koreans have found their way to South Korea, almost all of them since the mid-1990s.

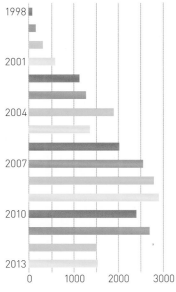

Source: South Korean government

02

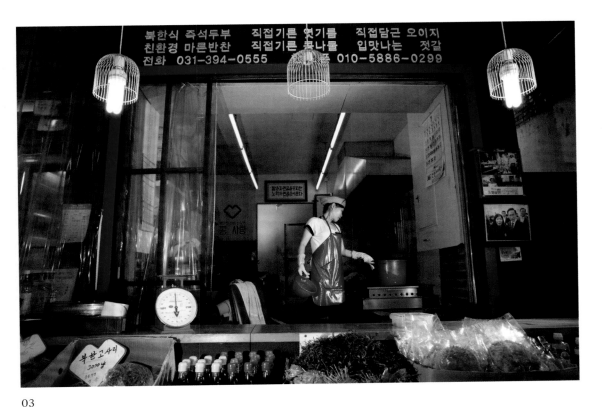

03

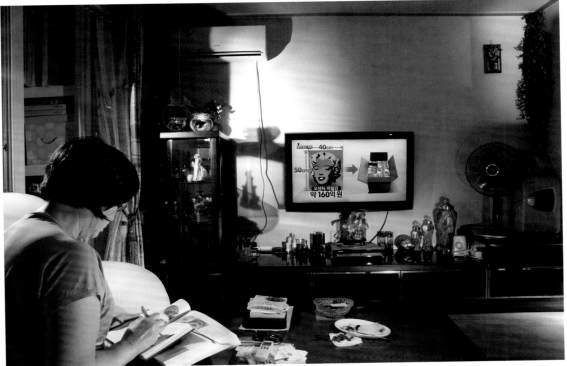

04

01 Kim Daesung is chief executive of Working North Korea Refugees, a micro-finance institution that provides seed financing and mentoring to would-be entrepreneurs from the North. Since founding the organisation in 2008, he has extended loans worth US$1.8 million to 43 businesses run by refugees.

02 Park Jina, 37, opened a traditional medicine clinic with support from Working North Korea Refugees. A hospital doctor before she fled to South Korean, she still speaks proudly of the standard of medical treatment in the North: "South Korean media describe North Korean medical quality as being very low, but it's not true. We may not have had cutting-edge technology but the quality of care was quite high."

03 Park So-yeon, who left North Korea in 2002, makes and sells traditional food. In a photograph hanging at the front of her small shop she appears smiling alongside then South Korean president Lee Myung-bak, whom she met at a small business owners' forum in 2013.

04 Kim Na-yong is preparing to open a cookery school in Cheongju, a town in central South Korea. During her first attempts to prepare non-Korean food, she discovered that North Korea's isolation from the rest of the world had left her with some areas of ignorance. "When I looked at recipes with things like butter, cheese and mayonnaise, I didn't know what these things were," she says. "I went to the supermarket and tried to figure it out."

163

TOKYO, JAPAN

Kanako Iwase is the founder and owner of Arusha, a Tokyo nail salon that trains and employs refugees as manicurists.

Her first brush with social entrepreneurship came as a student when she worked as a volunteer helping people cope with the aftermath of the Kobe earthquake in 1995.

Several years later, in 2008, she almost joined a micro-finance programme in Tanzania organised by Sumiko Iwao, a psychology professor at Tokyo's Keio University.

Although that fell through, it led her to decide to leave her job at an international executive search firm and set up Arusha in 2010, naming it in honour of the Tanzanian city that hosts Sumiko Iwao's micro-finance project.

Kanako decided on the nail salon format partly because of her own liking for nail art and partly because it seemed like a good way to offer work to people who were good with their hands but had limited language skills.

Today, Arusha employs manicurists from Myanmar, China and the Philippines, and an assistant from Peru.

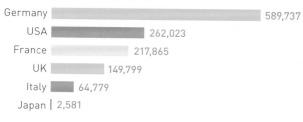

PLACES OF ASYLUM

Refugee population, 2012

Country	Population
Germany	589,737
USA	262,023
France	217,865
UK	149,799
Italy	64,779
Japan	2,581

Source: World Bank

Photographer
KAZUHIRO YOKOZEKI

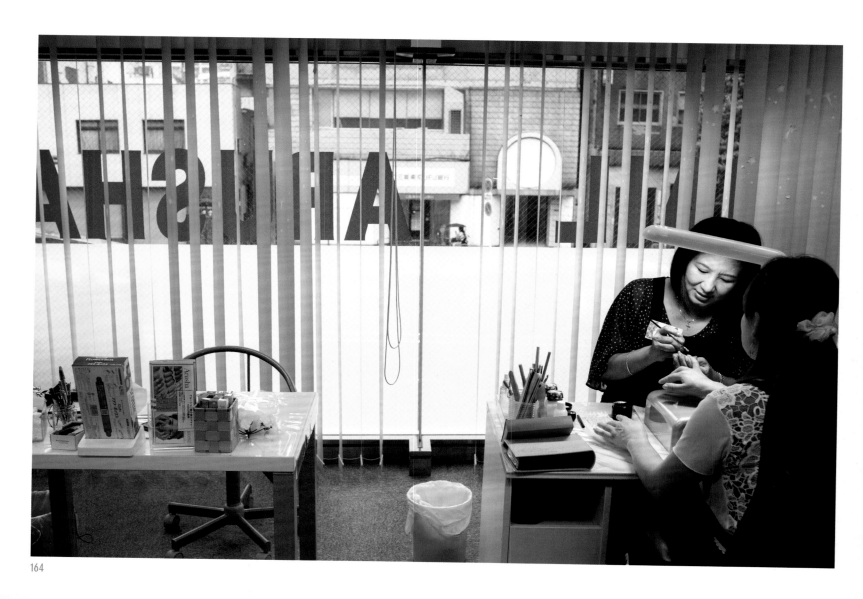

DIGITALLY RELEASED

Huang Wenhai

DIGITALLY RELEASED

Huang Wenhai

Looking through the pictures of this book, I was struck by a number of conflicting thoughts.

The first picture that stood out was that of the house painters in Kolkata: a group of men, suspended by ropes, with zero safety equipment, risking their own lives each day as they made their living. That's how I feel when I'm making a film – swinging around, with no safety net, never sure whether I am quite going to make it to the end.

Then I started seeing elegies – portraits of trades that modern society has gradually reduced to dwindling vestiges, such as the portrait of Ma Xiancheng, a shoe repairer in Gansu. A few years ago, such figures were a common sight across China; now they are becoming rarer and rarer.

But in their place come other sights. A few years ago I worked on a film called Passage that showed huge machines cutting their way through a mountain with the same ease that a butcher cleaves his way through a hunk of fatty pork. I was reminded of a story Mao Zedong once told, of a supposedly foolish old man whose view was blocked by a pair of great peaks. One day, the man started digging away, determined that eventually his home would enjoy an unencumbered view. Challenged by a "wise" neighbour, who pointed out the futility of his task, the man replied: "I will dig, my sons will dig, their sons will dig – and eventually the mountains will be gone."

Mao's moral was that given the right commitment, anything was possible. Seventy years since telling his tale, however, we have other means – technological ones – of realising that foolish old man's goal. The present reality of China and its era of "economic revolution" losses can be lamented mean that events that recently would have been regarded as miraculous now are part of daily life, so much so that they need to be filmed if they are not to be overlooked.

Such losses and changes are often greeted with ambivalence. Technology has brought us greater power to tame nature and ease our daily lives, but at a cost of distancing ourselves from the world or devaluing the work of once skilled craftspeople. In my own case, however, it has proved not just a tool of creative liberation, but an avenue opening up new ways of thinking.

Independent film-makers, even those living under authoritarian regimes can now create works single-handedly thanks to the emergence of digital video recorders. No longer tied to the need to travel and film with a large crew of technicians and support staff, we have joined the ranks of entrepreneurs – people able to take risks in our pursuit of new impressions, images and ideas.

The flip side of this empowerment, however, is greater responsibility. I can't speak on behalf of others, but I can say what this means for film-makers – particularly in term of their general outlook. Up to now, film-makers have tended to be romantic, possibly because of the need to meet the wider needs of any film organisation, to produce work that must appeal to a broad audience in order to recover its costs.

Now, however, we have the means to concentrate on capturing the essence of a scene unmediated by others.

Film-makers are now entrepreneurs, able to take risks in pursuit of new impressions, images and ideas

I was struck at the possibilities this opens up when filming at 3,500 metres above sea level in Yunnan. The mountain scenery was spectacular, but my subject – local villagers – filled me with dread. No doubt as a result of long "education", I had long believed that city dwellers, such as myself, and country folk were inseparably divided. I lay on a mound of earth, immediately next to people planting potatoes. The wind whipped up layers of dust that assaulted me in waves until my mouth, nose and body were so full of soil I seemed to have grown from it. The distance between town and country vanished.

Is working like that entrepreneurial? I think so. No one has ever been able to film like this before; the techniques are new, the outcome is unknown, and there are no guarantees of success. I think again of those house painters swinging on their ropes in Kolkata.

Another question I ask myself is whether intellectuals and artists can move forward when they live under an authoritarian regime. Traditionally, people like me have discussed their condition in terms of being spiritually "shackled" – and so maintained that the only valid form of existence was wholehearted mental resistance. This resulted in a tendency to create works of moral superiority in which one's willingness to confront any subject showed your courage and conscience. The outcome was a "gratifying" experience, because one had acquired an "awareness" of why you were like the way you were, which in turn led to a certain complacency.

Today, however, freed from a reliance on having to work as part of large organisations, film-makers and other artists have the means to liberate themselves by venturing out alone, testing new ideas, abandoning old ones. Like entrepreneurs in any business, we can never be complacent.

Of course, one has to start from an awareness of your limitations, but being an entrepreneur also allows you to use your resources to grow and develop as a person. With the tools of digital video recorders, those concerns can be replaced with more practical ones. If you can make a film anywhere, then the only limits are those you impose on yourself. At last – at least in my profession – film can liberate the mind.

Translated by *Stacy Mosher*

Raymond Lun runs his fashion store on Haven Street, a quiet back street just a few hundred metres from the heart of Causeway Bay, one of Hong Kong's busiest shopping districts. A fashion designer and tailor, after graduating from fashion design school, he worked with a local tailor for six years, then went and lived in Australia for a year.

Returning to his hometown five years ago, he decided to launch his own brand of tailor-made suits and leather shoes for men. The first several months were tough for a "no-name" fashion designer, but slowly his designs and craftsmanship attracted recognition. Now in his mid-30s, his clients include a handful of local celebrities and performing artists.

Photographer
LEO KWOK

Who wouldn't want to work at internet search company Baidu, China's answer to Google? Song Xin and Luo Gaojing for two, both of whom quit jobs as finance officers to open a snack shop just around the corner from their old office in north-west Beijing's Wudaokou district.

After mastering the art of making the perfect roujiamo – a kind of meat sandwich based on a traditional snack from Shaanxi, a province 800 kilometres south-west of the Chinese capital – they started testing it on the same people they had once worked with. It was an instant hit, and within a few weeks their shop had become the must-visit place for local IT workers looking for a filling snack.

Song and Xin have now opened a second shop in Beijing, and already have plans to build a nation-wide chain within a few years.

Photographer
ROBIN MAS

TOMORROW'S CHINA

Chinese undergraduates studying, percent

Science & engineering	43
Humanities	25
Management	19
Medicine	7
Law	4
Agriculture	2

Source: National Bureau of Statistics

XIAHE COUNTY, GANSU, CHINA

Ma Xiancheng, 66, has worked at the entrance to Labrang Monastery in Gansu's Xiahe County in west China for more than 30 years. Arriving each day at eight o'clock in the morning, he stays at his stall, repairing boots and shoes for monks and other people living nearby, until six o'clock in the evening.

Labrang Monastery, founded in 1709, is one of Tibetan Buddhism's most important monasteries outside Tibet. At its heyday, it had more than 4,000 monks. After being forced to close during China's Cultural Revolution, it reopened in 1980, and is now home to 1,500 monks.

Photographer
TASHI DORJEE

TIBETAN BOOTS

Tibetan boots come in three main varieties: made of leather, corduroy or a kind of woollen felt known as pulu. There is almost no difference between boots for women and for men, nor between those for the left foot and those for the right.

To make putting them on and taking them off easier, most boots have a ten-centimetre-long split at the back. Their soles, two to three centimetres thick, typically comprise between five and seven layers of leather. Corduroy boots, like those pictured, are usually black edged with red cloth, whereas pulu boots usually have different coloured felt on the top of the foot and up the leg, often adorned with traditional embroidery.

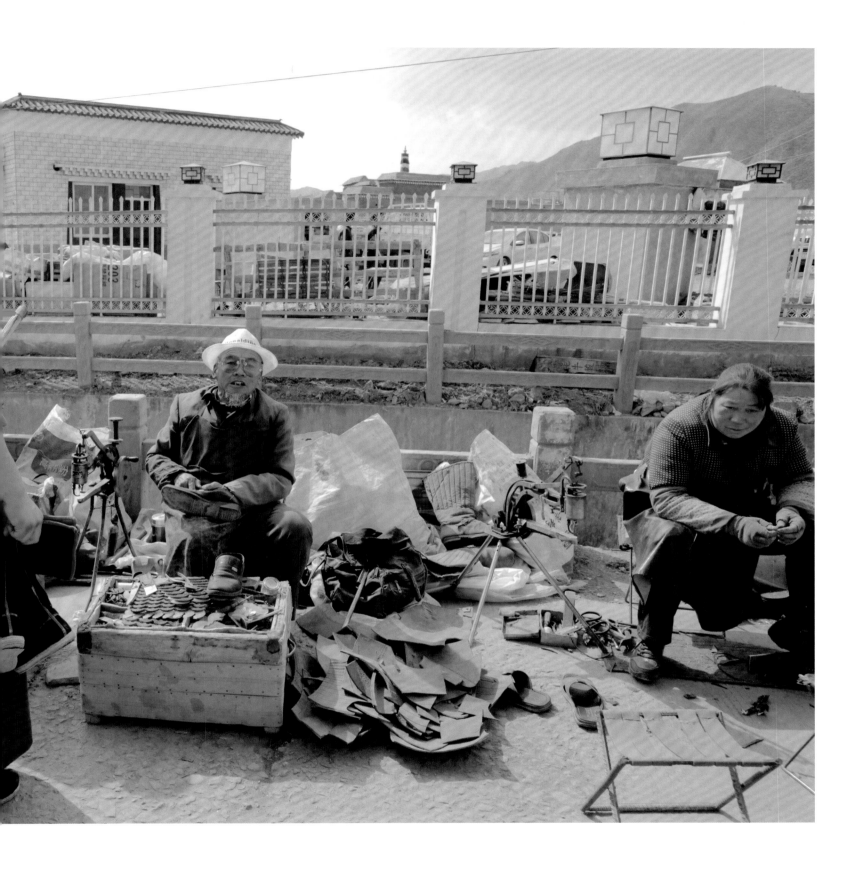

KATHMANDU, NEPAL

Ever since he was a student at Kathmandu Engineering College, Amrit Singh Thapa has believed wind energy could hold the key to overcoming the power blackouts that daily hit Kathmandu, the Nepalese capital.

To help come up with answers, he set up Eenergys.com, a business that supplies and installs windpower transformers and related equipment. But he admits making progress in Nepal – despite the country's need for power – is a struggle.

"My experience is very limited, but there is no one else with even my experience in Nepal. I have to manage and tackle everything," he says.

Photographer
ROBERT VAN WAARDEN

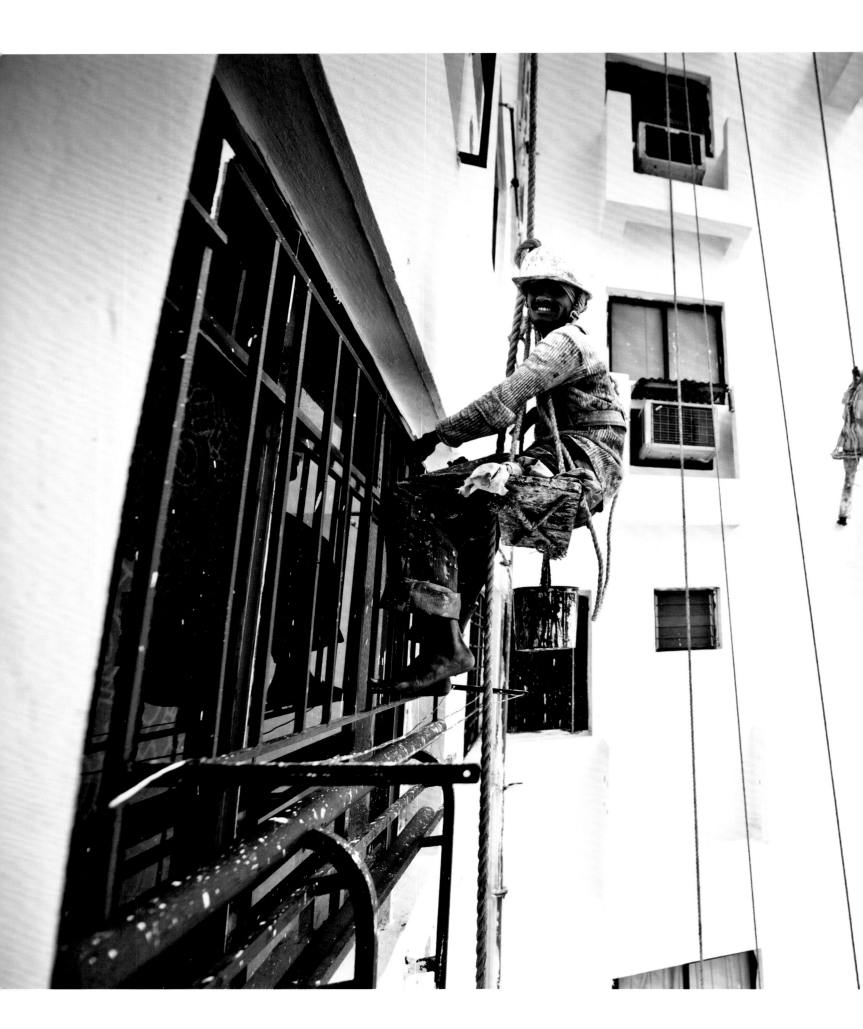

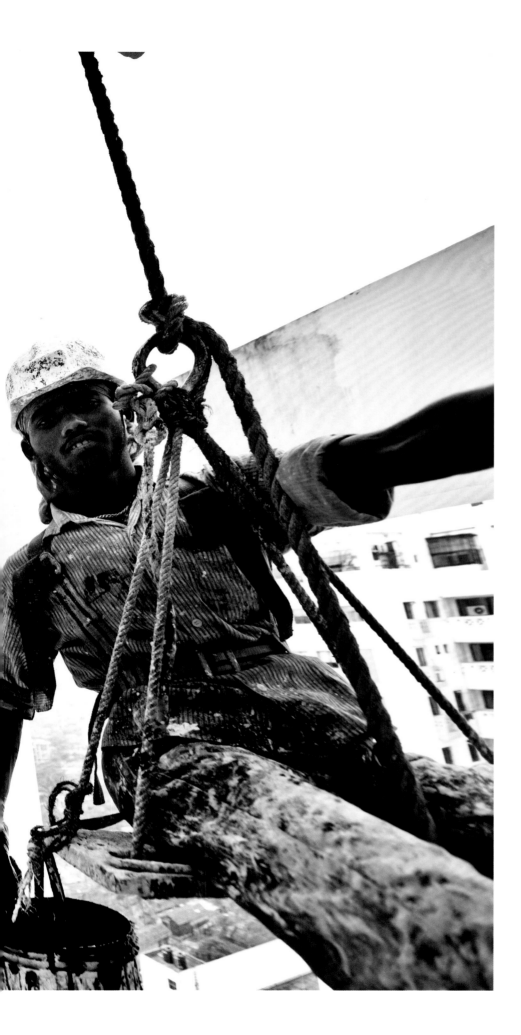

Avid Kumar runs a four-person business painting the exteriors of high-rise towers in Kolkata, the capital of India's West Bengal state. Painting a building typically earns him around 10,000 rupees (US$160), far more than he could earn by taking on many smaller projects. Even so, he cannot afford proper safety equipment for himself and his team.

Avid was born in Kolkata after his parents moved there from Bihar state, West Bengal's western neighbour. He was raised and still lives in one of the city's many slum districts. His first job was carrying live chickens to a market on a bicycle. But as the rising popularity of Western-style supermarkets cut demand at the market, he switched to painting when he was 19. Although he relies on his personal connections with staff at the huge property companies that manage the blocks, his biggest worry is getting paid on time.

Photographer
DRIPTA GUHA ROY

INDIA'S BIG SWITCH

Avid and his team should not be short of work in the coming years. India's urban population is set to grow by between 250 million and 300 million people from 2012 to 2032. That is the equivalent of more than 20 Kolkatas – and housing everyone will call for at least half a million new tower blocks.

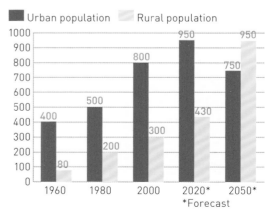

Urban population Rural population

Year	1960	1980	2000	2020*	2050*
Urban population	400	500	800	950	750
Rural population	80	200	300	430	950

*Forecast

Source: IBM, The Economist

Manshuk Lal Prajapati, 48, has built a career in the west Indian city of Wankaner making household appliances and kitchen goods from clay.

Since starting his business in 1989 with an experimental clay pan, he has added one product after another, so that today he runs a factory with annual turnover of US$75,000 and a staff of more than 35 people.

By far his most successful product is an electricity-free fridge. This works according to the simple scientific principle that evaporation causes cooling: as water placed in its top, bottom and sides turns to vapour, the contents inside remain eight degrees cooler than room temperature. Vegetables stored inside these fridges remain fresh for more than four days, and milk for two days.

Priced at just over 3,000 rupees – about US$50 – Manshuk has so far sold more than 9,000 of his fridges in India.

Photographer
SANJAY AUSTA

UNCOOL

India is the world's largest milk producer and its second-largest producer of fruits and vegetables. But much of this food is wasted. An estimated 18 percent of the country's total output of fruit, vegetables and other fresh produce is thrown away at or before the point of sale due to a lack of refrigerated transport and cold storage facilities.

Source: Saumitra Chaudhuri Committee Planning Commission

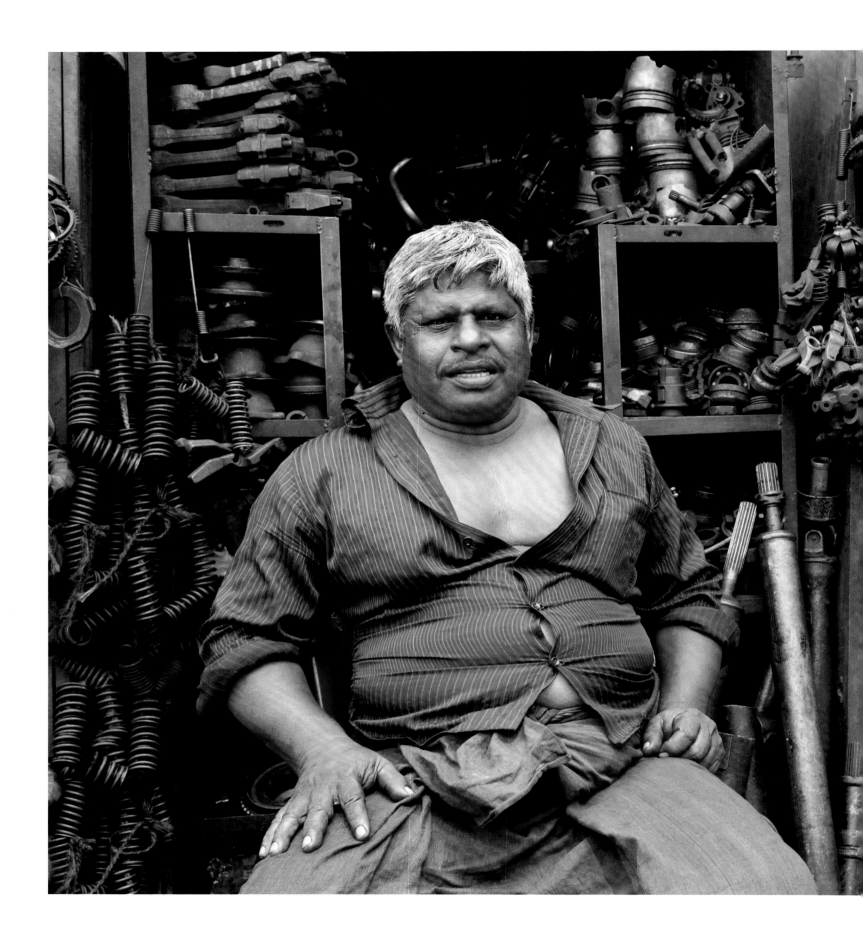

More than a quarter of a century ago, Kum Piyaratne started his pavement business selling cogs and spare car parts in exactly the same spot he occupies today.

Back then, in the late 1980s, he had seen that the number of imported cars, trucks, three wheelers and motorbikes on the streets of Colombo, the Sri Lankan capital, was rising fast. Spotting an opportunity, he borrowed 100,000 rupees – about US$1,000 at the time – from his family and starting buying secondhand and reconditioned cogs, bolts, shafts, springs and other parts.

Since then he has extended his range to include expensive imported components. Sales patter has also become a part of his repertoire of skills. "The parts don't sell themselves," he says. On a good day he will make more than US$20; but on bad ones – "It's hard to even make one sale."

Photographer
BRETT DAVIES

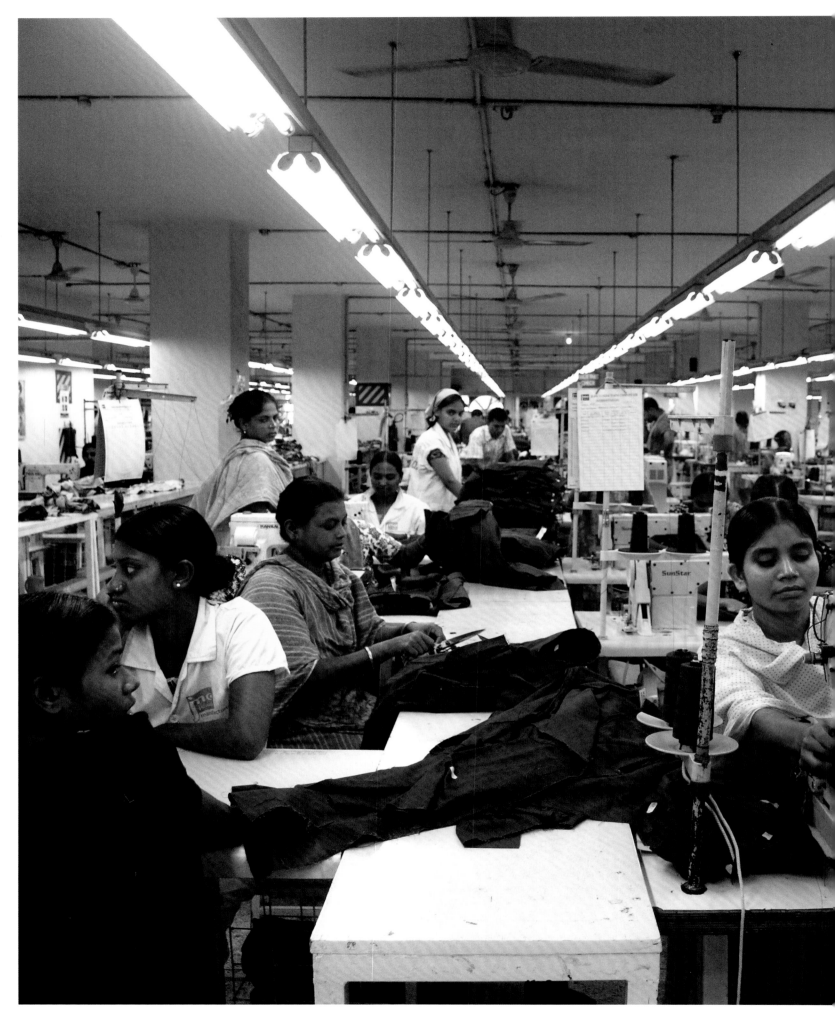

Yameen Rahim, 45, owns Jeans Manufacturing, a company that makes denim clothing for export to Europe, Africa, North America and Asia at a factory in north-east Dhaka's Mirpur district.

Yameen's father set up the company in 1997 with 20 sewing machines. It now has 1,280 machines and 4,500 staff, 3,200 of them women. Yameen's two main goals are increasing the size of his work force to 10,000 people and making his business a role model for other Bangladeshi garment makers.

He started working at the company after studying at universities in the United States and Thailand. Married with two children, he relaxes at gatherings with his family and friends that frequently run late into the night.

Photographer
MOHAMMAD ANISUL HOQUE

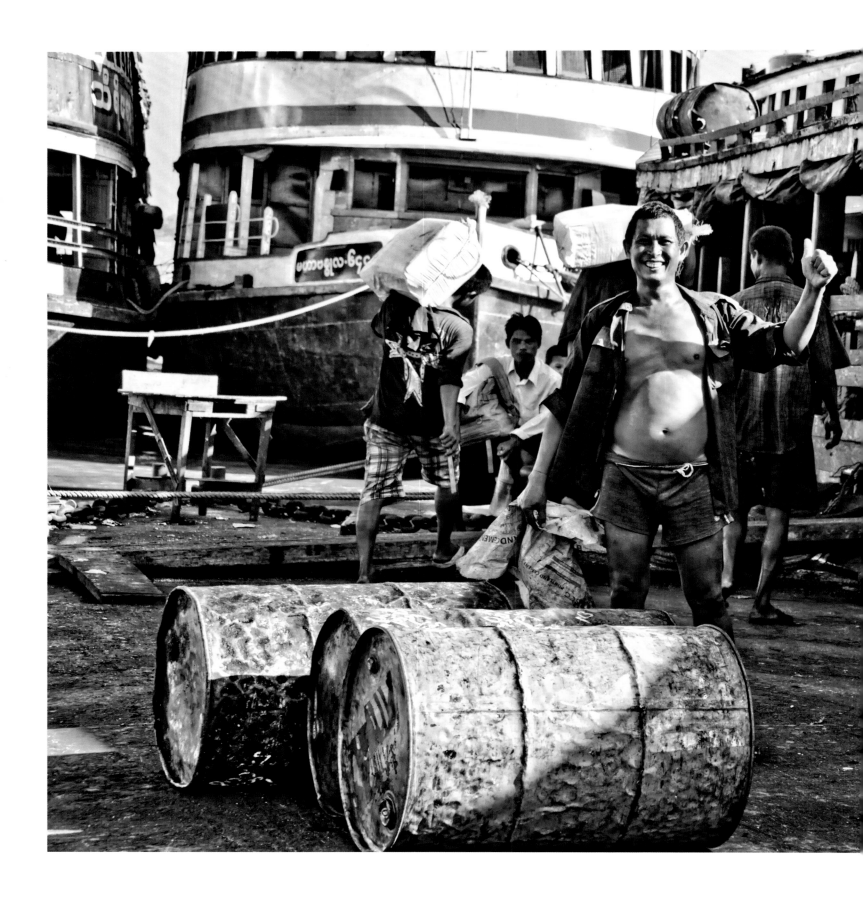

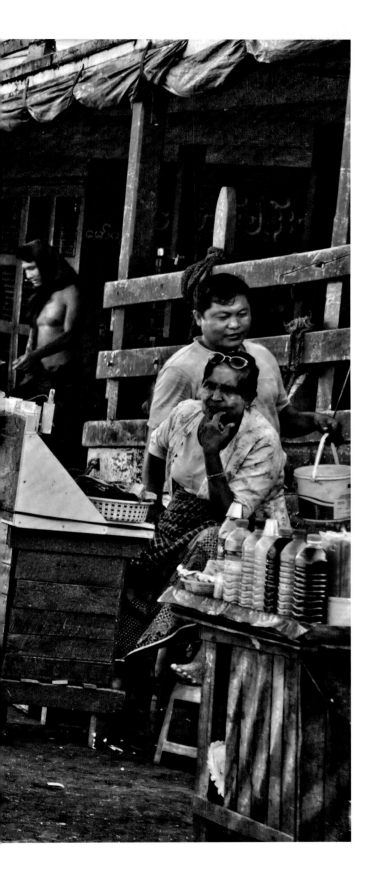

As Myanmar opens to the world, companies from neighbouring countries are setting up branches across the country. Ever more goods are flowing into the country, most of them carried on Myanmar's major waterways.

Kai, who two years ago struggled to make a living selling transport tickets, today runs a business helping truck drivers and boat owners load and unload their cargoes of flour, rice, cement and oil drums. Working ten hours daily with his four staff, his dream is to buy his own truck – a second-hand Tata transporter that he can use to move goods by expressway from Yangon, the Myanmar capital, to Mandalay, the economic hub of the country's north.

Already he has found a mechanic to keep his truck maintained, and his thirteen-year-old son is studying English so he can help his father deal with foreign customers.

Photographer
MICHAEL HEECK

MYANMAR'S WATERWAYS

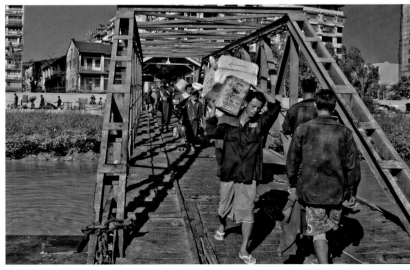

HANOI, VIETNAM

Every year, more than three million babies die in their first month of life. Most of these deaths could be prevented if appropriate technologies were available in the hospitals of the world's poorest countries.

Trying to make this happen is Nga Trang Tuyet, the founder of Medical Technology Transfer and Services (MTTS).

After spending a year studying in Denmark in 2003, Nga returned home to Vietnam imagining a world where every infant, no matter where they were born, had an equal chance for a healthy life. Assembling an international team of specialists in biomedicine, mechanics, electronics and industrial design, she tasked them with adapting developed world medical equipment and practices to meet the needs of treating the most common problems affecting newborn babies at hospitals and clinics in developing countries.

Twelve years later, the outcome is MTTS's range of low-cost, high-quality neonatal intensive care equipment. All made in Hanoi using readily available materials and parts, the machines are durable, easy to use, and do not require expensive materials. Installed in more than 250 hospitals, MTTS equipment has so far been used to treat more than three-quarters of a million babies suffering from infant respiratory distress system, jaundice or hypothermia.

Photographer
GREGORY DAJER

WORLD INFANT MORTALITY RATES

Deaths per 1000 live births

■ 100-175 ■ 50-100 ■ 10-50 ▫ 1-10

Source: Unicef

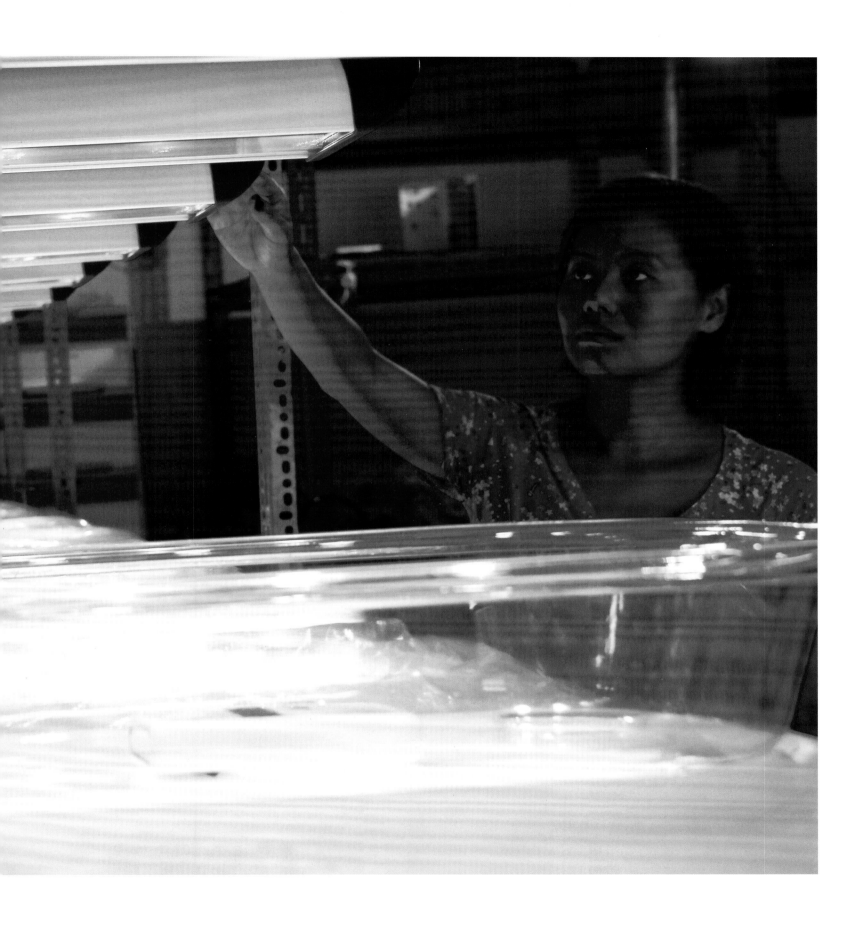

LUANG PRABANG, LAOS

When Jonlay Boriboon was growing up, Laos was largely closed off from the outside world. Even as late as the early 1990s, he was the only person in Luang Prabang, his home city in the country's north-west, with a computer, while his wife's mother owned the only restaurant.

Since the country's opening up to the outside world from mid-1990s onwards, and in particular since Luang Prabang was named a Unesco World Heritage site in 1995 because of its many Buddhist temples and monasteries, he has turned his background in carving and as an art teacher into a thriving local business.

After starting a printing firm, he branched out into design and invested in embroidery machines. Today, he works on a range of projects, most of them mixing older, traditional techniques with modern approaches. As well as continuing to make traditional wooden signs, he also helps other local businesses get started and advises foreign investors on how to find their way through the labyrinth of paperwork local officials are so fond of.

Photographer
ADRI BERGER

NEIGHBOURLY NUMBERS

GDP per capita, 2013	
Cambodia	3,000
Laos	4,800
Vietnam	5,300
Thailand	14,400
Singapore	78,700

Source: World Bank

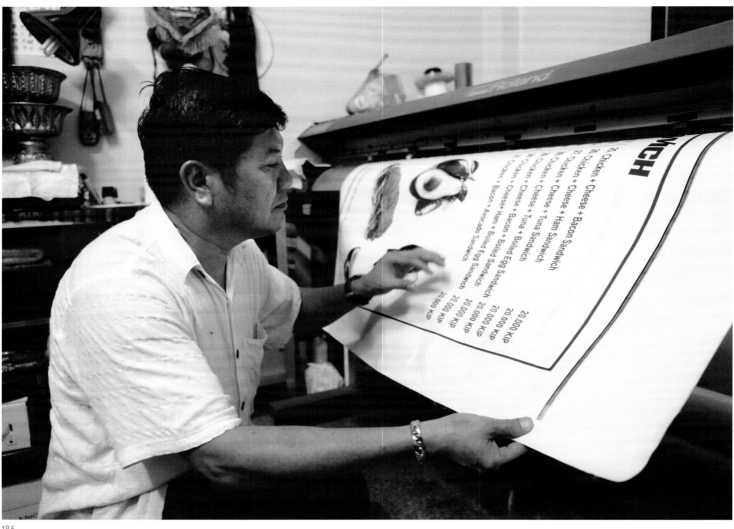

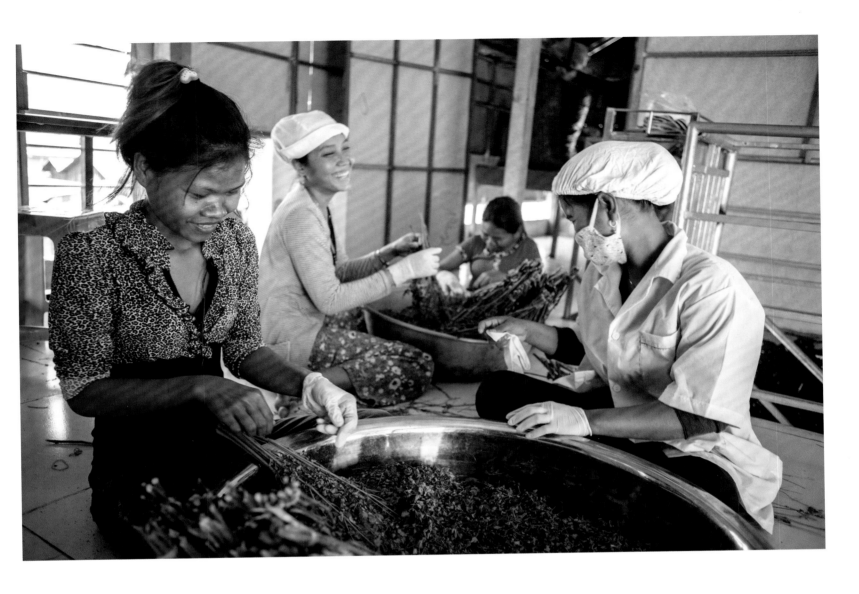

For the last five years, Vanna Ung has run a business collecting and preparing moringa leaves in Phnom Penh, the capital of Cambodia.

Previously a high-school teacher, she set up her business after taking part in a series of workshops organised by the Cambodian Center for Study and Development in Agriculture, a body founded in 1997 to promote ecologically sound agriculture.

Today, Vanna has eight people working for her, buying fresh leaves from farmers, drying them in her workshop and then making them into a powder which is sold in organic food stores in Phnom Penh and other Cambodian cities and towns.

The moringa tree is believed to have originated in India. It is now grown in tropical and sub-tropical regions around the world. Its leaves are rich in nutrients, and when dried can be added to everything from soups to smoothies.

MORINGA oleifera.

Photographer
THOMAS ROMMEL

BANGKOK, THAILAND

Nott Vachira Tongrow is the founder of If I Were a Carpenter, a Bangkok-based maker of hand-made furniture.

Born in Thailand, he grew up and went to high school in Australia and then went to London to study graphic design at Chelsea College of Art and Design.

He fell in love with carpentry after a friend asked him to help out with an interior design project for a wood-work shop, taking a wardrobe to pieces then reassembling it into a new form.

After returning to Thailand in 2011, Nott set up his own wood workshop in his garage and started to teach himself carpentry from the internet, books and other carpenters.

Finally, confident in his skills, in 2013 he opened a showroom selling his work in Ekkamai, an upmarket district of Bangkok.

Photographer
LEK KIATSIRIKAJORN

Lee Sheng Chow, 60, is a blind athlete and massage-business owner in Kuala Lumpur, the capital of Malaysia. His vision started deteriorating when he was 12; by the time he was 21 he was blind. Helped by a group of fellow blind people, he overcame a long period of depression by studying for school exams and supporting himself by selling insurance and biscuits.

In 1983, after learning Chinese traditional massage techniques, he used savings from his work to open a massage business in Kuala Lumpur's Brickfields neighbourhood. That business has kept growing, and Lee now employs 30 other blind masseurs.

As a shot putter and discus thrower, Lee has taken part in a host of local and international games, among them the 2006 Far East and South Pacific Games for the Disabled in Kuala Lumpur, where he won two gold and one silver medals, and the paralympics in Seoul in 1988, Barcelona in 1992, Atlanta in 1996 and Sydney in 2000. His national shot-put record of more than 12 metres has remained unbeaten since 1983.

Every morning, Lee does body lifts, pushups and other exercises for between one and two hours at a gym near his work place. Twice a week a friend drives him to a stadium where he goes running.

BLINDNESS AROUND THE WORLD

Million people	
China	8.2
India	8.1
Africa	5.9
Eastern Mediterranean	4.9
South & South-east Asia	4.0
America	3.2
Europe	2.7
East Asia & Western Pacific	2.3
World total	39.4

Source: World Health Organisation

Photographer
NAFISE MOTLAQ

ORCHARD ROAD, SINGAPORE

Allan Lim, 42, is the founder of Comcrop, an urban farm spread across a 6,000-square-foot roof-top on Singapore's downtown Orchard Road.

Comcrop, a social enterprise, uses "aquaponics" – a system of hydroponics – the process of growing plants in sand, gravel, or liquid with the use of nutrients – that uses broken down bio-waste from fish and aims at recreating the eco-system of a freshwater lake.

The farm's output includes a range of herbs and vegetables, including basil, peppermint, spearmint, and several varieties of tomatoes.

Allan, who is also CEO and co-founder of Alpha Biofuels, a bio-diesel business, and co-founder of The Living! Project, a collective of artists, social innovators and designers graduated from Singapore's Nanyang Technological University in 1999 with a degree in engineering.

Comcrop's staff include two young Singaporeans, one a recent graduate and another about to begin her university studies, helped by a group of local senior citizens who help with harvesting and packing.

Photographer
RICHARD KOH

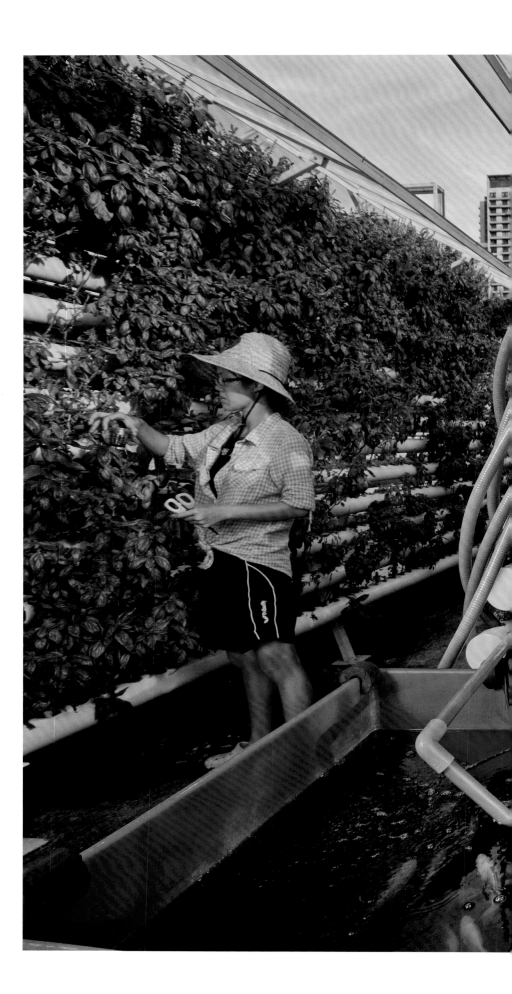

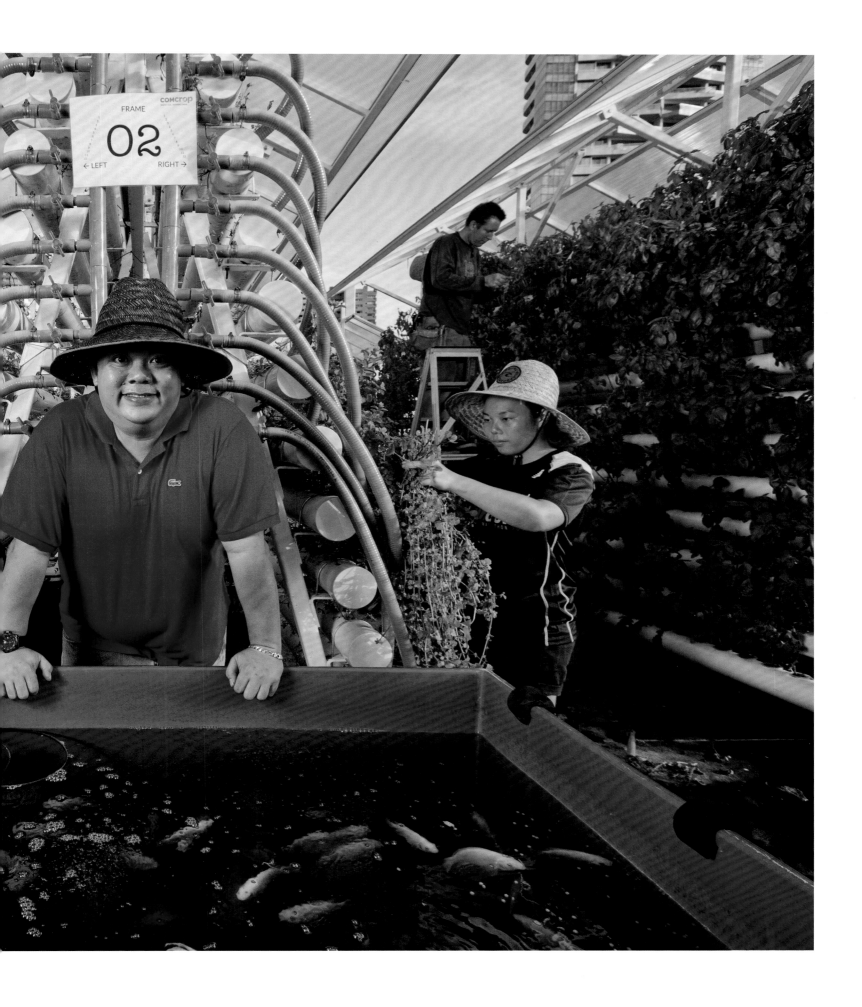

FRAME
02
COMCROP

← LEFT RIGHT →

WORDS OF MY OWN

Robyn Bargh

WORDS OF MY OWN

Robyn Bargh

I grew up in a small, rural, Maori community near Rotorua, New Zealand in the 1950s and 60s. Some of my most vivid childhood memories are meal times with my extended family, helping my father on the family farm on our traditional lands, day-dreaming while herding sheep along dusty roads, and spending time on our marae, the traditional community centre, listening to elders telling stories, some informative, some imagined, and many hilarious, before racing back to the kitchen and my real task of preparing meals and looking after our guests.

At night, I began to travel the world through books. My awareness of India began with Rudyard Kipling's Mowgli stories. I imagined myself growing up with a wolf pack in the jungle. I marvelled at the bravery of Rikki-Tikki-Tavi fighting Nag, the cobra – having never seen either a mongoose or a cobra. Some years later, when I left home to study at university, I discovered Africa through the African writers series edited by Chinua Achebe. From writers such as Dambudzo Marechera, Nadine Gordimer and Nelson Mandela I felt the heat and smelled the earth of Africa, I heard the beating of the drums and the wind blowing through the grasses of the plains, and I learned something of the painful realities of apartheid.

I attended teachers' college then university in the 1970s when it was still possible in New Zealand to wander through a broad liberal arts degree. However, it was in my work in Maori Studies where I began to make the links with my reading. In *Bury my Heart at Wounded Knee*, Dee Brown introduced me to an Indian history of America very different from the Saturday night cowboy

and Indian films I had watched as a child in the movie theatres of Rotorua. I began to realise that Sitting Bull, Crazy Horse and Geronimo were not renegades but leaders of their people striving to retain their traditional lands against a formidable foe – whose efforts were similar to and as courageous as those of Hone Heke, Te Kooti Rikirangi and Te Rauparaha, Maori leaders who fought to retain their traditional lands, resulting in wars between Maori tribes and colonial settlers and the eventual loss of about 95% of Maori land.

In the early 1980s, my husband and I and our two children lived in Papua New Guinea for three years. Besides the exhilarating heat of the tropics and the joys of living in a multi-cultural and multi-lingual environment, I saw 'tino rangatiratanga' or self-determination in practice. Despite the multitudes of advisors, a vestige of the colonial past, the Papua New Guinean people were the majority, they were in charge – it was their country and they could do things their way.

In the years before self-government, Papua New Guinean writers were the conscience of their nation, influencing public opinion and actively promoting political independence. But they found a post-independence environment characterised by disillusionment, ambiguity and pragmatism, and writers such as John Kasaipwalova and John Kolia expressed their frustrations through critical essays, fiction, plays and poetry. I continued my reading of writers from other parts of the world and thanks to Vikram Seth I tasted the curries of India, heard the vernacular of the people of Brahmpur, and engaged in a love story, all in the midst of the turmoil of a newly independent India. And from

With feathers a bird can fly – Maori proverb

Maya Angelou in *I Know Why the Caged Bird Sings* I learned the possibility of hope in the midst of violence and despair.

When we returned to New Zealand I saw life through a new lens. I had begun working as an editor, editing and producing publications. I began to see that the real experiences of Maori, both personal and political - our stories, our language and our perspectives on our history, apart from the work of writers like Patricia Grace and Witi Ihimaera, were hidden from the world and even from other New Zealanders; they were carefully tucked up in the quiet corners of our many marae.

By 1991 this combination of ideas had become the seeds of a publishing business. Huia Publishers aimed to capture stories of ordinary people like me, Maori as well as the other ethnic groups that make up the multicultural face of Aotearoa New Zealand today. We needed to describe the diverse experiences of Maori – workers, artists, academics and their families, all engaged in their daily activities on the marae, in the workplace, on the sports field, and in the community, and we needed to take these stories to the world.

We also wanted to help revive the Maori language, the traditional voice of Maori which is still threatened despite decades of revitalisation efforts. The company, Huia, was named after the beautiful, distinctive and valued native bird whose last mournful cry was heard over a century ago. For us, the Huia bird symbolised the uniqueness of the indigenous knowledge and language that was being lost to the world.

Despite knowing nothing about the publishing industry and very little about business, I rented an ex-pie factory as an office, purchased a second-hand desk, phone and computer and put a sign on the door – Huia Publishers. The greatest challenge we faced was finding Maori writers and providing opportunities for them to develop skills – we needed to grow writers of international stature. We began a programme of writer contests, workshops, mentoring and an incubator programme.

The 1990s was a time of intense activity for Maori language advocates. The number of Maori language schools increased to nearly 300 and Maori language television was established. The demand for publications in Maori grew and consequently a large part of the Huia publishing programme has been works in Maori language.

As I looked at the photographs in this book, I was more aware of the commonalities of experience than the differences. The differences of place, culture, ethnicity and political situation were much less significant than the shared experience of initiative, determination and vision that enable people and their families to survive and, at the same time, build on their traditions.

Over the last 20 years, Huia has produced hundreds of books – novels, short stories, graphic novels, histories, biographies, artbooks and academic texts on all kinds of topics, many in Maori language. I was introduced to the world through books; I hope that Huia books have shared some of our Maori perspectives with others. In the same way *The Other 100 Entrepreneurs* records the experiences of 100 other people, their places and their dreams, and presents these to the world.

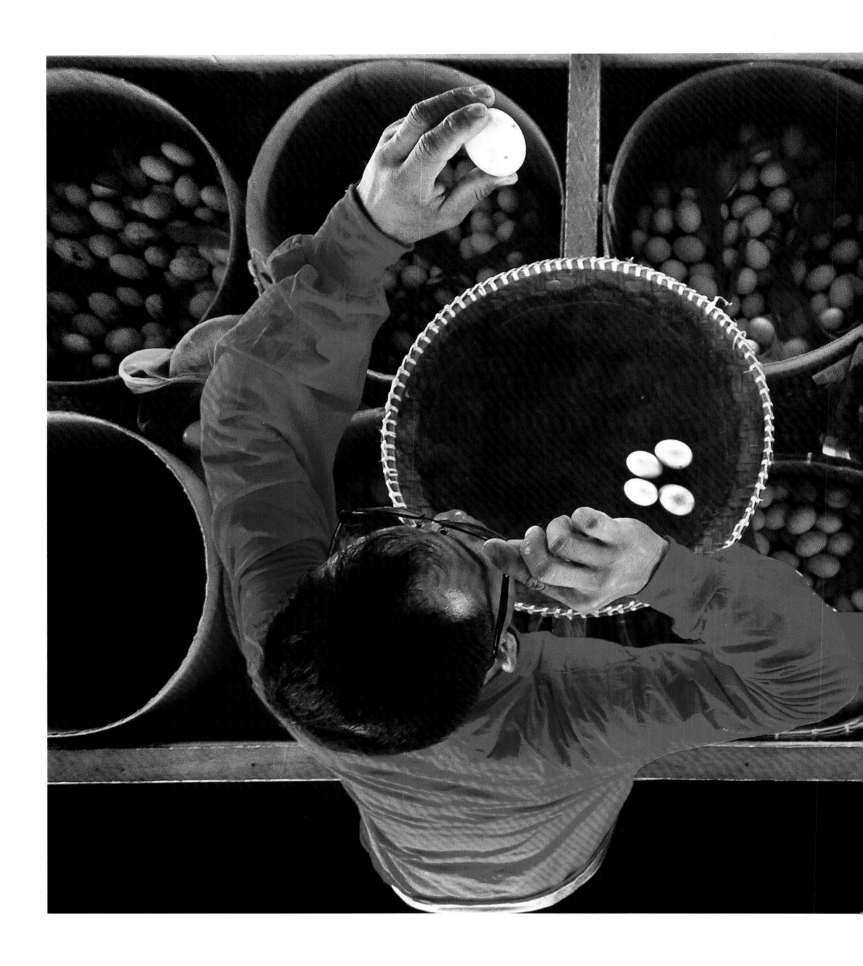

Balut – a boiled duck's egg containing an almost fully developed embryo, usually eaten at night accompanied by salt, chili, garlic and vinegar, is one of the Philippines' most popular street foods.

Jeff Matawaran, 48, set up his balut-processing business in 2007, beginning with two workers and a single incubator. Today, his business in Jala-jala, a town 75 kilometres south-east of Manila in Rizal province, serves shops and restaurants in nearby towns and cities.

Married with two children, Jeff also raises ducks and grows rice on a small lot.

Photographer
MARIA FRANCESCA AVILA

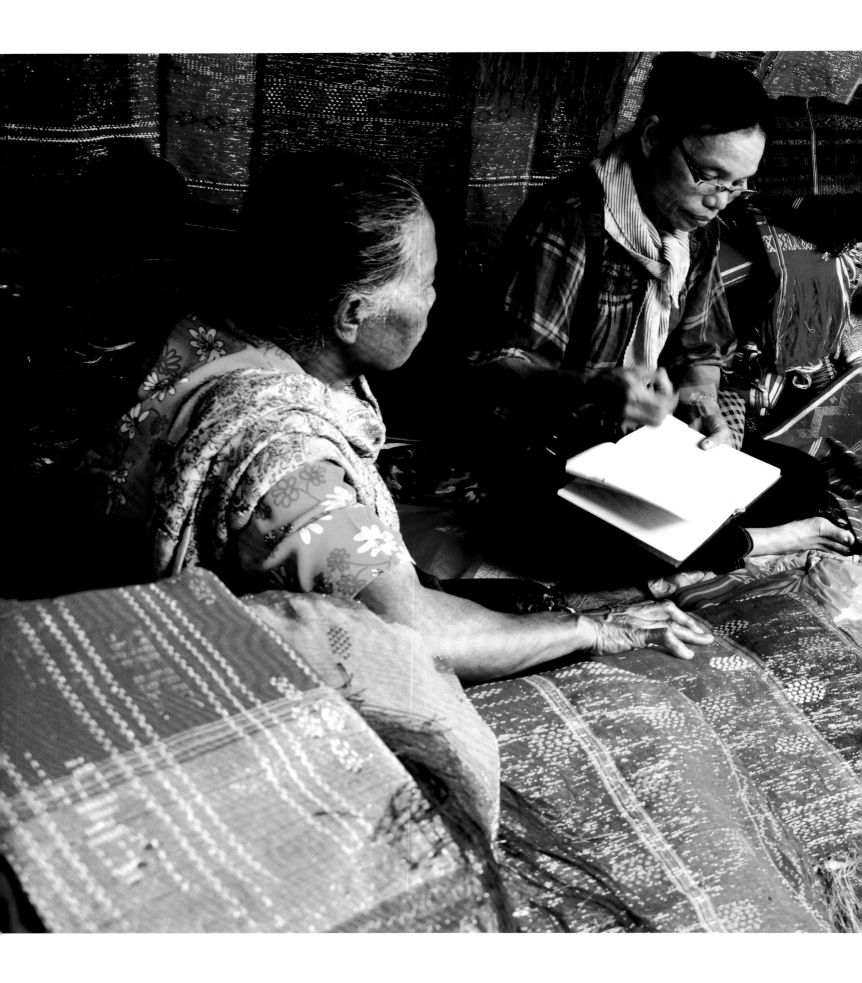

Rolika Manik is a trader of ulos cloth from Lumban Suhi Suhi village on Samosir Island in Indonesia's North Sumatra province. For more than 150 years, weavers in the village, mostly women, have used hand looms to make ulos.

The traditional cloth of the Batak people, North Sumatra's largest ethnic group, ulos comes in a range of varieties, each with its ceremonial significance.

Every Wednesday, after collecting the week's output from local weavers, Rolika travels to the local market to trade and meet with other producers. Most of her customers are other Batak people. A piece of ulos typically takes two to three days to make and sells for between US$10 and US$15.

As well as being a trader, Rolika also organises training for new weavers to try and ensure that future generations can continue to make ulos with traditional tools and techniques. Persuading young people to take up the craft is hard; most want to leave their village to go and live in towns and cities where they can earn more money.

Photographer
BASTIAN SAPUTRA

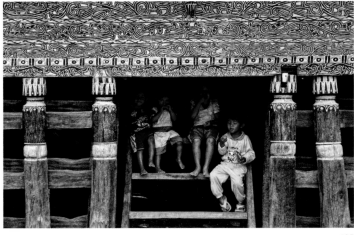

MAUDEMO VILLAGE, TIMOR-LESTE

Maria Fatima is the chief of Maudemo, a village in Timor-Leste where life has long centred on small-scale farming. "Farmers are important, because they are the ones who provide food for the other people. If there are no farmers, there will be no food," she says.

But with output from village farms facing rising competition from cheap, factory-processed foods, Maria spends much of her time helping her community look for ways of producing better tasting, higher value food both for them to eat themselves and sell in nearby markets.

The villagers have had some success with snails. Long considered nothing more than a pest, they now collect and prepare them in a way that they can be eaten. Treatment of cassava is also undergoing a rethink. Long the third most important source of calories after rice and maize for people in tropical regions, traditionally villagers would just peel it, boil it and then eat it. Now, says Maria, they prepare it into chips that are both tastier and retain more nutrients.

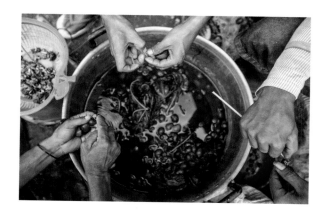

Photographer
RODNEY DEKKER

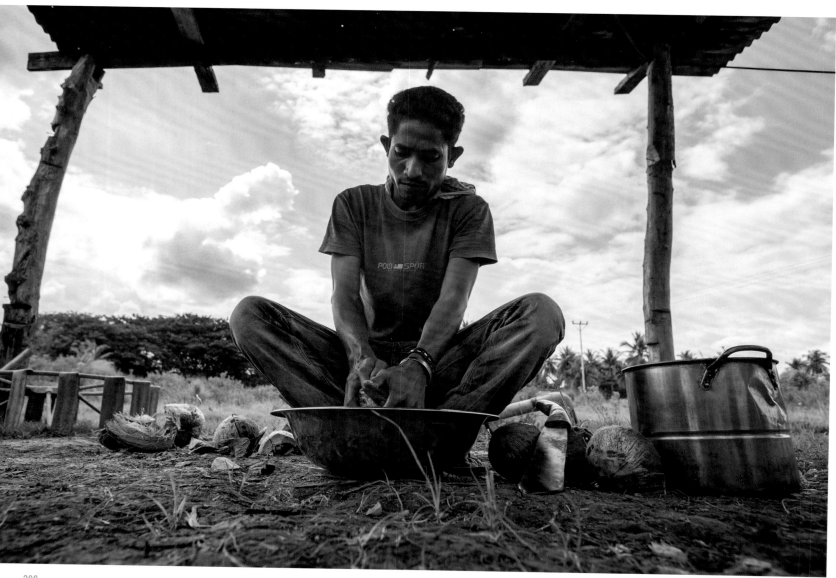

On Nusa island, about five minutes by boat from Kavieng, New Ireland, in far northern Papua New Guinea, this father, his son, aged about 10, and his daughter, around 15, make bread for their village of about 200 people.

All born in the village, every day, they get up at half-past two in the morning and start baking bread and other items. Their oven is home-made, and the hut which houses it soon becomes smoky.

By the time the sun rises, their bread is ready. Villagers drop by to buy their breakfast, paying between US$0.10 and US$0.50 for rolls and loaves.

NUSA ISLAND

Photographer
VANESSA KERTON

FO'ONDO, SOLOMON ISLANDS

Wally Faleka, 44, has run Village Level Art and Graphics since 1989 in his home village of Fo'ondo on Malaita, one of the Solomon Islands. An artist, screen printer, sign writer, teacher and occasional taxi driver, he lives and works in a small house with his wife and seven children, four of them adopted from other relatives.

Despite the island's lack of running water and electricity, Wally has developed his own screen printing technique, recycling x-ray plastics and surgical knives from a nearby hospital for making and cutting his stencils. Whenever he can get his hands on some emulsion, he uses sunlight and water from his water tank to expose his designs onto cloth screens.

Through the year, he designs and paints banners and t-shirts for events and meetings held on the island. Every Christmas, he creates his own collection of special t-shirts that he sells in Auki, the island's capital.

Since he bought an old car two years ago, he has also travelled around the island giving free workshops where he shows women how to dye and screen-print beach wraps known as "lava-lavas". Afterwards, many of these women carry on creating their designs and products that they then sell.

When orders dry up, Wally works as a taxi driver, earning enough to pay a mechanic to keep his car maintained.

Photographer
JOUK INTHESKY

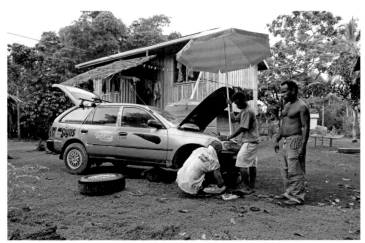

PINK LAKE, AUSTRALIA

Twenty-three years ago Neil and Jane Seymour, with their son, Richard, left their home in suburban Melbourne to farm olives in western Victoria state.

Forced to diversify after a ten-year drought, Neil decided to try harvesting the vividly coloured salt from nearby Pink Lake. Its hue caused by naturally occurring micro-organisms, the salt forms as a natural crust each year as the summer heat evaporates most of the lake's water.

Today, Richard runs the original olive business, while Neil and Jane run Pink Lake Salt in partnership with the Barengi Gadjin Land Council, a body representing the area's five indigenous peoples, the Wotjobaluk, Jaadwa, Jadawadjali, Wergaia and Jupagulk.

The business is seasonal. During the harvesting period at the end of the summer, Neil employs seven or eight local indigenous workers. To protect the environment from vehicle damage and over-harvesting, the salt is harvested manually, dug from the lake bed with wide-mouthed shovels, then dragged to the lakeside by hand trolleys.

Photographer
BRENDAN MCCARTHY

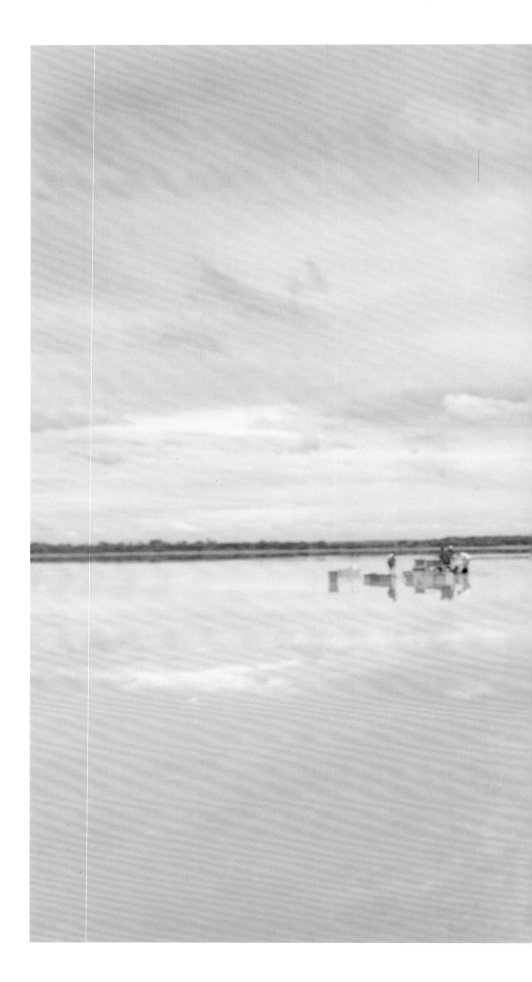

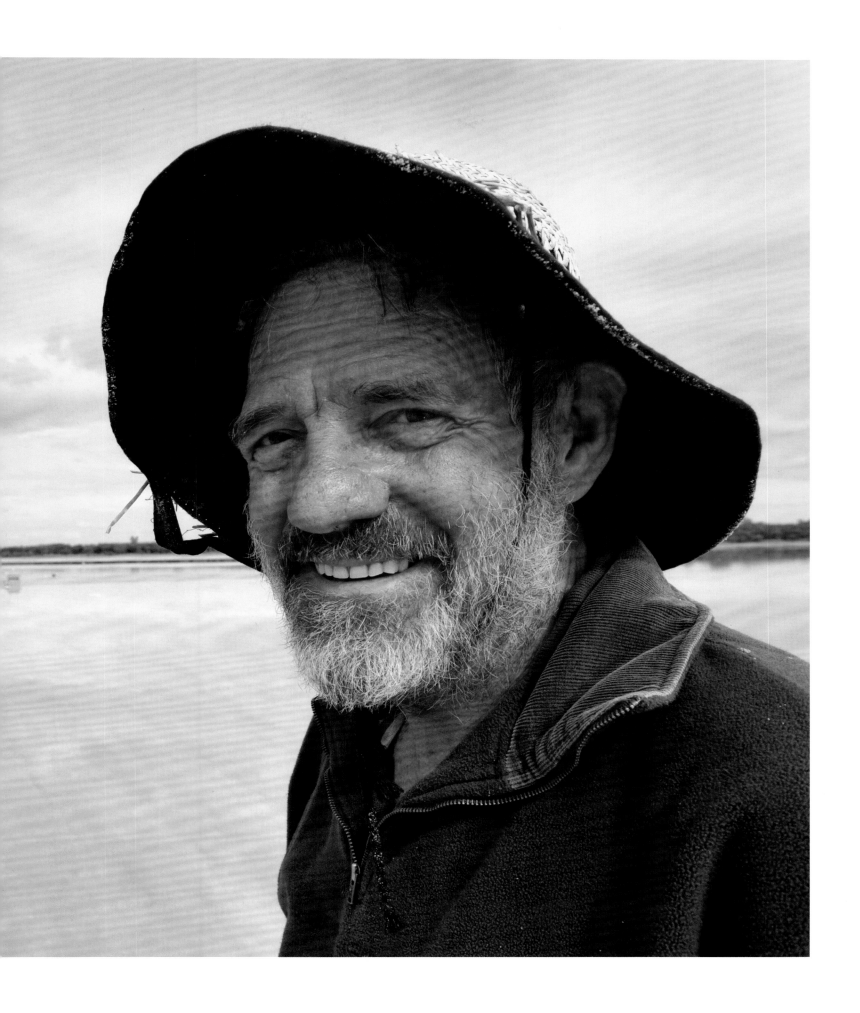

Alex Wright and Sam Keer set up the Cabinet Collective, a woodworking collective based in Wellington, New Zealand, after a chance meeting over a pile of old floorboards abandoned on a pavement in Wellington in 2008.

In search of timber to scavenge, Sam had arrived there first with a wheelbarrow. Alex came a little later in his battered old Citroen. From the conversation the two struck up emerged first the seeds of a friendship and the idea for a setting up a collective business.

Today, their collective has seven members, who as well as sharing each other's workshops, equipment and vehicles, also have similar concerns about social and environmental issues. They often lend each other a hand with their work, and for their materials prefer reclaimed and recycled timber over freshly felled trees.

Working collaboratively is the most rewarding way to work, says Alex. "Collectives promote togetherness, people working with people rather than people working for people."

"Learning how things are made and crafted connects people to their community, contributes to their well-being and helps to provide identity for local culture. Creating something from scratch enables people to feel more capable and connected to material culture," he says.

Photographer
ANTONY KITCHENER

Alex measures the thickness of a series of laminated timbers he will use to produce a kitchen worktop.

AFTERWORD

Ian Johnson

AFTERWORD

Ian Johnson

These are the people we never hear about. They are not the richest, the poorest, the sexiest, the ugliest, the weakest or the strongest, and yet they are the most important people on the planet. If we humans are to make it, to overcome the ecological ruination and the wars that threaten our existence, it will be through the people you have just looked at: the ones who are decent, working, striving, caring, hoping.

One of the many things that links them is a sense of community and work. Today, our societies are being pulled apart through forces we vaguely understand. Technology can unite but also pushes us inward, into small, concentric circles of like-minded people. Ethnic conflicts and conflicts over resources push us in the other direction – apart and at odds with each other. At times it seems that if the world doesn't melt down or implode from overuse, it will fly apart from our frenzied and thoughtless lifestyles.

But these people are pulling us back together. They are engaged with their communities. They are carpenters in New Zealand, shoemakers in Portugal, and shoe repairers in Tibet. They aren't romantics; instead, they understand what people have known through the ages – that you cannot go it alone, you need allies, you need a civic spirit. So we see miners who form cooperatives, local people who farm seaweed, shopkeepers who offer vanishing products, migrants who travel far but are anchored back in their homes.

Many of the people break sexist stereotypes – female auto mechanics in Senegal, or women entrepreneurs in Poland – while others do the improbable in other ways. They create art out of leftover materials or review books for a living (on the street, no less) in South Africa. We wonder how the survivor of genocide in Rwanda can still smile, or how the one-person printing press operator in Somalia has lived through his country's turmoil.

And yet they make their lives work. These Other Hundred show what the news shows do not or cannot – that the world can survive, but also how tenuous life can be. One slipped rope and the Indian house painter has left a widow and orphans; one misstep and the Iranian nomads plunge into the river. Life for most people on the planet is like this, and yet the muscular longshoremen in Myanmar laugh in front of the barrels they have to carry, while the baker in Papua New Guinea who has to get up each day at half past two in the morning doesn't care: he smiles with pride that he can work next to his son. This is the human spirit incarnate: the love of life, the hope for the future.

But these are the people who want to do more than survive. They have the dream to quit an internet company in Beijing and cater to the new class of white-collar workers; they start up convenience stores in Kazakhstan, even though it means staying open 24 hours a day; they take a huge chance and open an ice-cream stall in North Korea. These are people who want more for themselves and their children.

They have dreams and are trying to realise them. They are proud family owners of shoe stores in

These are the people who want to do more than survive

Argentina, or students working late into the night in Uruguay. They are romantics, holding onto an old photography shop in Ecuador while the world goes digital, or keeping in touch with people's spiritual yearnings by indigenising global religions. They believe that in an age of speed, when people don't pay attention to their environment, they'll stop and lose themselves in sensory-overloaded stores. Out of love, they try to make a living doing things that aren't supposed to be profitable: the small Welsh lamb herder, the squatters on French farms, the Dutch neighborhood barber shop. These are people who realise the potential of life – not by pushing for the ephemeral fame of social media or money, but by doing something that matters, that lasts.

Seeing this broad scope of humanity is humbling. I have spent most of my life trying to understand one country, China, and often feel a failure. There are too many dialects, too many places, too many ethnic groups, too much history to take it all in, and make sense of it. How much more then, is it possible to understand all these people, from all the continents, the countries, the languages, the religions, the cultures, the suspicion, the mistrust. How can we bridge this?

And yet these pictures show that it is possible. Around the world, we recognise the same impulses, the same desire to make life better for the next generation. The same kinds of jobs, the same hope to save tradition, to find meaning, to make a living. Even if well off, we can see the precariousness of human existence, the sense that we are here in this

world for a finite amount of time and what we do will one day end quickly. And if we think about it, as many of these people have, we decide to try to make it matter.

In these pictures, if we open ourselves to them, we see humanity in its messy, precarious reality. If we do this, we are faced with a choice. We can shake our heads and wonder skeptically how these other hundred possibly can ever make it, or we can wonder, in awe, at their spirit and join them.

THE PHOTOGRAPHERS

NANA KOFI ACQUAH (GHANA)

Nana Kofi Acquah is a storyteller who uses the camera as his favourite medium. After five years in advertising working as the Executive Creative Director of TBWA/ Ghana, he decided to pursue photography full time. Since then he has taken pictures for companies, non-government organisations and magazines in countries including Cameroon, Uganda, Angola, Nigeria, Mali, Togo, Tanzania, The Gambia, Cote D'Ivoire, Liberia, and Ghana. He lives in Kokrobite, a rural district of Accra with his wife, Gloria, three children and two boerboels.

IMRAN AHMED (UNITED ARAB EMIRATES)

Imran came to the UAE in 1976 in his early teens from Bangladesh. His interest in photography began to take a serious turn in early 2009 when he took to taking photos of life on the Creek, the historic open harbour area in Deira, Dubai. Eighteen months later this led to a book titled *Dubai Creek* depicting the bustling commercial activity on one of the busiest part of this water inlet that once was the city's economic lifeline.

HUSSAIN ALMOSAWI (BAHRAIN)

Hussain Almosawi has a bachelor's degree in computer science from the University of Bahrain. Fond of documentary photography and film making, he founded the Everyday Bahrain project and is now working on a documentary about Ashura in Bahrain. His travel blog, *Dilmuni Couple*, was recently named Bahrain's best travel and photography blog. He has also been sponsored by Nikon MEA for a road trip to the ancient city of Mada'in Saleh in Saudi Arabia.

VLADIMIR ANTAKI (CANADA)

Vladimir Antaki is a French photographer based in Montreal, Canada. He was born in Saudi Arabia after his parents left Beirut, Lebanon during that country's civil war. His family moved to Paris when he was three years old. He grew up there before leaving for Montreal in 2003. A self-taught photographer, he loves sitting with strangers and getting to know them. In August 2012, he started working on The Guardians project, which is still ongoing.

SANJAY AUSTA (INDIA)

Sanjay Austa is a photojournalist based in New Delhi, India who spends most of his time traveling. His first assignment took him on a two-month expedition to Kanchenjunga, where he documented the Indian Army's climb to the summit. Since then he has photographed many different subjects in numerous locations both in India and abroad.

MARIA FRANCESCA AVILA (PHILIPPINES)

Maria Francesca Avila from Bataan, Philippines is a hobbyist photographer who specialises in travel photography. She enjoys exploring new places, meeting people, and experiencing diverse cultures. A member of the Samahan ng mga Litratista sa Rizal camera club, she has been taking part in photo contests since 2011, and has won both local and international competitions. She is a software developer and single mother to a five-year-old daughter.

EDU BAYER (SPAIN)

Edu Bayer, born in 1982 in Barcelona, graduated with a degree in chemical engineering from the Universitat Autònoma de Barcelona in 2005. He then enrolled in the Institut d'Estudis Fotogràfics de Catalunya and in 2013 earned a master's degree at the Danish School of Media and Communication. Since 2006, he has worked as a photojournalist for *El País* and *Público* newspapers in Spain. He has traveled extensively, covering stories in Kosovo, Turkey and Iraqi Kurdistan, The Gambia, Rwanda, Burma and Libya, and has been published in *The Wall Street Journal*, *The New York Times*, *Le Monde*, and other newspapers. He is currently working on a long-term project about contemporary rural life in his homeland.

CÉSAR RODRÍGUEZ BECERRA (MEXICO)

César Rodríguez Becerra was born in Tepic, Nayarit, in 1983. He studied photography at Ansel Adams Photography School in Mexico City. His work has been exhibited in New York, London, Buenos Aires, California, China, Biel, Bogota, Mexico City and elsewhere. The recent recipient of a full scholarship from the Foundry photojournalism workshop, he currently lives in Tepic, Mexico.

ADRI BERGER (LAOS)

Adri Berger is a photographer and filmmaker based in Laos. He has worked with a variety of clients including South Korea's KBS, the BBC and a number of development agencies. His current projects include a mini-documentary about Navajo weavers visiting Laos on a cultural exchange, a film about a new children's hospital in Luang Prabang and a documentary about Luang Prabang which will coincide with its 20th anniversary of becoming a Unesco World Heritage Site.

ZOLTAN BESE (HUNGARY)

Zoltán Bese is a Hungarian-based photographer. His favourite subjects are sports and contemporary dance. His numerous awards include being a Federation Internationale De L'art Photographique artist in 2010, 2011, 2013 and 2014. In 2013, he was named a member of the International Association of Press Photographers, and in 2014 he served on the Jury Essence of Light.

DAVID BRUNETTI (PALESTINE)

David Brunetti is a London-based photographer. His work centres on issues affecting identity in conflict and post-conflict situations. His current project, "Looking for Palestine", aims to challenge prevailing perceptions of Palestinians as either victims or perpetrators of the occupation of their land.

FLORIAN BÜTTNER (USA)

Florian Büttner was born in Bielefeld, Germany in 1980. After completing high school in Detroit, he traveled widely in Asia. He graduated in 2002 from the University of Applied Sciences in Bielefeld where he studied photography. Since 2008, he has been a Berlin-based freelance photographer working with numerous publications including *GEO*, *GEO International*, *Stern*, and other magazines. He is currently working on a project about refugees in Germany. He is represented by LAIF-Agency.

JAY CABOZ (ZAMBIA)

Photojournalist Jay Caboz works for *Forbes Africa* magazine. He is often found wandering the streets of Johannesburg hunting for photographs and stories.

PETRUT CALINESCU (ROMANIA)

Petrut Calinescu is a Bucharest-based photojournalist. He graduated with a bachelor's degree in journalism and mass communication from Bucharest University, and has twice been awarded the Romanian Photojournalist of the Year Award. Personal projects have led him to India, Kenya, Bolivia, Afghanistan, China and the Black Sea region, though today he prefers to work nearer home. He is represented by Panos Pictures.

AYDIN CETINBOSTANOGLU (TURKEY)

Aydin Cetinbostanoglu was born in 1954 in Izmir, Turkey. He studied political science and history at Ankara University before starting his photography career as an apprentice in the late 1960s. He turned professional in 1973. Since then has won multiple awards, including the 2013 Cedefop Fotomuseum Award in Thessaloniki, Greece and two Unesco Humanity Photo Awards.

ELISA CHIU (BOSNIA)

Elisa Chiu is a Hong Kong-based photographer who believes in the social impact of powerful visual stories and the value of documenting grass-root observations. Born in Taiwan, she moved to Canada, where she obtained her master's degree in Financial Economics, before settling in Hong Kong. Formally a hedge fund trader, she is currently straddling different worlds, devoting herself to journalistic photography and personal projects during a sabbatical year.

BRUNNO COVELLO (BRAZIL)

Photojournalist Brunno Covello is the son of a professional photographer and grandson of an amateur one. After working for eight years in the City of Curitiba, Brazil, he became a photojournalist at the *Gazeta do Povo*, a local newspaper.

GREGORY DAJER (VIETNAM)

Gregory Dajer has lived in Hanoi since he moved there to join his wife's medical technology start-up in 2006.

BRETT DAVIES (SRI LANKA)

After growing up on a farm in Australia, Brett Davies studied finance and then worked for large international companies. He and his wife now live on the southern coast of Sri Lanka with four dogs. He has been photographing street scenes and people in Sri Lanka since he arrived there.

CHRIS DE BODE (BURUNDI)

Chris de Bode is a documentary and portrait photographer and film director. He has travelled to more than 70 countries documenting humanitarian issues. His latest project is a documentary film about children collecting scrap in Jordan commissioned by Save the Children NL. He is represented by Panos Pictures and LAIF.

ISABELLA DE MADDALENA (POLAND)

Isabella De Maddalena was born in 1978 in Santa Margherita Ligure, Italy. After graduating from the Brera Academy of Fine Art, she worked in various photography studios in Milan and London from 2001 to 2006. In 2007, she became an assistant to photographer Stefano De Luigi. And in 2010 she completed a master's degree in visual storytelling at the Danish School of Photojournalism in Aarhus. Her work focuses on social issues, often related to the status of women in contemporary society. Her pictures have been published in various magazines including *Women's Wear Daily*, *Io Donna*, *L'Espresso*, and *Rolling Stone Italy*.

RODNEY DEKKER (TIMOR-LESTE)

Rodney Dekker is a documentary photographer and filmmaker. His images and short films have appeared worldwide in major media outlets and a number of his prints are held at the national and state libraries of Australia. His photography has received awards from *Head On*, *Moran* and *Reportage*, and he has been the recipient of the International Photography Award and the United Nations Media Peace Award. He has a master's degree in environmental analysis and international development.

TASHI DORJEE (CHINA)

Tashi Dorjee is a self-taught Tibetan photographer born in 1972 in China's Gansu province. Now based in Beijing, he has lived in India, Nepal and France. His passion for taking pictures started with travel photography. He has a deep interest in the traditional music of China's minority peoples such as Tibetans and Mongolians and enjoys photographing and filming their performances.

LAURA EL-TANTAWY (EGYPT)

Laura El-Tantawy is an Egyptian photographer. She was born in Worcestershire, England to Egyptian parents and grew up between Saudi Arabia, Egypt and the United States. A graduate of the University of Georgia in Athens, Georgia with dual degrees in journalism and political science, she started her career in 2002 as a newspaper photographer with the *Milwaukee Journal Sentinel* and *Sarasota Herald Tribune*. In 2006, she became a freelance photographer so she could focus on pursuing personal projects.

RUI FARINHA (PORTUGAL)

Rui Farinha was born in 1958. From 1982 to 1986 he worked as a freelance photojournalist, after which he became the Portugal area representative for Olympus Cameras. In 2012, he completed a degree in audiovisual communication technology at the School of Music, Arts and Entertainment in Porto, followed in 2013 by a graduate degree in photography from the School of Arts of the Portuguese Catholic University. He currently works for the photographic agency NFactos.

VLADIMIR FILONOV (RUSSIA)

Vladimir Filonov was born in 1948. He left his job as an electronics engineer in 1991 to become a professional photographer with *Moscow Magazine* and has worked for *The Moscow Times* since 1992. His photographs have won more than 100 awards at Russian and international exhibitions. He has exhibited in 29 countries at more than 500 exhibitions and his work has been published in books and periodicals.

MICHAEL HEECK (MYANMAR)

Michael Heeck, 55, lives in central Germany. For nearly four decades he has combined his twin passions of travel and photography in journeys across Africa, Europe and Asia. A member of DVF, in 2013 his photograph in the black and white category of the Hamdan International Photography Award reached the final and was published in the B&W yearbook.

THE PHOTOGRAPHERS

SANNA HEIKINTALO (SWITZERLAND)

Sanna Heikintalo is a Finnish-born freelance photographer who has lived in Winterthur, Switzerland since she was six. As a press photographer, she has a strong journalistic background, explaining why most of her images have a documentary nature, regardless of their subjects. She works mainly for small and medium-sized companies, both photographing them and advising them about visual communication. She also teaches photography and holds a master's degree in visual journalism.

PAULA HOLTZ & YANNIK WILLING (GERMANY)

Paula Holtz and Yannik Willing have worked together on photography projects and commissioned works since 2014. Their focus lies on authentic portrait photography.

MOHAMMAD ANISUL HOQUE (BANGLADESH)

Mohammad Anisul Hoque is a graduate of the Pathshala, South Asian Media Academy. His "High Life" photo story was shown at Bangladesh's Chobi Mela VI in 2011 and in *The Guardian* in 2012. Other works of his have been shown at Cambodia's Angkor Photo Festival in 2012, Japan's Month of Photography in 2013 and France's Photography Biennial Photoquai 2013.

ZANN HUIZHEN HUANG (LEBANON)

A self taught photographer, Zann Huizhen Huang began her first serious foray into photojournalism in 2005. Since then she has covered humanitarian and socio-political issues in the Middle East and Asia. Her works have been published in *Time, Le Monde, Geo Italia, L'expresso* and other publications in the US, Europe and Asia. In 2014, she received the Magnum Foundation Emergency Award for her work titled *Remember Shatila*.

CHEDLY BEN IBRAHIM (TUNISIA)

Chedly Ben Ibrahim, born in Tunisia in 1970, is a self-taught independent photojournalist. He ran his own accounting and auditing firm until dazzled by images of Tunisian revolution in 2011 he decided to become a photojournalist. Since 2012 he has covered Tunisia's democratic transition, working for SIPA USA, Wostok Press and Corbis via Demotix. His pictures have been published in *Afrique Magazine, Jeune Afrique, The Sunday Times, Time* and other international publications.

ALI IMAD (IRAQ)

Ali Imad has a Master of Science degree in pharmacognosy from the College of Pharmacy, University of Mustansiriyah and a Bachelor of Science degree in pharmaceutical science from Baghdad College of Pharmacy. His hobbies include photography, reading scientific books and social networking. He has been a volunteer at Iraq Builders since 2013.

JOUK INTHESKY (SOLOMON ISLANDS)

Jouk Inthesky is a freelance graphic designer, illustrator, street artist and documentary photographer. He was born in Barcelona, Spain, but has lived and worked around the world. His photography focuses on describing social and cultural identities and the relationship between people and their environment. In 2011 he launched the Malaita Project on the Island of Malaita in the Solomon Islands. The project supports local artists and different communities from remote villages of the island by teaching screen-printing and dyeing techniques.

YAAKOV ISRAEL (ISRAEL)

Yaakov Israel, born in 1974, lives in Jerusalem. Most of his work involves long-term independent projects exploring the ways in which religion, society and politics affect and create his personal reality. "As a person who takes an interest in my surroundings, I find that I return again and again to the same places, and these places and their inhabitants have become vital parts of my biography," he says.

FELIPE JÁCOME (HAITI)

Felipe Jácome is a documentary photographer born in Ecuador. Since completing his education, his work has focused on issues of human mobility and human rights. In 2010, he won the International Committee of the Red Cross Young Reporter Competition. His photos have appeared in publications such as *Foreign Policy, The Guardian,* and *The Miami Herald.* His piece "The Vertical Border" about human rights violations of migrants in Mexico was shown at the 50th Annual General Meeting of Amnesty International in San Francisco. His work has also been exhibited in London, Geneva, Amsterdam, Quito and Washington DC.

CIRIL JAZBEC (UGANDA)

Ljubljana-based Ciril Jazbec was born in Slovenia in 1987. After studying management, he moved to the United Kingdom where in 2011 he graduated from the London College of Communication with a Master of Arts degree in photojournalism and documentary photography. His awards include the Leica Oskar Barnack Newcomer Award (2013) and the Photo Folio Review Les Rencontres d'Arles (2013). His work has been published in various media outlets including *The New York Times, GEO, Der Spiegel* and *Neu Zürcher Zeitung.*

JONATHAN KALAN (SOMALIA)

Jonathan Kalan is an award-winning independent photographer and journalist. He covers innovation, technology, start-ups and hidden stories of creativity in emerging economies.

VANESSA KERTON (PAPUA NEW GUINEA)

Vanessa Kerton has been a photographer for more than 20 years, the last six of which have been spent in Papua New Guinea.

MUHAMMAD JAHANGIR KHAN (PAKISTAN)

Muhammad Jahangir Khan is a senior photojournalist who has worked for numerous foreign and Pakistani news organisations. He has both undergraduate and graduate degrees from Shah Latif University in Khairpur. He started his career in 1998 as a photographer for *Daily Din*, and since then has worked at *Daily Kainat, Dawn* and *Reuters*. He organised the first exhibition of Pakistani photojournalists in Tokyo and represented the Pakistan Association of Photo Journalists at the 2013 World Photographers Focusing on Beijing organised by the Information Office of Beijing Municipality.

LEK KIATSIRIKAJORN (THAILAND)

Lek Kiatsirikajorn was born in Thailand in 1977. He graduated with a degree in fine arts from Silpakorn University in Bangkok and in 2001 went to England to study photography at The Arts Institute at Bournemouth. After completing the photography course, in 2005 he went on to work as a fashion photography assistant in London. He is influenced by documentary photographers such as Walker Evens, Stephen Shore, Joel Sternfeld and Alec Soth. In 2008, Lek returned to Thailand and has since been working both commercially, as well as on his personal projects. His works have been exhibited internationally.

ANTONY KITCHENER (NEW ZEALAND)

Antony Kitchener is a freelance photographer and photojournalist based in Wellington, New Zealand. He has a strong interest in documentary photography, focusing on social, humanitarian and environmental issues. In addition to commissioned work for local and national magazines, he pursues self-directed projects he believes in, endeavouring to create images that dig beyond the surface and explore the human condition. He was professionally trained as a photojournalist with the National Council for the Training of Journalists in the United Kingdom.

JESPER KLEMEDSSON (PERU)

Jesper Klemedsson was born in 1984 and is a Swedish documentary photographer and visual storyteller. He works predominantly in Latin America with a special focus on the region's indigenous and social movements. He has a master's degree in photojournalism from the University of Westminster in London.

RICHARD KOH (SINGAPORE)

Richard Koh considers photography a mystical art where "one harvests light from above". Since leaving a career in engineering research in 2003, his photography has won him multiple awards from the Paris Photo Prize and International Press Association, among others. He runs Amaranthine Photos, focusing on documentary and editorial work, including aerial photography.

ANATOL KOTTE (ARGENTINA)

Anatol Kotte was born in 1963 and has been a self employed photographer since 1988. He is based in Hamburg, Germany and is a proud father of four daughters.

ANTHONY KURTZ (SENEGAL)

Anthony Kurtz is an award-winning, Euro-American, commercial, editorial and art-documentary photographer based in Berlin. He specialises in environmental portraiture, striving to depict the unexpected beauty in people and the spaces they occupy.

LEO KWOK (HONG KONG)

Leo Kwok is an award-winning photographer. His work covers a wide range from street, documentary to fashion photography and his goal is to touch people's hearts with photographs.

CLAIRE LADAVICIUS (GAMBIA)

Claire is a French photographer based in The Gambia, West Africa where she has worked for more than ten years for an international humanitarian organisation. She believes that the beauty and uniqueness of the people surrounding her need to be shared.

FRANCESCO LASTRUCCI (GREECE)

Francesco Lastrucci is a freelance photographer, born in Florence in 1977. After pursuing architectural studies for a while, he moved to Stockholm, dedicating himself to photography. Since then he has lived in Italy, New York, Hong Kong and Colombia, and is now based in Florence. His work has appeared in *The New York Times, International Herald Tribune, The Independent on Sunday, Monocle, Vanity Fair* and many other publications. He is currently working on a long-term project about Colombia.

FRANCESCA LEONARDI (COLOMBIA)

Francesca Leonardi was born in Rome where she is currently based. Most of her work has focused on long-term projects on immigration, urbanisation and social issues in Italy and abroad. In 2009, she gained a special mention at the Fotoleggendo Italy for her project on the living conditions of immigrants in Italy. In 2010 and 2011, she was a finalist for the Amilcare Ponchielli Award. In 2011, she started a year-long photo investigation about Egypt and its post-revolution development. She is represented worldwide by Contrasto.

RAMON LEPAGE (VENEZUELA)

Ramon Lepage was born in Mérida in 1965 and is a founding member of Venezuela's Orinoquiaphoto Agency. A graduate in communication sciences from Emerson College in Boston, he also studied photography at the Art Institute of Boston. He has organised photojournalism workshops in Latin America and his work has been published in many magazines. Currently he is working on a personal photography project about the coasts of the Isthmus of Panama.

NIKOLAI LINARES (DENMARK)

Nikolai Linares graduated from the Danish School of Journalism in 2012. During his studies, he spent 18-months interning at the Danish daily *Berlingske*. Since graduating he has mainly worked as a staff photographer for *Scanpix* Denmark. Today he is a freelance photographer based in Copenhagen, working mainly for daily newspapers and monthly magazines.

JOANNA LINDEN-MONTES (MALAWI)

Joanna Lindén-Montes was born in Finland in 1984 and is a Helsinki based photographer. She has a master's degree in the history of art. She studied journalism in Peru, where she also worked for Lutheran World Relief, and has travelled to various developing countries documenting the work of the Finnish Evangelical Lutheran Mission (FELM), where she currently works as a communications officer. In 2013 she served as an official photographer at the World Council of Churches 10th Assembly in South Korea.

ANNA LOSHKIN (AFGHANISTAN)

Anna Loshkin was born in Odessa, Ukraine, but has lived much of her life in the United States. She spent a decade in the internet industry before deciding to pursue a career in photography and journalism. Her work has appeared on *BBC Russia* and in *The Diplomat* and *Tablet Magazine*. Her photographs have been exhibited in the United States and the United Kingdom, as well as online at the International Museum of Women. She is currently working on a long-term project about influential Afghan women.

THE PHOTOGRAPHERS

DARRIN ZAMMIT LUPI (MALTA)

Born in Malta in 1968, Darrin Zammit Lupi started his photography career in 1992. After a year's training in the United Kingdom, he undertook freelance foreign assignments in Albania and Yugoslavia. He joined *Times of Malta* in 1996 and *Reuters* the following year, and has since won nine Malta Journalism Awards for Journalism, Press Photography and Sport Photography. He has done assignments all over the world, with a particular emphasis on Africa, and has been documenting irregular immigration in the Mediterranean for the past decade. He holds a Master of Arts in photojournalism and documentary photography from the University of the Arts, London.

INGUN ALETTE MÆHLUM (NORWAY)

Ingun A. Mæhlum is a photojournalist based in Tromso, Norway and works mainly in the Arctic region. Born in 1973, she studied Photojournalism at Oslo University College and Documentary Photography at Volda University College in the spring of 2014. She has worked for various magazines and newspapers, as well as undertaken various personal projects. In 2013, she published the book, *Barents Portraits – A Journey Across Borders*, together with journalist Arne Egil Tonset, in which they told the stories of the normal lives in the northern parts of Russia, Sweden, Finland and Norway.

TEBOGO MALOPE (SOUTH AFRICA)

Soweto born Tebogo Malope is a 2014 SAFTA award winning Director and one of the 2013 *Mail and Guardian* top 200 Young South Africans. His drama works on highly popular series such as Tempy Pushas, Skeem Saam and Isibaya have jointly reached a viewership of more than 13 million per week. Tebogo is also an award winning Music Video Director/DOP with expansive work around the African continent. He has directed commercials for some of the biggest brands in Africa.

ROBIN MAS (CHINA)

In documenting migrant workers or the "second generation rich", Robin Mas, working with the writer Andrea Fenn, has been trying hard to blend in and get closer to "getting" Chinese people for about half a decade. Still a work in progress, his latest lead is the country's exponentially growing tech start-up scene.

ALEX MASI (SAO TOME AND PRINCIPE)

Alex Masi is a photojournalist dedicated to exposing issues of human injustice, focusing mainly on the living conditions, health and human rights of children. He believes documentary photography is an essential channel for audiences to learn about how other people face the realities of life. His goal is to produce intimate, touching images that can sensitise viewers in positive, engaging and proactive ways, hoping to contribute towards a slow change in people's behaviour and policy-making.

FELIX MASI (DEMOCRATIC REPUBLIC OF CONGO)

Felix Masi is an award winning Kenyan-born independent multimedia photojournalist and filmmaker. In 2005, he quit his job as a newspaper photojournalist to focus on covering social issues. Currently based in Washington DC, he works with international non-profit organisations documenting humanitarian work and development, mainly in Africa. Most recently, he has worked in Kenya, South Africa, and Angola, though his work has taken him to Uganda, Ethiopia, The Democratic Republic of Congo, Burundi, and Tanzania, among others. Masi has participated in the Save and Protect the Planet project produced in Portugal, Switzerland and New York.

SERGEY MATISEN (ESTONIA)

Sergey Matisen was born in Novosibirsk, Russia in 1978. A self-taught freelance photographer, he mostly works on his own projects.

VALERIAN MAZATAUD (BOLIVIA)

Born in 1978, Valerian Mazataud is a French Canadian freelance documentary photographer based in Montreal. He is mainly interested in human rights stories, migrations and refugees and has been working in the Middle East, Asia, Africa and South America. His clients include TV5, La Presse, Liberation, Radio-Canada and Handicap International. He is represented by Redux Pictures in New-York and has a master's degree in agriculture and marine sciences. Antoine Dion-Ortega and Pierrick Blin are two Canadian journalists who accompanied him on his Bolivian trip.

BRENDAN MCCARTHY (AUSTRALIA)

Brendan McCarthy is a professional photojournalist who has worked in Australia's local and regional media for 20 years. His work has appeared in international publications such as *Slow Magazine, Lonely Planet*, and *Asian Geographic*. In 2010 he won the Nikon-Walkley Photographic Prize for Community and Regional Photography. "I love photography's ability to tell stories that cross the barriers of language and culture," he says. "The stories I most enjoy shooting are always about life's quiet people." He lives on a small farm north of Melbourne with his wife, two dogs, two alpacas and some sheep.

LASSE BAK MEJLVANG (MOZAMBIQUE)

Lasse Bak Mejlvang is a freelance photographer and photojournalist based in Copenhagen. He has travelled the world with his camera and in 2010 entered the Danish School of Journalism, completing his education as a photojournalist in early 2014.

JUSTYNA MIELNIKIEWICZ (BELARUS)

Justyna Mielnikiewicz is an award-winning photographer who mainly focuses on countries from the former Soviet Union. Her work has been featured in various international publications including *The New York Times, Newsweek, Monocle*, and *Le Monde*. Since 2001, she has worked on a project about the South Caucasus and its conflicts, publishing her findings in 2014 as a book titled *Woman with a Monkey – Caucasus in Short Notes and Photographs*. She is currently working on a series focusing on women in ex-Soviet countries as well as on an in-depth project about modern Ukraine.

NAFISE MOTLAQ (MALAYSIA)

Nafise Motlaq is an Iranian documentary photographer and journalism senior lecturer at University Putra Malaysia. She worked for newspapers in Iran before moving to Malaysia in 2004 to acquire a PhD in Mass Communication. Her photographs, multimedia, and video reportages have been published in the media and exhibited in several group exhibitions in Iran and overseas. Her first photo book, *A Given Path*, was published in Malaysia in 2010 and was selected as one of the 50 best publications on international rights.

SEYED ESMAIL MOUSAVI (IRAN)

Seyed Esmail Mousavi's interest in documentary photography began while he was studying graphics. He is currently preparing a book on the Bakhtiari tribe, a nomadic people with a distinct language, culture and clothing.

CELESTE ROJAS MUGICA (URUGUAY)

Celeste Rojas Mugica was born in Chile in 1987 and is a photographer and visual artist. Her art centers on the issues surrounding identity, life and absence, and has been featured in numerous exhibitions and publications in Chile, Uruguay, Argentina, Brazil, the United States and the United Kingdom, among others. Her last creation, *El Espacio de la Resistencia*, was a multidisciplinary work of imagery created in Latin America.

ANDREI NACU (UNITED KINGDOM)

Andrei Nacu was born in 1984 and is a Romanian documentary photographer based in London. He recently graduated with a Master of Art in Documentary Photography from the University of Wales, Newport. His work has been exhibited internationally and was selected by The Photographers' Gallery for the FreshFaced+WildEyed exhibition in 2013.

ZED NELSON (SOUTH SUDAN)

Zed Nelson is a London-based, internationally acclaimed documentary photographer. His work has been published and exhibited worldwide. Having worked in some of the most conflict-torn areas of the developing world, he has increasingly explored the dark side of contemporary Western society. His recent book, *Love Me*, reflects the cultural and commercial forces that drive a global obsession with youth and beauty. The project spanned five years and involved photography in 18 countries across five continents. He has received numerous awards, including First Prize in World Press Photo Competition, the Visa d'Or (France), and the Alfred Eisenstaedt Award (USA).

NIK ERIK NEUBAUER (SLOVENIA)

Nik Erik Neubauer is a 20-year-old photographer from Ljubljana, Slovenia. He loves photography because he believes his photos can make people stop for at least a moment, forget everyday problems and think about the content of the pictures. His aim for his pictures is for them to be not only beautiful but also meaningful. His dream is to become a professional photographer so that he can continue to impact people with his photos.

NEO NTSOMA (SOUTH AFRICA)

Neo Ntsoma is the first woman recipient of the CNN African Journalist Award for photography. She is also the recipient of the National Geographic All Roads Photography Award. Her work has appeared in *The Daily Telegraph*, *Time* and *The Washington Post*. She has also exhibited in several countries around the world, including the Netherlands, Norway, Italy, France, India, Bangladesh and the United States. She was co-editor of the book, *Women by Women*, a celebration of the 50th anniversary of South Africa's 1956 Women's March.

NYADZOMBE NYAMPENZA (ZIMBABWE)

Nyadzombe Nyampenza is a Zimbabwean freelance photographer whose work appears in daily and weekly newspapers. He is a member of the Zimbabwean photography group Gwanza Arts, exhibiting his works at its Gwanza Month of Photography exhibitions held at the Zimbabwe National Gallery for the last several years. In 2012 and 2013 he participated in the Joburg-Photo-Harare Masterclass facilitated by South Africa's Market photo Workshop and Harare's Gwanza Arts.

OYEDELE OMOKAGBO (NIGERIA)

Oyedele Omokagbo is from Nigeria's Edo state. He has a Higher National Diploma in mass communication from Auchi Polytechnic, Auchi, Edo State, Nigeria. Married with two children, he currently works as a photojournalist with the Abuja-based Leadership Group of Newspapers.

JIRO OSE (ETHIOPIA)

Born in Osaka, Japan, Jiro Ose has covered news events and worked on documentary projects around the globe since he received his Bachelor of Journalism from the University of Missouri-Columbia in 1993. He turned to freelance work after 12 years as a staff photographer at several daily newspapers including *New York Newsday*. He has received various prizes including Picture of the Year International. He is now based in Kampala, Uganda.

BENJAMIN PETIT (USA)

Benjamin Petit received a master's degree at ENS Louis-Lumière in Paris and received a Fulbright scholarship to pursue his studies at the International Center of Photography in New York City. He has covered news and produced long-term reportage in Yemen, Morocco, Colombia and the United States. He is now based in New York City, where he contributes to *The New York Times*. Petit is part of the Bronx Documentary Center founder team. In 2011 he received the *Paris Match* special jury award and *The New York* Times award at the Eddie Adams workshop XXIV. He is a member of the Haytham pictures agency.

REBECCA RADMORE (CUBA)

Rebecca Radmore is a documentary photographer and visual story-teller. Having studied Latin American Studies at University College London, she was awarded a scholarship to study documentary direction at the EICTV Film School in Cuba before later moving on to gain a Masters in Documentary photography and photojournalism at London College of Communication. She recently returned from an artist's residency at Objectifs Centre for Film & Photography in Singapore where she developed long-term visual research on beauty and skin tone in contemporary society. This was followed by a brief stint working for the leading photographic agency in Botswana. Currently she is freelancing in the United Kingdom while developing ideas for her next project in Cuba.

KELLY RANCK (KENYA)

Though still closely tied to her West Coast roots, Kelly Ranck lives and works in Nairobi, Kenya as a photojournalist. Her work focuses on capturing and sharing, through photos and words, human variances and similarities.

THE PHOTOGRAPHERS

FERNANDO RODRIGUEZ (CHILE)

Fernando Rodriguez was born in Chile a few months after the coup of September 11, 1973. After a relatively quiet middle-class childhood and adolescence, he started his career as a photographer after studying audiovisual media and communication. He later studied professional photography, majoring in photojournalism. During the first decade of this century, he worked on both photographic and audiovisual projects. After the Chilean earthquake in February 2010, he decided to dedicate himself exclusively to photojournalism.

JAMES RODRIGUEZ (GUATEMALA)

James Rodríguez, who was born in 1972 is an independent documentary photographer and photojournalist focusing primarily on social justice issues involving land tenure, human rights abuses, post-war processes and negative effects of globalisation. Based in Guatemala since 2006, his work has been shown in individual and collective exhibitions in North America, Mexico, Central America and Europe. Notable individual exhibits include The El Estor Evictions, sponsored by Amnesty International Canada, and Mining in Central America: Pain and Resistance, sponsored by Oxfam America and exhibited during the 2008 Americas Social Forum in Guatemala.

THOMAS ROMMEL (CAMBODIA)

After several years in West Africa, Thomas moved to Germany in 2013 to study organisational development and human resources. He resumed his photographic work in the second half of 2013 as a freelance photographer in South East Asia for several development organisations, then became a coordinator for an NGO in Dresden in order to apply and broaden his knowledge in donor-relations and cooperation with civil society. After travelling in Ethiopia, Kenya and Bosnia, he left Germany to move to Haiti and work running a country development project and taking photographs of a "life beyond crisis".

FLURINA ROTHENBERGER (TOGO)

Photographer Flurina Rothenberger was born in 1977 and raised in Ivory Coast, West Africa. She has traveled the African continent extensively. Her assignments and long-term projects explore the human condition in the context of economic and social consequences as well as the effects of social coercion, anarchic urbanisation and global warming. She studied photography at the University of Art and Design in Zurich/Lausanne. Her second book was published in spring 2014.

JOHANN ROUSSELOT (FRANCE)

Johann Rousselot was born in Brussels in 1971, where he studied photography at ESI from 1992 to 1995. He was an associate member of Oeil Public agency from 2001 till its closure in 2010. Based in Paris, he is currently represented by Signatures in France, and LAIF for the rest of the world. He has won numerous awards for his Freedom Fighters solo exhibition at Visa pour l'Image in Perpignan (2012).

DRIPTA GUHA ROY (INDIA)

Dripta Guha Roy was born in Kolkata, India, but then moved abroad at the age of two. He grew up in Canada, the Netherlands and Singapore. He studied at McGill University in Canada and Eindhoven University of Technology in Netherlands. For the past six years, he has run his own design studio in London, while also working as a photographer covering events such as the London Olympics, the ColorRun and The Holi Festival in London.

KAROLINA SAMBORSKA (TAJIKISTAN)

Karolina Samborska was born in Poland in 1979. She is a graduate from landscape schools in both France and Poland, and is now based in Paris where she works as a freelance photographer. She travels extensively, mainly focusing on exploration of mountain regions in northern and central Asia. Her work focuses on the photography of individuals, storytelling and open landscape and "grande paysage".

BASTIAN SAPUTRA (INDONESIA)

Bastian Saputra works at a national NGO that focuses on local and regional economic development, especially the strengthening of small and medium-sized enterprises in Indonesia. His photographic interests centre mainly on issues relating to how entrepreneurs can improve their competitiveness. He is also passionate about human interest and travel photography related to economic sectors.

OLAF SCHUELKE (NORTH KOREA)

Olaf Schuelke is a self-taught German documentary photographer based in Singapore. He holds a master's degree in architecture but works as a freelance photographer.

MASSIMO SCIACCA (ITALY)

Born in Italy, Massimo Sciacca has been involved in documentary photography since the 1990s, focusing mainly on social, political and economic topics. He has worked for different magazines and newspapers, producing several reportages in the Balkans, South East Asia, South America, the United States and Africa. He received a World Press Award in 1998, and the Linea D'ombra Prize and Fuji Award in photojournalism in 1999. Since 2002 he has also worked as a film maker, producing documentaries and shortcut movies in Bosnia, Italy, Nigeria, Cuba and the United States. He currently lives in Bologna, Italy.

KRISTIAN SKEIE (RWANDA)

Kristian Skeie is a Norwegian, Swiss-based photojournalist working with a number of organisations and publications. He also teaches photography at Webster University in Geneva. The principal subject of his current work is the aftermath of war, specifically in Srebrenica, Bosnia and Rwanda. He has Bachelor of Arts and Master of Arts degrees in photography from Richmond University and Goldsmiths College in London.

ELENA SKOCHILO (KYRGYZSTAN)

Elena Skochilo is from Bishkek, Kyrgyzstan. She works as a freelance photographer, reporter and editor for various local and international media. Her blog was awarded the prize of Blog of the Year after her coverage of the Tulip Revolution in Kyrgyzstan in 2005. In 2009, she won the Edmond Muskie Fellowship and graduated from Middle Tennessee State University with a Master of Science in journalism and mass communications. She has been a photography instructor and the chair of journalism and mass communications at the American University of Central Asia for three years. Currently she works as a programme manager at the Internews Network office in Kyrgyzstan.

DAVID MAURICE SMITH (JORDAN)

David Maurice Smith is a documentary photographer based in Sydney, Australia. Originally from Canada, much of his work focuses on cross cultural issues and marginalised communities. In 2012, he joined Australia's Oculi photographic collective.

PHILLIPPA STEWART (KAZAKHSTAN)

Phillippa Stewart is a British multimedia journalist who has been living in Asia for five years. Her entry for The Other Hundred was taken during a year-long cycle ride from Malaysia to the United Kingdom. She holds a Bachelor of Arts degree in modern history and politics from the University of Oxford, and a master's degree in journalism from the University of Hong Kong.

TOMASZ TOMASZEWSKI (GHANA)

A graduate of Warsaw's Academy of Fine Arts, Tomasz Tomaszewski specialises in press photography. For more than 20 years, he has been a regular contributor to National Geographic Magazine, which has published 18 of his photo essays. He has also taught photography in Poland, the United States, Germany and Italy.

MISHA VALLEJO (ECUADOR)

Misha Vallejo was born in Riobamba, Ecuador in 1985. He graduated from the Saint Petersburg Faculty of Photojournalism in 2010 and completed his Master of Science in Applied Informatics at the Saint-Petersburg State Polytechnic University in 2011. His photographs have featured in various publications, festivals and exhibitions in Europe and the Americas. He was a finalist for the FotoVisura in 2010 and 2013 and Exposure 2011 contests, and the winner of the Sonimagfoto Grant from the Autonomous University of Barcelona. He is currently in the process of acquiring his master's degree in photojournalism and documentary at the London College of Communication. Vallejo is a member of the collective Runa Photos and he lives between London and Quito.

ROBERT VAN WAARDEN (NEPAL)

Robert van Waarden is a Dutch-Canadian photographer based in Montreal who focuses on climate change, the environment and editorial photography. His work has taken him to the Arctic and across five continents. His images have been exhibited around the world including in Trafalgar Square in London, the European Parliament in Brussels, Parliament Hill in Ottawa and the Royal Gallery in Amsterdam. His clients include *National Geographic Traveler*, *Canadian Geographic*, the British Council and numerous NGOs.

ANNE-MARIE VERMAAT (NETHERLANDS)

Anne-Marie Vermaat was born in July 1967. A former care manager, she became a professional photographer in 1999 after becoming a member of Photo Club de Rarekiek. Since 2002, she has participated in the international competitions of the FIAP, winning an award in 2007. She likes to photograph people and animals in their environment, be it in Ethiopia, North Korea or Libya.

KAZUHIRO YOKOZEKI (JAPAN)

Kazuhiro Yokozeki was born in Osaka, Japan. After receiving his Bachelor of Arts in film and television studies from the University of California, Santa Cruz, he studied Photography at S.I. Newhouse School of Public Communications, Syracuse University, New York. After working as a contract photographer at the Asahi Shimbun Publications Division in Tokyo for three years, he became a freelance photographer in 2007 to make documentaries. He is now based in Tokyo, Japan.

SUYEON YUN (SOUTH KOREA)

Korean-born Suyeon Yun is an artist, an educator and a curator based in Seoul, the Middle East and New York. Her work has mostly focused on war and history. Among the awards she has won are the International Art Fellowship (Korean Art Council 2014), KT&G Photography Fellowship (2010), 7th Daum Prize (ParkGeonhi Art Foundation 2008), Alice Kimball Travel Grant (Yale University 2009) and Tierney Fellowship (2008). She is currently working on a new film.

SVEN ZELLNER (MONGOLIA)

Sven Zellner studied cinematography at the HFF Munich. His photos have appeared among others in *DAS MAGAZIN*, *GEO*, *Terra Mater*, *LFI magazine* and *VIEW*. The documentary, Price of Gold, is his debut cinema film which received the ARTE Documentary Film Award in 2012. His photo essay about the gold rush among Mongolian nomads titled Ninjas, was presented at Visa pour l'image – Perpignan in 2011, and in an exhibition in Munich 2012 and in Ulaanbaatar in 2013. He is currently working on long-term projects in Romania, Greenland and Mongolia.

NICOLA ZOLIN (AZERBAIJAN)

Nicola Zolin explores the relationship between people and their political systems, nature, and God through his work. He is fascinated by the different ways people express their sense of freedom and by the ways people give meaning to their lives. He has lived and traveled extensively in Iran, Turkey, Palestine, India and Nepal. Before devoting himself to photojournalism, he worked with international NGOs on issues such as environmental and geopolitical issues. He was born in Italy in 1984, and has a Bachelor of Arts degree in communication science and a Master of Arts degree in international relations.

CONTRIBUTORS

TASH AW

Tash Aw was born in Taipei to Malaysian parents. He grew up in Kuala Lumpur before moving to Britain to attend university. He is the author of three critically acclaimed novels, *The Harmony Silk Factory* (2005), *Map of the Invisible World* (2009) and *Five Star Billionaire* (2013), which have won the Whitbread First Novel Award, a regional Commonwealth Writers' Prize and twice been longlisted for the MAN Booker prize; they have also been translated into 23 languages. His short fiction has won an O. Henry Prize and been published in *A Public Space* and the landmark *Granta 100*, amongst others.

ROBYN BARGH

Robyn Bargh founded publishing company Huia in 1991 to promote Maori writers, Maori language and Maori perspectives. Among the many awards she has won for her work are the New Venture Award 1994, presented by Women in Publishing, London, Creative New Zealand's Te Tohu Toi Ke a te Waka Toi award in 2006, and being made a Companion of the New Zealand Order of Merit in the New Years Honours List 2012 for services to Maori language and publishing.

ELIANE BRUM

Eliane Brum has worked as a journalist, writer, and documentary filmmaker. In two decades of reporting, she has won more than forty national and international awards in journalism, among them the Premio Rey de España and the Inter American Associated Press Award. In 2008, she received the United Nations Special Press Trophy. In the field of documentary film, she was the co-director and co-writer of *Uma história severina* (Severina's Story), winner of 17 national and international awards. She currently works as a freelance journalist. She writes a regular column for *El País*. She also has her own personal project of investigating the so-called "new Brazilian middle class" and the agricultural-extractive communities from the Amazon rainforest. She has published five nonfiction books and the novel *One Two*.

DAVID GOLDBLATT

David Goldblatt, who lives in Bristol in the west of England, is the author of several books about football and its history, including *The Ball is Round: A Global History of Football*, and most recently *Futebol Nation: The Story of Brazil through Soccer*. He also writes for *The Guardian*, *The Observer*, *The Times Literary Supplement*, the *Financial Times*, and *The Independent on Sunday*, as well as magazines *New Statesman*, *New Left Review*, and *Prospect* magazine.

HUANG WENHAI

Huang Wenhai was born in central China's Hunan province. In 1995, he moved to Beijing to study courses at the Beijing Film Academy. From 1996 to 2000, he worked as a journalist, screenwriter and director for China's national television channels. In 2001, he left that job to become an independent filmmaker. Since 2002, he has worked on a series of documentaries as director (*Wo Men*, 2008, and *Dream Walking*, 2005), cinematographer (*Alone*, 2013, *Three Sisters*, 2012, and *A Journal of Crude Oil*, 2008), and editor.

IAN JOHNSON

Ian Johnson splits his time between Berlin and Beijing, where he has lived for much of the past 30 years. He won a Pulitzer Prize for his coverage of China, and has written two books on grassroots civil society in China and Europe.

TOLU OGUNLESI

Tolu Ogunlesi, born in 1982, is a Nigerian journalist, poet, photographer and fiction writer. He is the author of a collection of poetry, *Listen to the geckos singing from a balcony* (2004) and a novella, *Conquest & Conviviality* (2008). His awards included a Dorothy Sargent Rosenberg poetry prize (2007), the Nordic Africa Institute Guest Writer Fellowship (2008) and a Cadbury Visiting Fellowship by the University of Birmingham (2009). His fiction and poetry have been published in *The London Magazine*, *Wasafiri*, *Farafina*, *PEN Anthology of New Nigerian Writing*, *Litro*, *Brand*, *Orbis*, *Nano2ales*, *Stimulus Respond*, *Sable*, *Magma*, Stanford's *Black Arts Quarterly* and *World Literature Today*, among others. He lives in Lagos, Nigeria.

YASMINE EL RASHIDI

Yasmine El Rashidi is a writer based in Cairo. She is a frequent contributor to *The New York Review of Books*, and the author of *The Battle For Egypt, Dispatches from the Revolution*. Her writing is anthologised in *Best American Nonrequired Reading*, *Fifty Years Abroad*, *Writing Revolution*, and *Diaries of an Unfinished Revolution*. She has written for *The London Review of Books*, *The Guardian*, *Aperture*, *The New York Times*, *Bookforum*, *Lapham's Quarterly*, *The Wall Street Journal* and other publications.

ACKNOWLEDGEMENTS

PROJECT DIRECTOR
Chandran Nair

EDITOR-IN-CHIEF
Simon Cartledge

PHOTOGRAPHY DIRECTOR
Stefen Chow

PROJECT MANAGER
Adeline Heng

LOGO DESIGN
Claudia Fisher-Appelt

BOOK DESIGN
Vickie Chan

ASSISTANT EDITOR
Surya Balakrishnan

PROJECT ASSISTANTS
Bridget Noetzel, Rachita Mehrotra,
Samara Melwani, Shawn Koh,
Yuxin Hou

PROJECT INTERNS
Austin Liu, Chi Yeung Yau,
Jinney Chong, Maya Petersohn,
Ruby Lai, Tricia Harjani

SPECIAL THANKS
Eric Stryson, Karim Rushdy,
Mei Cheung, Feini Tuang,
Caroline Ngai, Helena Lim,
Chika Unigwe, Janice Galloway,
David Bandurski

SPONSORS

ADDITIONAL PROJECT SPONSORS
BASF
Nexus Group
Jim Hildebrandt
Laurie Young
Ranjan Marwah
Swire Properties
Uniplan Hong Kong Limited
International New York Times

PROJECT SUPPORTERS
Cocoon Hong Kong
English Schools Foundation,
Hong Kong
East Wing Gallery
PROVAAT
Aliança Empreendedora

The Other Hundred is a project of the Global Institute for Tomorrow

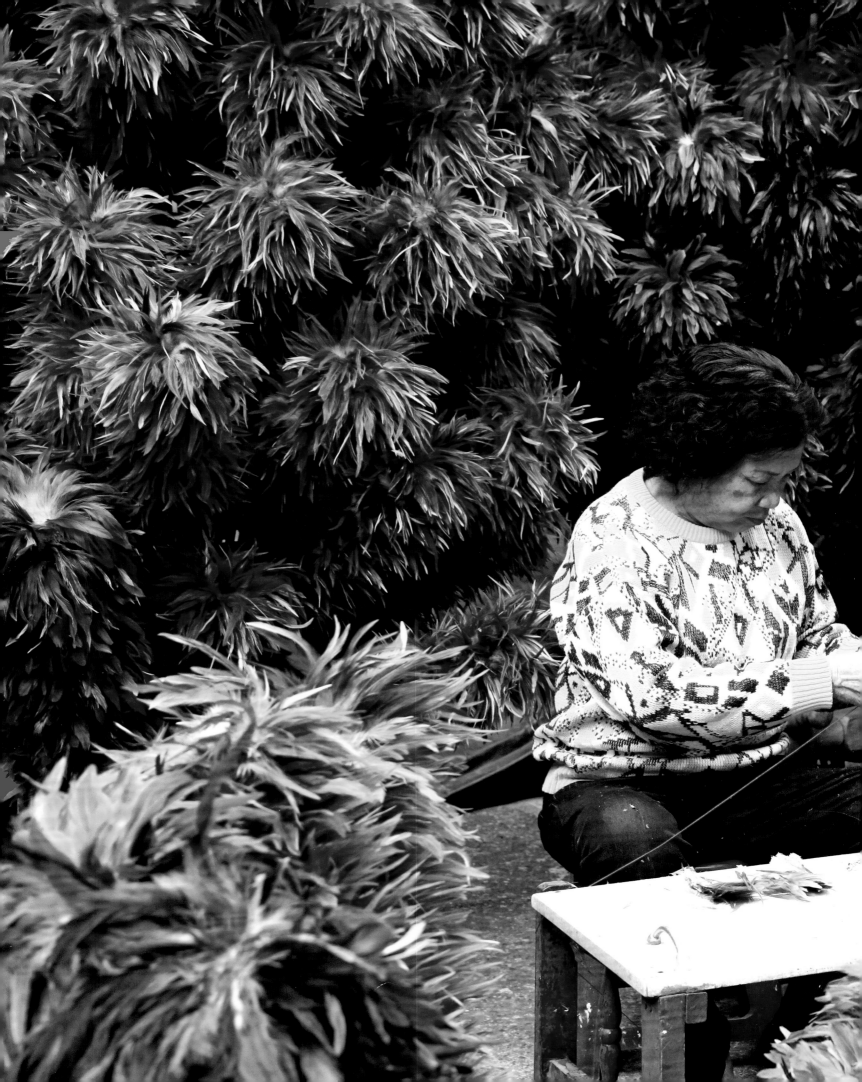